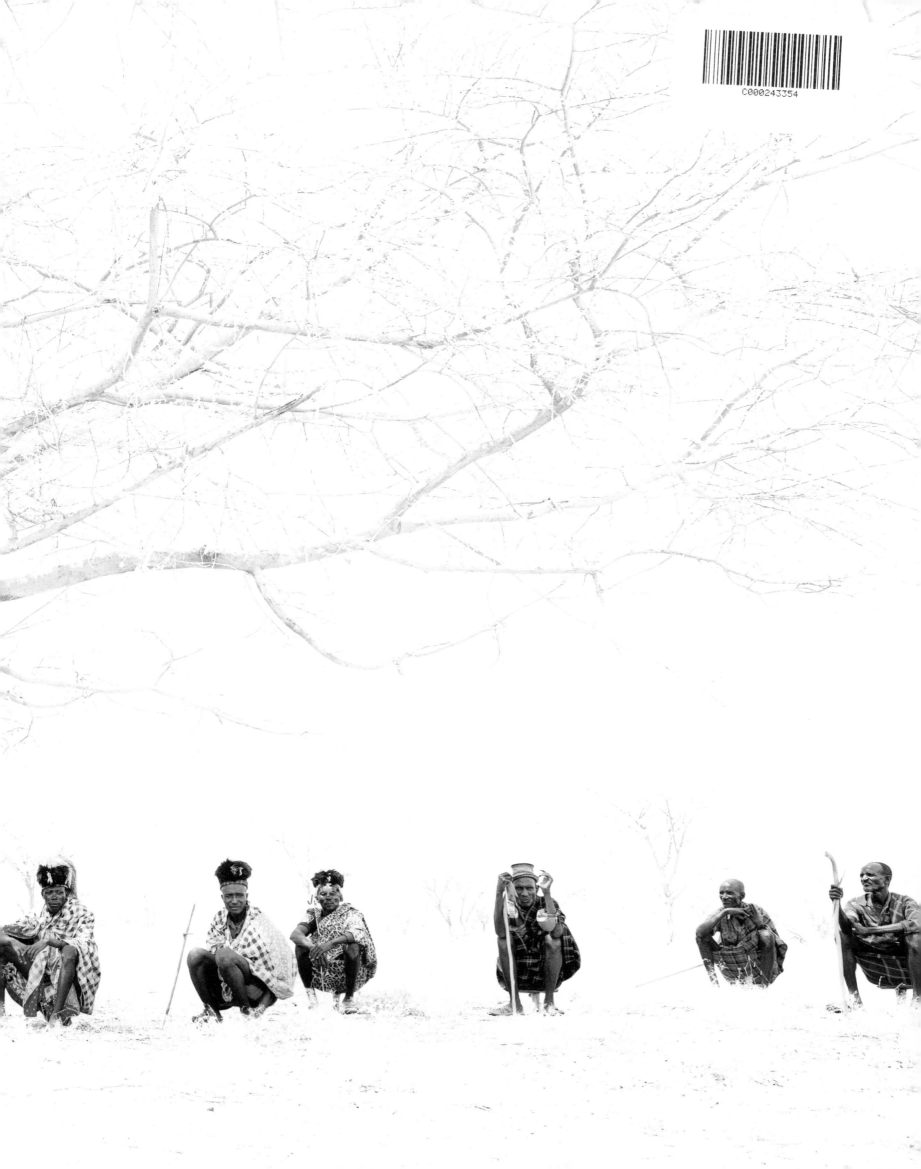

hope

teNeues

water

earth

growth

power

consumption

disorder

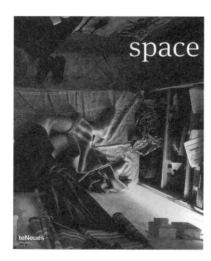

space

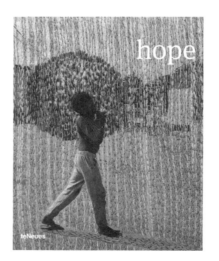

hope

water earth growth power consumption disorder space hope

Contents

Prix Pictet:
Twelve Years in Photography

2008

Launch of the first
Prix Pictet – theme **Water**

Kofi Annan appointed
President

The *Financial Times*
becomes global
media partner

Prix Pictet awards
exhibition at Palais
de Tokyo, Paris

Benoit Aquin's
The Chinese Dust Bowl
wins inaugural award

teNeues publishes first
Prix Pictet book

Michael Fried
publishes seminal *Why
Photography Matters
as Art as Never Before*

Polaroid discontinues
the production of all
instant film products,
citing the rise of digital
imaging technology

2009

Munem Wasif
completes first
Prix Pictet *Commission*
(Bangladesh)

Nadav Kander wins
Prix Pictet **Earth** for
his series *Yangtze,
The Long River*

First shortlist
presentation as part
of 40th edition of
Les Rencontres d'Arles

First Prix Pictet touring
exhibitions in Eindhoven,
Thessaloniki, Hong Kong
and Dubai

Tate appoints
Simon Baker, its first
photography curator

Kodak drops
Kodachrome film

2010

Ed Kashi completes
second Prix Pictet
Commission
(Madagascar)

First Prix Pictet
exhibitions in Russia
and India

**Victoria and
Albert Museum,**
London presents
groundbreaking
exhibition *Shadow
Catchers: Camera-less
Photography*

Instagram launches

The global population
of **camera phones**
exceeds a billion

2011

Mitch Epstein's
American Power wins
Prix Pictet **Growth**

Collaboration with
Whitechapel Gallery,
London begins with
a series of conversations
on photography

Christie's New York
sells Andreas Gurksy's
photograph *Rhein II* for
$4.3 million, the most
expensive photograph
ever sold at auction

2012

Chris Jordan completes
third Prix Pictet
Commission (Kenya)

Saatchi Gallery
stages first Prix Pictet
awards exhibition
in London

Luc Delahaye wins
Prix Pictet **Power**

First Prix Pictet exhibitions
in USA and Lebanon

Photographers' Gallery,
London reopens in a new
purpose-designed space

Annual number of **mobile
phone photographs**
exceeds those created
with cameras

2013

Prix Pictet announces
historic partnership
with **Victoria and Albert
Museum**, London, and
Musée d'Art moderne
de la Ville de Paris

Simon Norfolk
completes fourth
Prix Pictet *Commission*
(Afghanistan)

First Prix Pictet
exhibitions in Turkey
and Israel

The Family of Man,
a groundbreaking
post-war exhibition
seen by more than
10 million people, reopens
in the restored Château de
Clervaux, Luxembourg

Media Space opens at
Science Museum, London

Oxford Dictionaries'
Word of the Year is 'selfie'

Sebastião Salgado's
Genesis opens at the
Natural History Museum,
London

For each Prix Pictet cycle, a bespoke trophy, inspired by a location associated with the prize,
is designed and made by silversmith Vicki Ambery-Smith and presented to the winner
at the award ceremony

2014

First Prix Pictet awards exhibition at Victoria and Albert Museum, London

Michael Schmidt's *Lebensmittel* wins Prix Pictet **Consumption**

Juan Fernando Herrán awarded final Prix Pictet *Commission* (Colombia)

Les Rencontres d'Arles stages first Prix Pictet *Laureates* exhibition

Prix Pictet *Consumption* at the National Museum of Art, Mexico City attracts a record audience of over 100,000

2015

First Prix Pictet awards exhibition at **Musée d'Art moderne de la Ville de Paris**

Valérie Belin wins Prix Pictet **Disorder** for her series *Still Life*

First Prix Pictet exhibition in Japan (Tokyo)

2016

Tomoko Kikuchi's series *The River* wins first Prix Pictet Japan Award

Works of the Prix Pictet *Laureates* exhibited in Moscow

Prix Pictet *Disorder* at Somerset House, London

2017

Richard Mosse wins Prix Pictet **Space** for his series *Heat Maps*

Lieko Shiga's series *Blind Date* wins second Prix Pictet Japan Award

2018

Les Rencontres d'Arles stages second *Laureates* exhibition

Eighth theme of Prix Pictet *Hope* is announced in Arles

teNeues publishes special edition **ten** to mark the first decade of the prize

2019

Hope shortlist announced at Les Rencontres d'Arles

Prix Pictet *Hope* exhibition at Victoria and Albert Museum, London

Hope exhibition begins tour to Hillside Forum, Tokyo, with announcement of third Prix Pictet Japan Award

175th anniversary of the **invention of photography** by Daguerre and, separately, Fox Talbot

The **LUMA Foundation**'s Frank Gehry building breaks ground in Arles

Peter Lik's *Phantom* photo sells for **$6.5 million** to a private buyer

Photo London launches at Somerset House

The **Ansel Adams Act** restores the constitutional rights of American citizens to take photographs in public spaces

Sebastião Salgado awarded Photo London's first **Master of Photography**

Collection of Royal Photographic Society (RPS) is transferred from National Science and Media Museum, Bradford to **Victoria and Albert Museum**, London, and becomes one of the most significant holdings in the world

SFMOMA completes major expansion with new Center for Photography

Paris Photo celebrates its 20th anniversary

130 years of ***National Geographic Magazine***

Growth shortlister **Taryn Simon** awarded third Photo London Master of Photography

Victoria and Albert Museum, London opens its Photography Centre

Edward Burtynsky is awarded the fourth Photo London Master of Photography

Dr Yasufumi Nakamori is appointed senior curator of photography at Tate

Tate Britain presents comprehensive retrospective of **Don McCullin**

Diane Arbus: in the beginning, an exhibition organised by **The Metropolitan Museum of Art**, New York, is adapted for **Hayward Gallery**, London

Les Rencontres d'Arles photography festival celebrates its 50th anniversary

A Fragile and Elusive Hope

David King
Chairman of the Jury

Speaking at what would turn out to be his last awards ceremony, Kofi Annan, the Prix Pictet's President, highlighted the vital role played by the prize in shining a light on the critically important issue of global sustainability.

He painted a grim picture of a world running out of time and of lives being lived under difficult, even intolerable, conditions. And yet his conclusion was framed with hope: "Perhaps in this ability to carry on in adversity lies hope for us all. Hope that, despite the catastrophic damage that we have visited upon the natural world and upon the lives of our most vulnerable fellow citizens, it is not too late for us to reverse the damage that we have done."

These words were the cue for our current theme: *Hope.* Hope that, despite all the evidence to the contrary (evidence that has already led many to quit the fray), there is the vision, leadership and the collective will to keep on trying. Hope that we have the courage to take the difficult personal and political decisions that will be essential if we are to succeed in repairing the damage we have done. And, finally, the hope that we have the ingenuity, imagination and, indeed, the time to act and arrest the acceleration towards catastrophe.

But let's be very clear. We have reached the endgame.

The mood of optimism that followed the Paris climate change conference, at which 195 countries adopted the first-ever universal and legally binding climate accord, has dissipated. Time that should have been spent implementing solutions has been frittered away as the consensus achieved in Paris has begun to crack and shatter. And so, at the very moment when we should be reviewing our progress, we find our world bereft of leadership on this critical issue and once more accelerating towards catastrophe.

————————

There is an image by Lucas Foglia (page 88/89) that shows a house built upon a lava flow that buried the previous house and that will surely rise again

with similar consequences. Green shoots are forcing their way through the black lava. This image is a potent metaphor for the world's climate predicament. There are of course many important initiatives, from the bold and brilliant work that the 16-year-old Greta Thunberg has done to give voice to the fears of her generation; to the exemplary efforts by some African and Asian countries to base development on clean technologies. Across the world there are highly laudable efforts to recycle, rewild and reforest and to produce energy through renewable technology. Yet the growing fear is that the damage we are still doing, and have done, is so profound as to be irreversible to any significant degree. As I write, fires are newly raging in the Brazilian and the Bolivian rainforests. These precious ecosystems are a major natural means of pulling carbon dioxide out of the atmosphere and converting it into oxygen. The threat of their destruction reminds us that, with the powerful inevitability of the lava flow in Foglia's photograph, our planet may simply rise up and dismiss all of our responses as too little, too late.

And there is the great hope that art can triumph where words alone have failed

For centuries, we have been hopeless custodians of the planet. We have simply taken whatever we needed, wrecking the state of the oceans by throwing our waste, including plastics of every kind, into them; wrecking the state of the atmosphere by greenhouse gas emissions and removing the forests. And now the planet is paying us back. The Arctic is heating up at nearly three times the rate of the rest of the planet. In the Northern hemisphere summer, we are losing Arctic sea ice at an unprecedented rate. The newly exposed blue Arctic Sea is soaking up the heat from the sun, causing the rapid rise in temperature in the Arctic Circle. And as the ice is lost from neighbouring Greenland, global sea levels rise. If this continues unabated, we will reach a point this century when coastal cities (for example, Calcutta, London, New York and Shanghai) and then whole countries (Bangladesh and Indonesia are very vulnerable) will become unliveable. Rising levels of salination

will slowly destroy agricultural land with devastating social and economic consequences. This is the future that we face.

To have a hope of averting this fate, we urgently need the kind of leadership that was evident at the time of the Paris accord. We also need the creative genius of our scientists and engineers (who have succeeded in such seemingly impossible projects as space travel) to be fully focused on dramatic schemes of climate repair – from refreezing the icecaps to the greening of the deep oceans. And as individuals we need to recognise that this is not a remote problem that can be solved by politicians and brilliant men and women in distant laboratories. We need to learn how to become better custodians of the planet. That means making sacrifices to mitigate climate change, by altering our diet, our holiday destinations and shopping habits. Our future development means being totally in step with nature; developing a circular economy, in which there is no waste – every manufactured object must be designed so that it can be recirculated and reused, as nature does.

————————

So, hope persists albeit fragile and elusive. It is there, too, in the work of each of the 12 artists shortlisted for this year's Prix Pictet. Their chosen subjects may not seem intrinsically hopeful – the horrors wrought by Islamic State in Syria and Iraq, the life of a Bangladeshi prostitute – yet hope manifests itself again and again. Whether through the dogged determination to carry on as seen in Margaret Courtney-Clarke's celebration of abandoned tribes eking out an existence in the desolate nothingness of the Namibian desert (page 26/27) or Ivor Prickett's portrait of a seated woman surveying the devastation of Mosul (page 70/71). Prickett describes her defiance as simultaneously one of the most heartbreaking and inspiring things that he has ever seen. The triumph of an individual in the face of adversity and destruction finds its echo in the work of Shahidul Alam, Ross McDonnell, Gideon Mendel and Joana Choumali.

If we needed any reminder of exactly what we stand to lose, then the photographs of both Janelle Lynch and Awoiska van der Molen offer

Photo: Andreas Pohlmann, Munich

a lyrical hymn to the fragile beauty of the natural world. And Alexia Webster's portraits of friends and family are a stirring reminder of the links that bind us – as she puts it, "my work is an archive of family and love, an archive that documents not what makes things fall apart but what keeps them together."

And finally, the artist Robin Rhode makes the dilapidated streets of Johannesburg his studio. Working in communities still plagued by the problems of apartheid – high levels of gangsterism, violence, poverty, drug abuse, unemployment, and with HIV/AIDS on an upward rise due to poor facilities and lack of education – Rhode describes his work as "More a wager in the present tense than an edifying work of art, my photographic work is a vital challenge to our current disaffection. It is a testimony, perhaps, that art can save us."

And right there is the great hope of the Prix Pictet, the wager that we all make with the future, that art can triumph where words alone have failed. That images can alarm our politicians into action and inspire us all to act before it is too late. ∎

Sir David King

David King was born in Durban, South Africa, educated at St John's College, Johannesburg, and at Witwatersrand University. He is currently an Affiliate Partner of SystemIQ Limited, Senior Strategy Adviser to the President of Rwanda and a Fellow of Downing College Cambridge. Between 2000 and 2007 he was the UK Government Chief Scientific Adviser, and from 2013 to 2017 he served as the UK Foreign Secretary's Special Representative for Climate Change. He was the Founding Director of the Smith School of Enterprise and the Environment at Oxford University, 2008–2012. He has published over 500 scientific papers and received 24 honorary degrees from universities around the world.

The Contagion of Hope

Roger Scruton

Hope is one of the three Christian virtues advocated by St Paul, and despair – the loss of hope – is often described as the ultimate sin, the barrier between the soul and God.

Those theological ideas have largely lost their former adherents. But there is, nevertheless, a deep truth that they convey: hope is not something that happens to us; it is something that we do. In our most difficult trials, when all else has failed, there is still something left to us, which is hope – not the passive fantasy of rescue, which is mere escapism, but the active refusal to despair. To hope in the face of adversity is to endow adversity with a human face. Hope, in these circumstances, is a virtue in the one who possesses it, a source of strength and compassion. In the shadow of such a hope others too can shelter from the storm. All experienced soldiers are aware of this, and remember with gratitude those officers who have remained hopeful in whatever threatening circumstances, so renewing the courage of their troops.

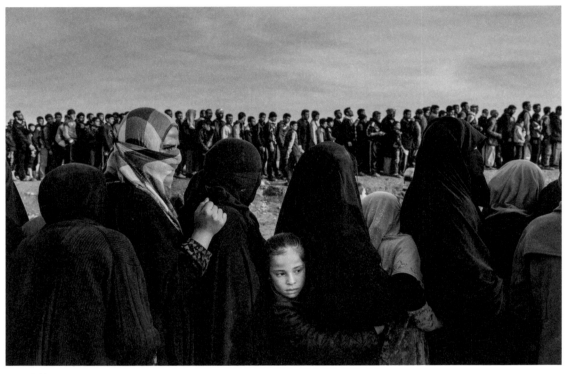

Ivor Prickett
From the series: *End of the Caliphate*

To hope in the face of adversity is to endow adversity with a human face

Surely, it will be said, hope exists only if there is something to be hoped for. Hope does not occur in a vacuum – it is not like joy or sadness, a state of mind that can exist without an object. Even in the most desperate situation the person who hopes is hoping for something – if not for rescue, at least for a loss that is bearable. The Spartans at Thermopylae did not hope to survive; but they hoped to acquit themselves honourably and fittingly and to avoid the worst of pain and shame.

Against that, however, I would urge that there is another kind of hope – what one might call *intransitive* hope, in which hope irradiates the mind without the thought of something hoped for. Hope in this sense is closely allied to trust. Just as we can confront the world in hope, with no precise idea of what we hope for, so can we confront the world in trust, without knowing in what or whom we trust. In both cases we are confident

that, if we do our best and follow our lights, then we cannot be harmed. Of course, we might be injured, we might lose what we are struggling to keep, we might even die. But there is a way of accepting these bad results which tells us that the loss involved is not an absolute loss. Even if we die, there is something, the most valuable part of us, which remains unharmed by this. For the Greeks this thing that remains when all else has been taken away is reputation: the honour bestowed by others which is the thing for which life itself can be rightly sacrificed. For us, who do not live in a world organised by honour, shame and distinction, things are not so easy. The opinion of others is, for us, an uncertain resource, and not the cure to our earthly failings. Yet we too can hope in the midst of calamity, and in doing so spread cheer among our neighbours. We too can enter adversity with the thought that, deep down, we cannot be harmed.

How is this possible? The crucial point, it seems to me, is to recognise that life is not a gift, but a loan. This thing that is the source of all that matters to

us must in time be given back. It is ours *for the time being*, to make what use of it we can. And in each of our trials there is a right and wrong way to proceed – a way that gathers support and reassurance, and one that involves a falling away from the task in hand. Intransitive hope is another term with which to describe our posture, when we enter the fray with a sense that this thing that has been loaned to us must be rightly used, and returned in proper shape when all is over.

The crucial point, it seems to me, is to recognise that life is not a gift, but a loan. This thing that is the source of all that matters to us must in time be given back

Such a hope does not lean on reputation, but reflects the fundamental *will to live* without which nothing can be truly valued.

Being hopeful in this way does not mean being reckless. Even in the worst of circumstances we must take reasonable measures to protect ourselves and those who depend on us, and to stay on top of the situation as best we can. Aristotle saw courage and hope as intimately combined, two aspects of a single virtue; but rashness, he argued, was akin to despair. The reckless person has, in a certain sense, *given up* on hope, and throws himself into the path of disaster in an act of futile defiance. Hopefulness, by contrast, involves a kind of inner calm, a desire to measure oneself against adversity and come out if possible on top.

———————

In writing of this state of mind I do not mean to refer only to dangerous or heroic actions, or to the great trials to which all of us might be put by illness or malice. Even in the smallest things the hopeful and the hopeless person are distinguished, and the distinction between them is more a matter of style than belief. A character of Oscar Wilde's tells us that, in matters of the greatest importance, it is style and not sincerity that counts, and there is a deep truth in those words. Hope has a style, a way of sweeping you along towards the obstacles that you must confront, towards the table to be dusted, the chair to be mended, the insulting colleague to be rebuked or the enemy to be defeated. This style is what leads you smiling towards the outcome. You may not be successful, but hope shines through even in the failure, as you gather your strength and try again. The person without hope, even when successful in his aims, blunders forward insecurely, his gestures tentative and uncertain, his triumph too much a matter of surprise to him to warrant a genuine smile.

Style is a social accomplishment, a form of communication. It is acquired by addressing others in words and deeds, but through the form and the rhythm rather than the plain unvarnished facts. Style illustrates what one might call the dance-like nature of human communities. In society we move together, weave our words and gestures around each other, create a fabric of connivance and cooperation, which may have no further purpose, but exist only because that is what we spontaneously desire.

Intransitive hope relies on that dance-like aspect of the human condition. It grows in the web of human relations, and nobody can really achieve it alone. The gestures and words of the hopeful person exert a magnetic effect on the surrounding society. People are lifted out of their solitude, their inbuilt solipsism, in order to breathe the same air as the one who dances before them in the realm of hope. This is what we all learn from the familiar role models: the cheerful nurse, the comforting mother, the disciplined officer, the researcher who resumes the experiment after every failed result. To the hopeful person every failure is a challenge, and every success a thing to be shared. This, surely, is one of the crucial features of style, that it reaches out to include the other, to make the other part of a communal action, as in a dance. Hopeful people do not merely spread the hope that they feel; they receive it back from the community that they also create, which smiles on them with their own emotion, so amplifying it, rooting it, and making it real.

This is why we value intransitive hope, and react with suspicion and hostility to those who show no sign of it. We do not easily accept the cautious wisdom of the risk-averse, or the fearful warnings of those who are inoculated against adventure. We need to be encouraged, and courage comes from those who already display it, and who make clear through their gestures and words that they are not to be beaten down. This natural desire to unite with the hopeful is not an entirely good thing. Indeed, unless tempered by caution and hesitation, it can lead to a bland and self-defeating optimism. But hope is contagious, and depends upon contagion for its power. It is only when the seeds of hope have been planted in a community that it comes fully to life, and that surely is why St Paul emphasised this state of mind to those early Christians, encouraging them to forget the recent calamity and to join in the dance. What can I hope? they asked St Paul, and he offered them the afterlife. What can we hope? we still ask today. And the answer must be that we hope for *this*, for hope as a style, a togetherness, an air that we breathe. And there need be nothing else we hope for, save hope itself. ∎

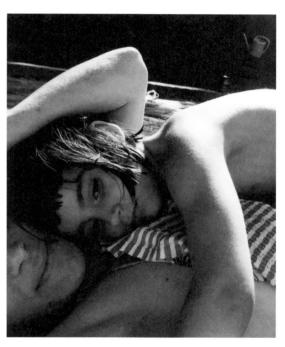

Christopher Anderson
From the series: *Son*

Sir Roger Scruton

The British writer and philosopher, Professor Sir Roger Scruton has for over three decades taught at institutions on both sides of the Atlantic, and more recently, the University of Buckingham. He is an author of over 40 books. In his work as a philosopher he has specialised in aesthetics, with particular attention to music and architecture. He engages in contemporary political and cultural debates from the standpoint of a conservative thinker and is well known as a powerful polemicist.

Photography Mania

William Boyd

In 1852, the Russian writer Ivan Turgenev ran into censorship issues with the Tsar of Russia's secret police.

His first book, *Sketches from a Hunter's Album*, had just been published and it was deemed subversive. He was detained and placed under house arrest at his estate, Spasskoe, some 250 kilometres south of Moscow. Bored and listless, Turgenev pined for his lover, the famous opera singer Pauline Viardot, and decided to send her a photograph of himself. He went – accompanied by a police guard – to the nearby small town, Orel, and had his picture taken in a photographic studio and despatched it first to Pauline Viardot and then sent other copies to his friends.

This little anecdote is very telling for a number of reasons. The fact that in mid-19th-century Russia a small provincial town, several days' travel from Moscow by coach and horses, had a photographic studio testifies to the revolution that had recently occurred in photography. In 1851, the invention of the wet-collodion process allowed any number of prints to be made from a single negative. The daguerreotype – slow, expensive – was immediately superseded. Suddenly photography was cheap and accessible to almost everyone. The next decades saw a massive expansion in the medium as the wet-collodion process was refined and improved. One statistic is very revealing: in Britain in the 1860s approximately forty million photographic cards (photographs stuck on cardboard cards) were sold, annually. The age of mass reproduction had begun. It was described as 'photography mania' – the world would never be the same.

How can we evaluate the aesthetics of a photograph?

We have witnessed, in recent years, a similar photography mania as the medium moved from the analogue to the digital version of the camera. Furthermore, the ability to install a highly-sophisticated camera in a smartphone has brought about a change in photography akin to the daguerreotype to wet-collodion transformation. Now everyone has a camera and everyone is a photographer. A trillion selfies are taken every year. Trillions more photographs are taken of plates of food. The proliferation of photographic images is unimaginably, infinitely huge.

How many photographs do we look at in a year? Thousands, probably, hundreds of thousands, conceivably. And how, in the face of this monstrous aggregation, can we ever determine or analyse what it is about one particular image that makes it memorable or good? How can we evaluate the aesthetic of a photograph? What makes it different from a painting? What are the artistic criteria of a photograph? What can one reasonably do in the face of this vast, exponential plague of images? How do we separate the few grains of wheat from this Sahara of chaff? These questions delineate the challenge: we have to find a way to distinguish a good photograph – let alone a great one – from this impossible, superabundant triumph of the banal. Therefore, it seems to me that the need for precise, argued evaluation and the establishment of basic critical criteria of assessment have never been more necessary and important. For photography to survive as an art form in the face of this mind-bending pestilence of images there has to be a basic method of determining what makes a photograph worthy of notice. Here, put as succinctly as possible, is my attempt at formulating such a scheme.

I have argued elsewhere[1] that what distinguishes photography from other visual art forms are the two factors it uniquely possesses. The first is the camera's astonishing facility as a stop-time device; its potential to freeze and trap a moment in the unending flow of time forever. No other art form can do this – painting can try but it doesn't come close. The other factor – and this is perhaps more controversial – is monochromaticity. The black-and-white photograph, it seems to me, appears truest to the medium. This is how it started and somehow is hardwired into our expectation of what a good or great photograph is. Once again the painter's *grisaille* technique – only using shades of grey and black and white – can't match photography's delicately subtle and marvellously

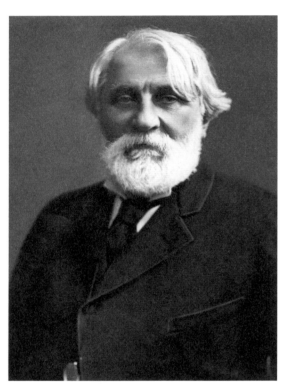

Ivan Turgenev (1818–1883)
Photo: Nadar/Bettmann

precise monochromes. The black-and-white image sets photography apart from its great rival, painting. Of course, there are many great colour photographs but colour, I would argue, somehow adulterates photography's power. The world isn't black and white but when we see it that way in a black-and-white photograph it is different – charged somehow. The medium imposes its own rules: colour photography, however brilliant, always seems to be dealing with a fundamental issue of representation. Orthodox colour photography presents an image of the world as the eye sees it. The grass is green, the sky is blue. This obviously isn't true of the monochrome image. In colour photography, representation, not transformation, seems to be the driving force.

"Scratch a photograph," the critic Janet Malcolm famously observed, "and you'll find a painting." Like many an aphorism it requires some decryption. What Malcolm is exposing here is photography's complex and troubled relationship with fine art. So many of photography's key

Awoiska van der Molen
From the series: *Am schwarzen Himmelsrund*

sub-divisions (the portrait, landscape, still life and the nude, for example) find it hard to break away from being a mere poor cousin to the paintings they mechanically replicate. Photography, however, can establish its own *sui generis* standards and parameters when it celebrates the very mechanical advantages of the camera.

[Composition] explains how we can separate the tiny number of sheep from the innumerable herd of goats

However, there is a third feature of photography that, paradoxically, relies more closely on painting and borrows from it. The third aspect of my theory is that – along with the stop-time effect and monochrome – the final factor that makes a photograph truly accomplished, that allows it to enter the realm of 'art', is when it replicates the virtues and standards of fine art composition. This recognition is often subliminal but I think it explains how we can separate the tiny number ▸

[1] The introduction to *Anonymous* by Robert Flynn Johnson, Thames & Hudson, London 2004.

of sheep from the innumerable herd of goats that
are the trillions of photographic images at large
in the world.

We're talking about, to put it simply, the secret
geometry of an image. Composition is about the
theory and technique of pictorial arrangement
and balance. Or 'design' – to be very concise.
Good photographs demonstrate this knowledge
and understanding. Good photographs exemplify
the careful use of proportion or disproportion,
of symmetry and asymmetry, of the juxtaposition
of empty space as opposed to crowded space,
of contrapuntal stresses in the movement of
vanishing points and diagonals, of perspective,
of placement of the figure and so forth – all the
academic terminology of fine art composition
(and its fruitful, deliberate distortion or inversion).
All these fine art concepts can be applied just as
easily to the analysis of a photograph and its
effect. And, the more achieved the composition –
the design – the better the photograph.

I was initially tempted to remove photography-
as-reportage from this theory. The camera is an
unrivalled, though not always perfect, witness.
Many photographs – particularly of war and
conflict – achieve their impact simply because
the photographer was actually there, recording
the distress and the horror. But, on reflection,
when we think of the great war photographs –
the ones that have become totemic (photographs
by Don McCullin, Robert Capa, Philip Jones
Griffiths, for example) – they too tend to reveal, on
further analysis, these same aspects of
well-deployed fine art composition. My claim
is that all great photographs are in some way
reflecting a brilliantly managed, submerged or
subliminal 'design' in the image and reportage
is no exception.

———————

As a thought-experiment, look through the images
in this year's Prix Pictet selection and pause at the
photographs that strike you, hold you or grab your
aesthetic attention. I would argue that when you
begin to study and analyse the ones that draw your
eye, they will illustrate in various degrees those
principles of fine art composition that I list above.
One will have a figure very close to the edge of the

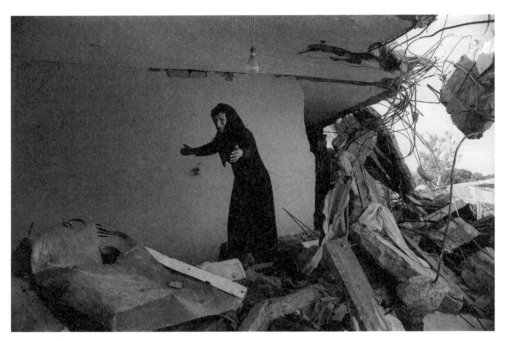

Don McCullin
A Palestinian Woman Returning to the Ruins of her House, Sabra, Beirut, 1982
Courtesy of Hamiltons Gallery

Installation view of *Diane Arbus: In the Beginning at Hayward Gallery*, 2019
Photo: Mark Blower

frame. Another will exploit the empty blank space of the sky. One will reflect differences in scale or exaggerate perspective. Some will use extreme close-up. One will be all competing diagonals, another toying with imbalance – and so on.

These analyses will all be investigating the 'secret geometry' of these images. It's there in every good photograph, and I think we instinctively recognise it when it's harmonious or when its clever disharmony draws attention to itself. The only problem – if it is a problem – is that the vocabulary we have to employ to describe these effects or tensions within an image is actually quite ancient and comes from the history of fine art. No matter – the concepts that apply to analysing the composition of a Titian or a Degas can work equally well on the snapshot of your sister jumping down a flight of steps. Think of the great photographs that haunt you or that you revere – by Lartigue, or Cartier-Bresson, or Saul Leiter, or Diane Arbus, or whomever – and I would suggest that you will find that those that impress and stay in the mind possess and reflect some inherent skill of compositional organisation (or deliberate disorganisation) that make them striking or memorable in some way.

The value of prizes and competitions and exhibitions [is that] – they force us to evaluate, compel us to select and judge

And this, surely, is the value of prizes and competitions and exhibitions – they force us to evaluate, compel us to select and judge. And this is a right and proper human thought-process. Not all art is equally good; not every photograph is as interesting or remarkable or as accomplished as another. Imagine a world where every year trillions of novels were published, or trillions of films were released – in these notional circumstances the urge to know what is good, what works and what is aesthetically satisfying would be overwhelming, more important than ever. This is the crisis photography is facing. 21st-century photography mania can't be halted. No one is going to stop

taking selfies soon. But we can all sharpen our critical faculties, we can all look very closely at the thousands and thousands of photographs that come our way and make a considered value judgement. That one is bad, that one is inept, that one is boring – but that one is really good. Then ask yourself why. It can be very stimulating and very satisfying. ∎

William Boyd

William Boyd is the author of 15 novels and the screenwriter of some 18 produced films or TV series. He has written widely on photography, principally for the Guardian *and the* Telegraph, *and has also written the introductions to several photographers' monographs including the work of Raymond Depardon, Rankin and Georges Simenon.*

The Great Wall of Cherry Blossoms

Naoko Abe

I recently lived in Japan for five weeks, the longest continuous period since moving to England almost 20 years ago. It was a sobering experience.

Geopolitical strains in East Asia and US-China trade tensions topped the international news agenda in Tokyo. Domestically, the murder by a former top government official of his reclusive son highlighted the problem of the *hikikomori*, the million or so Japanese men – rarely women – who live in solitary confinement, their only friends being computers and other digital devices. Returning to Britain, the Brexit debate dominated the airwaves. The US was riven and ruptured by Trump. Too often, no matter which country, a public mood of suspicion and intolerance prevailed over friendship, fraternity and even the notion of freedom. East and West were in disarray. Individual nations ploughed their own paths. Within each nation state, bitter arguments divided the populace. Topping these schisms sat the global threats of climate change, loss of biodiversity and environmental degradation.

Where, amid these calamitous concerns, lies hope? The answer is by no means certain in these unsettling times, but to me the seeds of hope lie in community cooperation. As Victor Hugo wrote 150 years ago: "In joined hands, there is still some token of hope. In clenched fists, none." Hugo was writing about the island of Guernsey, but his comments apply today to almost any place on Earth. The danger, of course, is that we will continue to sleepwalk towards our own planetary destruction. It's in the grassroots, in tens of thousands of small projects, that I detect hope and humanity even as our political leaders dither, disagree or dictate.

Each project, no matter its size, has the capacity to help change the world or at least to send the message that humanity will prevail when hands are joined. The Greta Thunberg phenomenon began when a 15-year-old schoolgirl demonstrated outside Sweden's parliament to call for action on the climate crisis. No one could have foreseen how such a solitary gesture could have sparked such global awareness. I myself detect a bud of hope in Japan from a project that has emerged in a north-eastern coastal city called Iwaki, which had been devastated by a monster earthquake and tsunami on 11 March 2011.

> It's in the grassroots, in tens of thousands of small projects, that I detect hope and humanity

While writing a book about an English cherry-blossom obsessive called Collingwood 'Cherry' Ingram, I came across a group of people in this Japanese city who were planting cherry trees. They were men and women, old and young, rich and poor, Japanese and non-Japanese. They had different views on life and different political persuasions. But they had joined hands and were working together with a single goal – to plant thousands upon thousands of cherry trees. They were united in their desire to create beauty out of devastation, hope out of despair.

The earthquake and subsequent tsunami that washed over Iwaki and other parts of Fukushima Prefecture killed more than 19,000 people. The Fukushima nuclear plant disaster that followed made a wide swathe of land unliveable because of the radiation.

The lives of hundreds of thousands of Fukushima residents changed irreparably that early spring afternoon. One man never lost hope. Tadashige Shiga, a 69-year-old businessman, fled with his family from Iwaki to Chiba, near Tokyo, after the disaster, but kept returning to Iwaki to bring food and provisions for his friends. Many had nowhere to go. Shiga was angry at the government and the region's electricity provider for failing to tell Fukushima residents about the safety of the nuclear plant.

The region's economy was devastated because lingering fears about radiation deterred people from visiting this mineral-rich *onsen*, or hot-springs, resort. Demand for Fukushima seafood, vegetables, fruit and trees plummeted. Shiga couldn't help but feel that while the earthquake and tsunami were natural disasters, the nuclear accident could have been prevented. It was time to act.

A month or so after the devastation, Shiga saw cherry trees blossoming in the streets and parks of Iwaki. They hadn't abandoned their hometown. Their branches waved in the cool sea breeze as if to glorify life no matter how contaminated the soil beneath. It was a healing experience for Shiga, and he resolved to plant thousands more *sakura*, traditionally Japan's iconic tree, to remember the dead, beautify the countryside around Iwaki and to leave a legacy for future generations.

His hope was infectious. Sixty residents who owned woodland in Iwaki donated land on which to plant cherry trees. They had previously grown cedars and other trees but the radiation had killed demand for the wood.

A well-known Chinese artist, Cai Guo-Qiang, became involved in the project. A long-time friend of Shiga, Cai was indebted to the people of Iwaki for helping him when he was a penniless artist living in Japan. Now based in New York, Cai made his name producing avant-garde artworks using

gunpowder that ignites to scorch the canvas. He produced the spectacular fireworks that lit up the opening ceremony of the 2008 Beijing Olympics.

After the Fukushima disaster, Cai travelled to Japan to help Shiga with the cherry project. "Let's plant 99,000 cherry trees in Iwaki because nine is a symbol of eternity in Chinese," Cai explained. "If we plant 99,000 cherry trees, you'll be able to see them from space. It will be the Great Wall of Cherry Blossoms!"

A month or so after the devastation, Shiga saw cherry trees blossoming in the streets and parks of Iwaki

Shiga's small idea blossomed into a symbol of hope for the residents of Iwaki. The government isn't involved. Shiga and his volunteers have planted over 4,000 wild cherry saplings so far. Each tree is sponsored by individuals and families in Japan and from around the world. From China and Korea, Denmark, England and the United States, scores of individuals and families have travelled to Iwaki to plant their trees. They're students, housewives, computer engineers, bank managers – people from all walks of life – all craving for something humane, something living, something with meaning, that they can pass on to future generations.

"None of us will be around when the goal is met," Shiga said wistfully. "But it doesn't matter, because the process of pursuing this dream is important. The idea of involving all kinds of people who follow our dreams and work together is what drives us on."

Shiga's project, of course, is but one of hundreds in Japan and one of thousands around the world that capture the human imagination and give hope for the future.

Shiga's grassroots project is a rebellion against the establishment. The primitive act of planting cherry trees is a community project that has galvanised support from around the world. History shows that people's power can spread like wildfire and overcome great hurdles when there's sufficient motivation and hope. "The best way not to feel

hopeless is to get up and do something," former US President Barack Obama once said, "If you go out and make some good things happen, you will fill the world with hope, and you will fill yourself with hope."

Who can say that the Iwaki cherry project won't ignite such a move? ∎

Naoko Abe

Naoko Abe is a London-based journalist and non-fiction writer from Japan. The English adaptation of her award-winning Japanese-language book, 'Cherry' Ingram, The Englishman Who Saved Japan's Blossoms, *was published by Chatto & Windus in March 2019.*

Instilling Responsibility for our Planetary Future

Martin Rees

My first response to the variegated images in this splendid book is to marvel at the varieties of habitat and human experience that they depict.

But I suspect those who turn its pages will have some twinges of sadness and guilt: they will realise just how privileged and comfortable their lives are, compared with the lives of many people portrayed in the photos. We must surely hope that the benefits we enjoy will spread to all of them. How realistic is this? What can we do to uplift the living standards of those who haven't yet shared technology's benefits?

I am one of the fortunate ones. I spent an idyllic childhood in a beautiful part of England, the rural county of Shropshire. One of my home town's most famous sons was the poet A. E. Housman, whose *A Shropshire Lad* combines lyricism with pessimism. Many young people less fortunate than I was would resonate with his famous couplet,

> *I, a stranger and afraid*
> *In a world I never made.*

There's no gainsaying the social, technical and medical progress achieved in the last few decades. But it's an indictment of our collective and political morality that so many remain trapped in frightening and impoverished lives. There's a shameful gap between the way the world is and the way it could be. We will have a bumpy ride through the century, but there are indeed grounds for hope.

Fifty years ago, there were about 3.5 billion people on Earth. The population was rising so fast that some influential gurus, such as the Stanford economist Paul Ehrlich in his 1968 book *The Population Bomb*, predicted mass starvation in the 1970s and 1980s. As it turned out, this extreme gloom was misplaced. World population has more than doubled in the last half-century to 7.7 billion, but food production has kept pace. Famines still occur, but as a result of maldistribution or conflict, not overall shortages. Most people enjoy greater health, life expectancy and per-capita income than their parents; and the proportion in abject poverty is falling. These improvements, against a

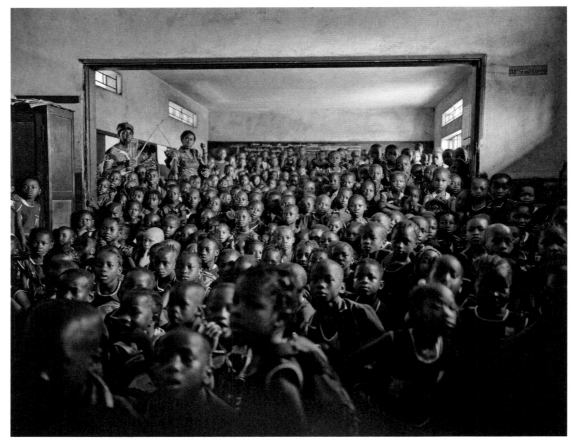

Mustafah Abdulaziz
From the series: *Water*

backdrop of a fast-growing population, couldn't have happened without advances in science and technology – which have been positive forces in the world.

Moreover, our lives, our health and our environment can benefit still further from advances in biotech, cybertech, robotics and AI. To that extent, I am a techno-optimist. But there is a potential downside. These advances expose our ever-more-interconnected world to new vulnerabilities. Even within the next two decades, technology will disrupt working patterns, national economies and international relations. In an era when we are all becoming interconnected, when the disadvantaged are aware of their predicament and migration easier, it is harder to be hopeful about a

peaceful world if today's deep geopolitical chasm between welfare levels and life chances in different regions, persists.

———

A world with nine billion people, a number likely to be reached (or indeed exceeded) by 2050, needn't signal catastrophe. Modern agriculture – low-till, water-conserving and perhaps genetically modified, together with better engineering to reduce waste, improve irrigation and so forth – could sustainably feed that number. But we'll need to foster dietary shifts and innovations. While we can be technological optimists regarding food – and health and education – it is hard not to be a political pessimist. Enhancing the life chances of the world's poorest by providing adequate

Lucas Foglia
From the series: *Human Nature*

nourishment, primary education and other basics is a readily achievable goal; the impediments are mainly political.

There's a shameful gap between the way the world is and the way it could be

We cannot confidently conceive what people's lifestyles, diet, travel patterns and energy needs will be beyond 2050. We will need to change the way we live but this need not signal hardship. Indeed, all can have a quality of life equal to that enjoyed by middle-class Westerners today – provided that technology is developed appropriately, and deployed wisely. This isn't a call for universal austerity; rather, it calls for economic growth driven by innovations that are sparing of natural resources and energy. To quote Mahatma Gandhi: "there's enough for everyone's need but not for everyone's greed."

The world couldn't sustain anywhere near even its present population if everyone lived as profligately – each using as much energy and eating as much beef – as the better-off Americans do today. On the other hand, twenty billion could live sustainably, with a tolerable (albeit ascetic) quality of life, if all adopted a vegan diet, travelled little, lived in small high-density apartments and interacted via super-internet and virtual reality. This scenario is plainly improbable, and certainly not alluring. But the spread between these extremes highlights how naive it is to quote an unqualified headline figure for the world's 'carrying capacity'. ▶

Diego Estol
From the series: *Shine Heroes*

action in humanity's long-term interest is the really stubborn challenge. Every nation needs to muster the political will to respond to a global threat. But, depressingly, nations are failing to stave off the climatic catastrophes that are increasingly likely to arrive in the coming decades. Why have these concerted efforts in science, technology, policy, communication and diplomacy not been enough?

————

The underlying problem lies in human psychology: our altruism focuses on issues too close to the 'here and now'. Too many of us resist making even a small sacrifice, or taking even a small risk, to help people we will never know in the future. Politicians may understand what needs to be done to future populations in remote regions but they will not act if their actions risk a loss of political support. Public attitudes must change first. Only then will political, industrial and financial leaders make decisions with sufficient regard for future generations.

Our health and our environment can benefit still further from advances in biotech, cybertech, robotics and AI

But there is a real hope that this can happen. To quote the great anthropologist Margaret Mead: "It takes only a few determined people to change the world – indeed nothing else ever has." When we think about the campaigns to abolish slavery, for women's rights, for civil rights and for gay rights, we realise the truth of this dictum. And we can indeed be hopeful for similar movements to preserve biodiversity, to reduce the risk of catastrophic climate change and to reduce global inequalities. Campaigns by the young – who expect to be alive by the end of the century indeed give grounds for hope.

————

I began by quoting A. E. Housman, with his focus on the hopes and despairs that infuse each individual human life. I end with some words from a near contemporary (and intellectual antithesis) of Housman who offered a grand perspective on space and time. Speaking in 1902 the novelist and visionary H. G. Wells said,

We must hope that, in the second half of this century, the global population declines rather than increases. Even though 9 billion can be fed (with good governance and efficient agribusiness), and even if consumer items become cheaper to produce (via, for instance, 3D printing) and 'clean energy' becomes plentiful, food choices will be constrained and the quality of life will be reduced by overcrowding and reductions in green space.

Optimists say that each extra mouth brings two hands and a brain. But the geopolitical stresses are surely worrying. Those in poor countries, even if they still lack basic sanitation, now know, via the internet, what lifestyles are like elsewhere in the world, and what they're missing – they're not fatalistic about the injustice of their fate. Migration remains a possibility. Moreover, the advent of robots, and 'reshoring' of manufacturing, mean that still-poor countries won't be able to grow their economies by offering cheap skilled labour, as the Asian Tiger states did.

It is a portent for disaffection and instability and reason enough to urgently promote prosperity in these regions.

————

Biodiversity remains a crucial component of human well-being. When we look to environmentalists, many feel that preserving the richness of our biosphere has value in its own right, over and above what it means to us humans. Human activities have altered the planet's surface so completely that future geologists will see our time as a new era in Earth history: the Earth has entered the Anthropocene Era. This has happened unwittingly, but now that we comprehend humanity's power over the planet, we need to regulate the use of that power.

For more than a half-century, scientists have warned that climate change and ecological disruption may degrade our civilisation beyond easy repair. The scientific case for urgent action seems compelling, but galvanising concerted

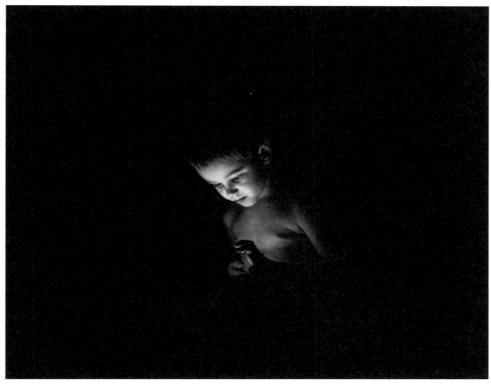

Matthieu Gafsou
From the series: *H+ (Transhumanisms)*

Humanity has come some way ... all the past is but the beginning of a beginning, and all that is and has been is but the twilight of the dawn. It is possible to believe that all that the human mind has accomplished is but the dream before the awakening; out of our lineage, minds will spring that will reach back to us in our littleness to know us better than we know ourselves.

His rather purple prose still resonates more than a hundred years later. But Wells also highlighted the risk of global disaster:

It is impossible to show why certain things should not utterly destroy and end the human story ... and make all our efforts vain ... something from space, or pestilence, or some great disease of the atmosphere, some trailing cometary poison, some great emanation of vapour from the interior of the Earth, or new animals to prey on us, or some drug or wrecking madness in the mind of man.

Wells eloquently highlights the challenges that nations collectively confront today. The stakes are higher than ever; new science offers huge opportunities, but our 'footprint' on the planet is far heavier and perhaps more perilous.

We need to bring cohesion and impetus to today's patchwork of efforts to secure humanity's future. In particular, we must use the two most powerful forces we have for shaping global social behaviour – religion and the world-wide web – to instil responsibility for our planetary future in thought and institutions. We need science and technology – but directed and constrained by values that both alone cannot provide. ∎

Lord Rees

Martin Rees is the UK's Astronomer Royal. He is based in Cambridge, where he has been Director of the Institute of Astronomy, and Master of Trinity College. He was President of the Royal Society from 2005 to 2010. He is a cross-bench member of UK's House of Lords. Internationally, he belongs to numerous academies including the US National Academy of Sciences, the Russian Academy, the Japan Academy and the Pontifical Academy. He is the co-founder of a Centre in Cambridge, with a focus on extreme technological risks and threats to humanity's future. His books include Before the Beginning, Our Final Century?, Gravity's Fatal Attraction *and, most recently,* On the Future: Prospects for Humanity.

Long Meadow Dam Ham

Stephen Barber

It was reported that 23 million Ethiopians (of a total population of 105 million) had participated in a national tree-planting scheme earlier this year.

It seems that in a single day a total of 353,633,660 trees had been planted – over a tenth of all the trees in the UK. The previous record was made in 2016 when just 800,000 people in Uttar Pradesh, India, planted 50 million seedlings in one day.

Uttar Pradesh needs it. Ethiopia needs it. According to the United Nations, tree cover in Ethiopia fell from 35 per cent of land area in the early 20th century to just 4 per cent a hundred years later. The story is similar throughout Africa and most of the developing world. And while controversy surrounds the 2019 reports of raging fires across the Amazon, the world's greatest tropical rainforest is still shrinking annually by an area the size of Wales.

So the fact that I plan to plant five native oak trees (*Quercus robur*) in a West Oxfordshire meadow this autumn is a distinctly modest counter to deforestation by comparison. As its name suggests, Long Meadow Dam Ham is a long, narrow strip of – probably – flood-meadow ('ham') abutting the raised bank ('dam') of a millstream. Ungrazed for decades, it's overgrown with meadowsweet, false oatgrass and greater pond sedge. Blackthorn, hazel and bramble are encroaching from the boundary hedges.

It's overgrown with meadowsweet, false oatgrass and greater pond sedge

I intend to allow the farmer to graze his English longhorn cattle once a year to encourage wildflower growth and improve the soil; not that this humble meadow demands quite the improvement that the Earth's estimated 5 billion hectares of degraded agricultural land so desperately needs. As the world's soils sequester over three-quarters of all the carbon held in organic matter – the 'terrestrial biosphere' (trees, vegetation and the like) – a tiny improvement in soil quality could absorb much of the annual output of CO_2 that threatens the world's climate. Soil is the world's great carbon sink.

———

We hear much about the loss of the world's tropical rainforests, chainsawed, uprooted and burnt for palm oil plantations and beef cattle; but the story is different in the West. According to Rewilding Europe, rising agricultural productivity will leave as much as 30 million hectares of European farmland permanently fallow by 2030. Here lies an enormous opportunity to transform the soil and allow wildlife to recolonise for the first time since the Black Death.

It's a different story too, when it comes to trees. Globally, the picture is one of "rapid reforestation in cool, rich countries outweighing slower net deforestation in warm, poor countries".[1] Indeed, according to a study of the University of Maryland[2], forest cover worldwide has actually increased by 2.24 million square kilometres since 1982 – a rise of 7.1 per cent.

———

All these thoughts come into my head as I sit in a (sustainable) teak garden chair in Long Meadow Dam Ham. It's late summer; banded demoiselles and emperor dragonflies hover, dart, reverse and mate amidst the tall maturing grasses; butterflies take nectar from the meadowsweet; bees and other pollinators lazily harvest the late pollen, thinking "warm days will never cease". High above, a juvenile buzzard calls for its mother. Later, at dusk, pipistrelle bats emerge from the hollow ash to flit in figures of eight in search of flying midges and night-time moths.

Pipistrelle bats emerge from the hollow ash to flit in figures of eight

I will preserve this meadow as a sanctuary for wildlife – roe, fallow and muntjac deer, badgers, foxes, hedgehogs, hares, voles, field mice, raptors, birds of all kinds – and trees, wildflowers, shrubs and grasses. But also for

the unsung heroes of our natural world, usually ignored, often unseen, and in many places in precipitate decline.

I mean insects, bugs and spiders, both above and below the ground; and below ground I mean worms, mycorrhizal fungi and soil bacteria. Their clandestine contributions to the health of our planet are incalculable.

Charles Darwin spent much of his later life in the study of earthworms. He wrote that, "it may be doubted whether there are many other animals which have played so important a part in the history of the world..."[1] Worms aerate the soil; in a single acre, they may turn over as much as a hundred tonnes of soil in a year. Bacteria and soil microbes are indirectly at least as important to our health as our own microbiota – the 9 kilograms of gut bacteria that we now know determine so much of our physical and even mental health.

Throughout the decades of agricultural industrialisation in the 20th century, we had little conception of the damage we were doing through monoculture, overfertilisation, deep ploughing and pesticides. Today we understand, or believe we understand, much better the complex web of interdependencies in nature.

Our hope is that knowledge gives the power to act

Our hope, therefore, is that knowledge gives the power to act, to arrest the potentially catastrophic consequences of overconsumption of resources. This year, Earth Overshoot Day occurred on 29 July 2019; in 1969 it happened on 31 December.[4] We can challenge the methodology, but there is no gainsaying the fact that we are consuming something like twice the resources that we are renewing. We have to find a way back to a circular economy.

In a few weeks' time, as I plant the five oak saplings in Oxfordshire, I shall think about the mighty trees I hope they will become; of the hundreds of species, vertebrate and invertebrate, they will host; of the vast mutually supporting underground interstitial networks of mycorrhizal fungi; of the cornucopia of acorns in a mast year; and ultimately, of the rich and heady scent of the tannins as the wood is split for timber and firewood. In two hundred years? Who knows. But, to plant a tree is an expression of hope, just as it was of our ancestors who planted the 180-year-old oaks that rise majestically above the hedgerows of Long Meadow Dam Ham today. ∎

Stephen Barber
Chairman, Prix Pictet

[1] Matt Ridley, *The Spectator*, 31 August 2019.
[2] ibid.
[3] Quoted in *Wilding*, Isabella Tree, Picador 2018.
[4] see Global Footprint Network
 (https://www.footprintnetwork.org).

Stephen Barber

Stephen Barber is an Equity Partner of the Pictet Group. He conceived the Prix Pictet in 2008 after a 30-year career in global investment management spanning the UK, Japan and emerging countries. He now specialises in writing and editing, design and communication generally.

Moving the Needle?

Michael Benson

The Prix Pictet is not an art prize. Neither is it a prize for documentary photography. It is, rather, a celebration of powerful storytelling using all forms of photography.

Photojournalists and artists who use photography have always happily co-existed on our shortlists. Hope is no exception. Often art takes the limelight but right now it's worth taking a moment to reflect on the critical importance of photojournalism.

While our troubled times should be a boon for photojournalists, their natural outlets are disappearing, and their traditional audiences are easily distracted by the often fatuous chatter of social media. Writing about the most recent US presidential election, Ed Kashi (Prix Pictet *Earth*) voices a familiar concern: "Some of the best photographic work doesn't seem to move the needle on public understanding, with none of it rising to the surface in the way it has in the past."

And there are more pernicious threats...

Dhaka, 5 August 2018. The photographer Shahidul Alam (pages 30 and 106) is forcibly removed from his apartment by twenty plain-clothed policemen. A few days later he appears in a chaotic courtroom bloodied and beaten. Despite an international outcry Alam spends the next one-hundred days in a Bangladeshi gaol.

A few months later, in mid-November, the equally distinguished Chinese photojournalist Lu Guang – who has spent nearly forty years documenting the effects of environmental destruction in rural and industrial China – mysteriously disappears in Xinjiang.

———

The stories of Shahidul Alam and Lu Guang are by no means unique. In China alone some fifty journalists (many of them photographers) are known to have been imprisoned since 2018. These are tricky times to be a photojournalist and yet,

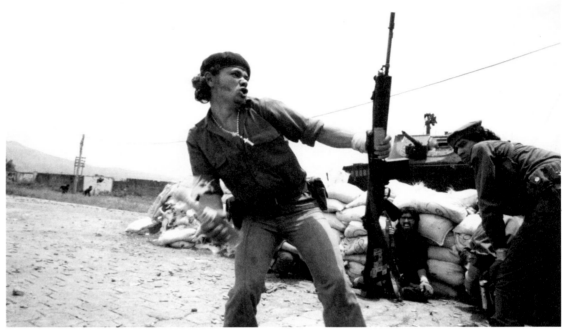

Susan Meiselas
Sandinistas at the walls of the Esteli National Guard headquarters. Esteli, Nicaragua, 1979
Courtesy of the artist and Magnum Photos

despite the escalating difficulty and risks, there seems no shortage of individuals willing to put themselves in harm's way to make searingly brilliant images that bring difficult stories to public attention.

In China alone some fifty journalists (many of them photographers) are known to have been imprisoned since 2018

They are part of a long tradition. On entering the Belsen concentration camp in April 1945, the broadcaster Richard Dimbleby calmly told his BBC listeners, "I passed through the barrier and found myself in the world of nightmare." Time and again since then journalists have crossed that barrier to document a variety of horrors. Countless photojournalists have shared the privations and dangers of victims of conflict to bring painful truths to Western breakfast tables. Don McCullin has more tales than most of making images against almost impossible odds; including one where,

having been flung amongst the dead and dying, he is still struggling against the failing light to get his exposures right.

So, why do they do this? What makes these men and women crave official permission to cross the barrier into one of the world's many nightmares? And why, even when that permission is not forthcoming, do they go anyway? It is possible to frame answers around a heady mix of the adrenaline rush of fear or nobility of purpose but it's neither of those alone. For some photographers the camera appears to create a magic cloak of invisibility that confers a strange kind of immunity. Time and again photographers fall back on this explanation. This kind of thinking granted Rena Effendi (*Power and Hope*) licence to operate in the Zone of Alienation – the name given to the still toxic environment ringed with razor wire and police check points that surrounds the toxic site of the Chernobyl nuclear accident. And why, exactly, was this a risk worth taking? "I needed to show ... the power and persistence of the human spirit in the face of

such devastation." Ivor Prickett (pages 70 and 122) is perhaps one of the most-acclaimed exponents of the invisibility principle. Operating in Mosul, shortly after fellow photojournalists James Foley and Steven Sotloff had been beheaded by IS in Syria, Prickett found a way to work on the frontline largely unimpeded. The result is a remarkable series of images of normal people who, through no fault of their own have been thrust into hell. Like Prickett, Alixandra Fazzina (*Disorder*) also seems to be possessed of an uncanny ability to remain unseen while documenting the desperate plight of Somalian migrants and the rapaciousness of people smugglers who prey on them.

———

Some years ago, I asked Prix Pictet *Power* laureate Luc Delahaye why, having declared himself done with photojournalism, he was still trying to find ways back into Syria. Delahaye, perched on a stool in the vast white expanse of his Parisian studio, sipped an espresso and considered his response: "It is simply that I am fascinated by the mechanics of evil."

Evil contorts itself into various shapes

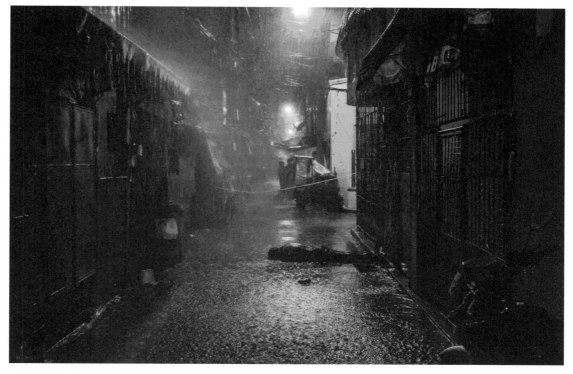

Daniel Berehulak
Heavy rain pours on the body of Romeo Torres Fontanilla, 37, who was killed by two unidentified gunmen riding motorcycles. Oct. 11, 2016, in Manila, the Philippines
Courtesy of *The New York Times*

Much of the work that Delahaye produced as a photojournalist (and subsequently as an artist working with photography) now finds a home in important museum shows. The same is true of Don McCullin, whose acclaimed Tate show earlier this year demonstrated that his (always beautifully printed) images enjoy an iconic status that was almost certainly the last thing on his mind as he was making them. In the 1970s, Susan Meiselas (page 102 and 103) returned to Nicaragua repeatedly to chronicle the Sandinista revolution – "because I had to". Her works include images of masked rebels, rotting corpses and one of a rebel – a machine gun clasped in one hand and a Molotov cocktail in the other – that sent ripples around the world. Her 'Molotov Man' has been widely adopted as a symbol of resistance, reproduced on murals and shirts and even in advertising. Again, nothing of this was in her mind when she made the work. The true power of photography became chillingly clear to her when *Time* magazine decided to publish one of her images of unmasked child

rebels. Spotting copies of the magazine on sale close to Government headquarters, "I realised for the first time that photography can kill."

Evil contorts itself into various shapes of course. A world away from Nicaragua and the Syrian hellhole, the images Pulitzer Prize-winning photographer Daniel Berehulak made on the streets of Paris following the Bataclan shootings, just days before the much-vaunted Paris climate accord (and the day after the Prix Pictet *Disorder* award in that same city), are often referred to as the defining images of 2015 – the 'year of the great unravelling'. Like many before him, Berehulak was where he should not have been. He had crossed the police cordon and slipped into the heart of the nightmare that had descended on the streets of Paris. The power of the images he made that night led *The New York Times* to commission a touring exhibition that presented his work alongside that of six very different photojournalists – Meridith Kohut, Mauricio Lima, Tomás Munita, Ivor Prickett, Sergey

Ponomarev and Newsha Tavakolian. Travelling the world under the title *Hard Truths*, the exhibition drew huge crowds wherever it went. The show's curator William Ewing explains why:

Their work is marked by artistry, intelligence, and perseverance. They sometimes risk everything to make their images because they are devoted to the people and their stories. As photojournalists they are compelled to be witnesses and report what they have seen so that you and I will stop our comfortable daily routines for a moment and recognise that our own humanity hangs by a thread; and that through awareness and understanding we can reinforce that thread. ∎

Michael Benson
Director, Prix Pictet
Founder, Photo London

Photographs

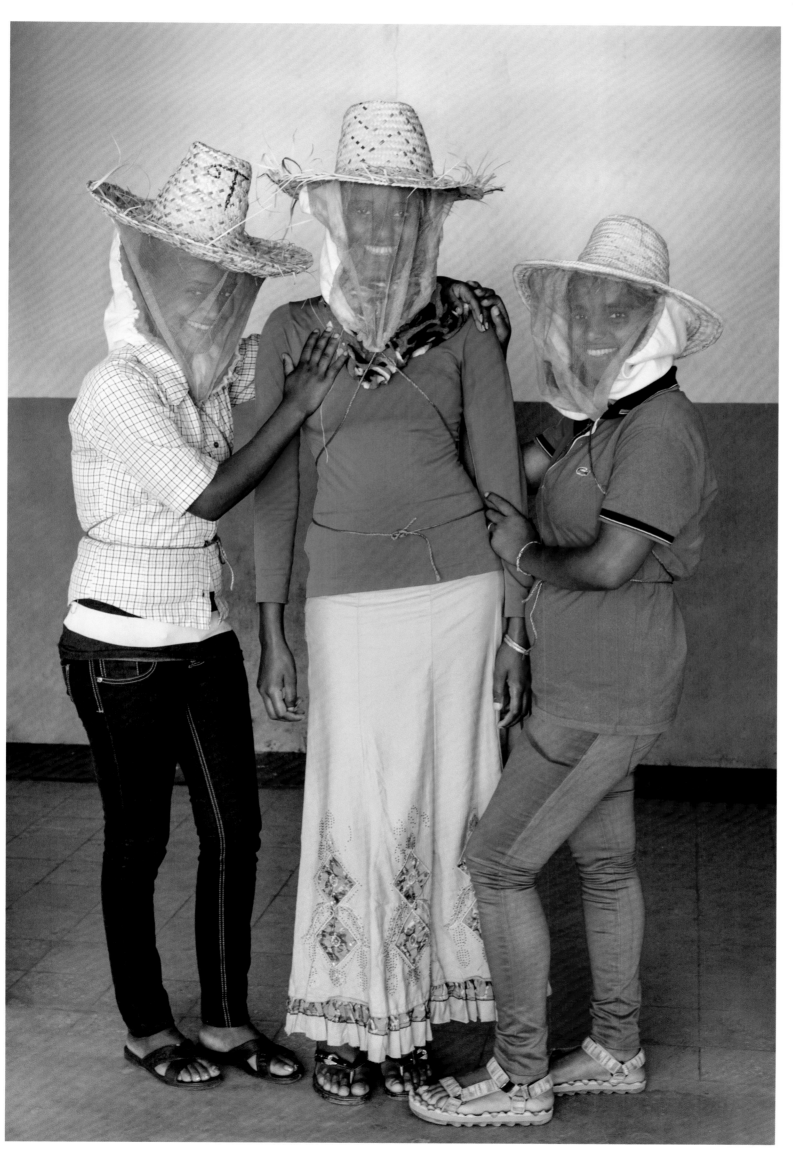

Flurina Rothenberger
Prospective female beekeepers
in Ethiopia learn a precious
sustainable trade

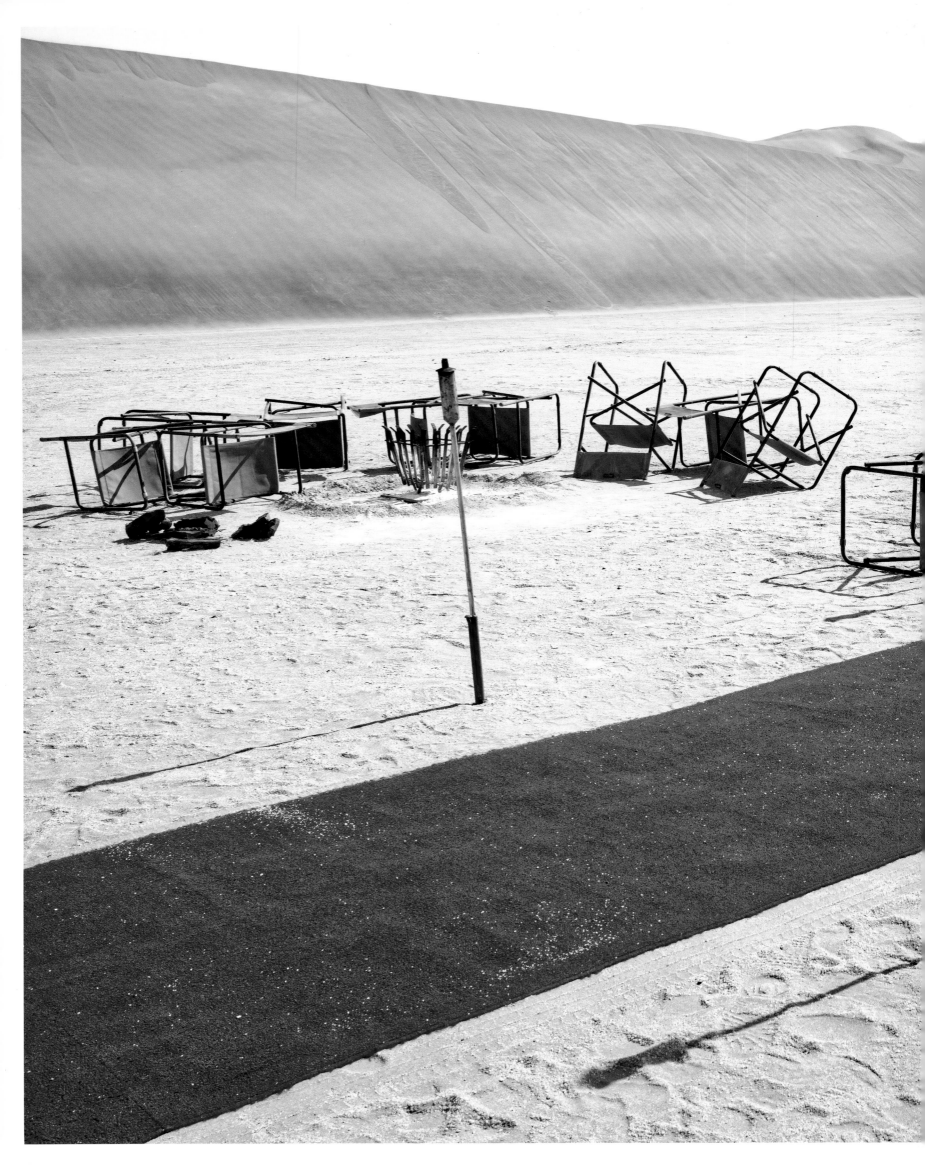

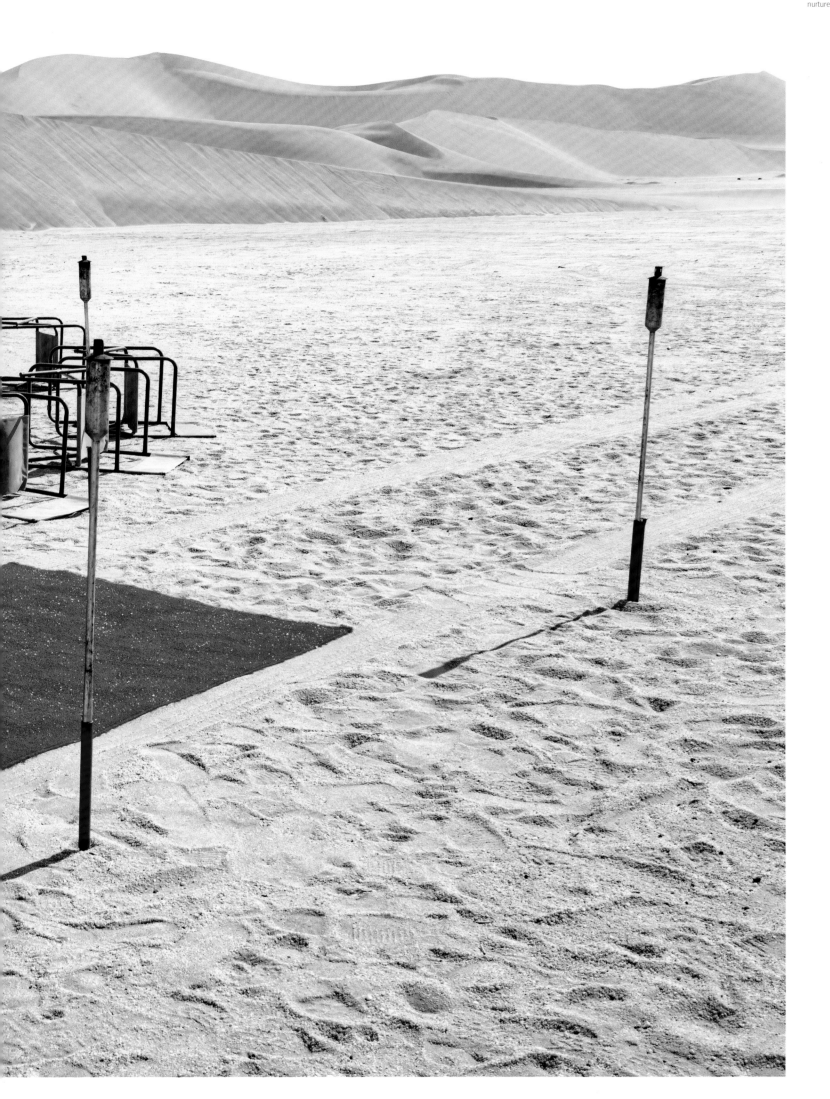

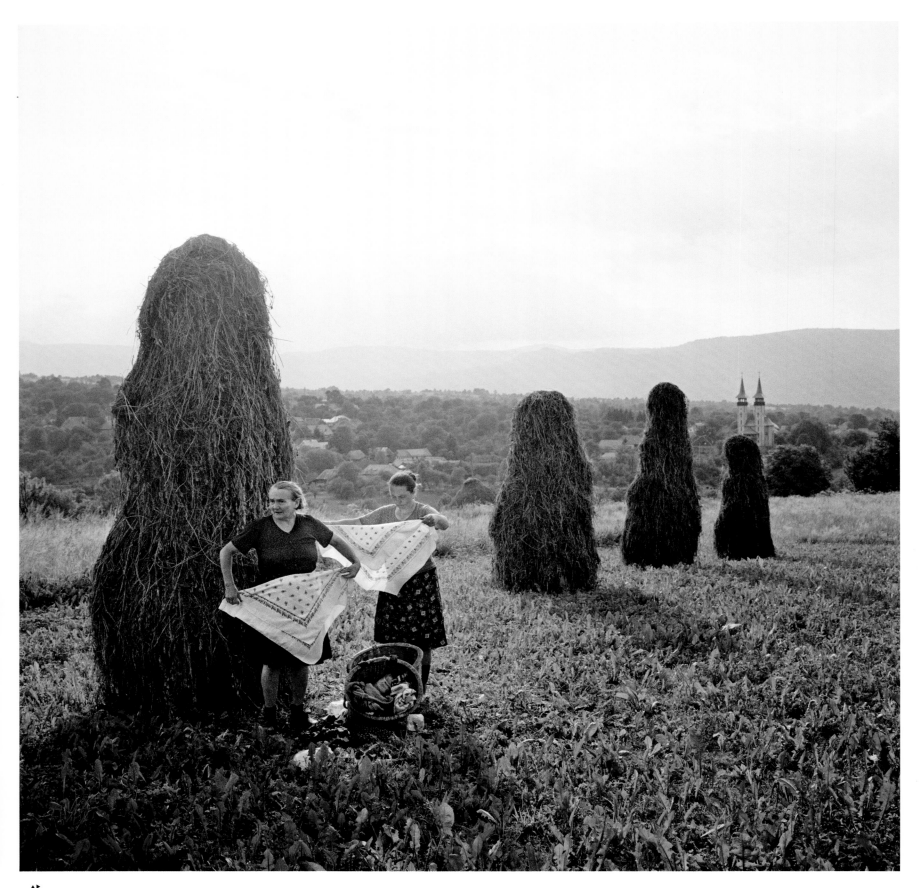

Rena Effendi
Transylvania's fragile agrarian fairy tale

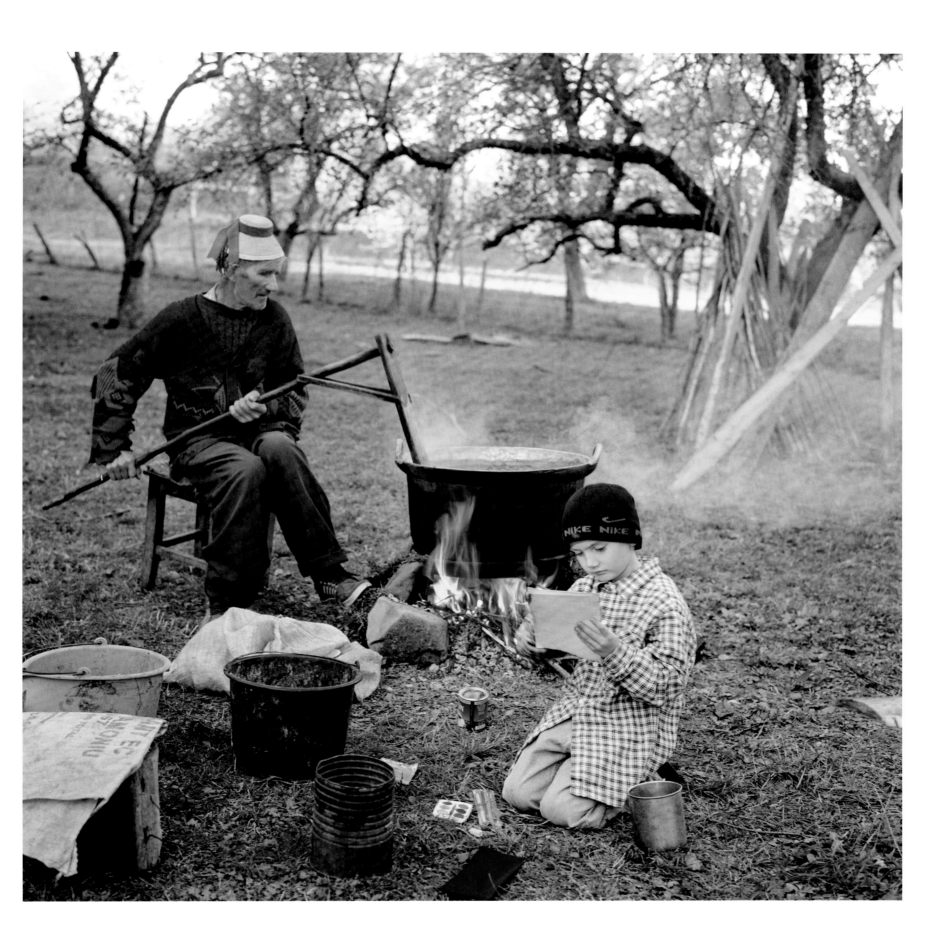

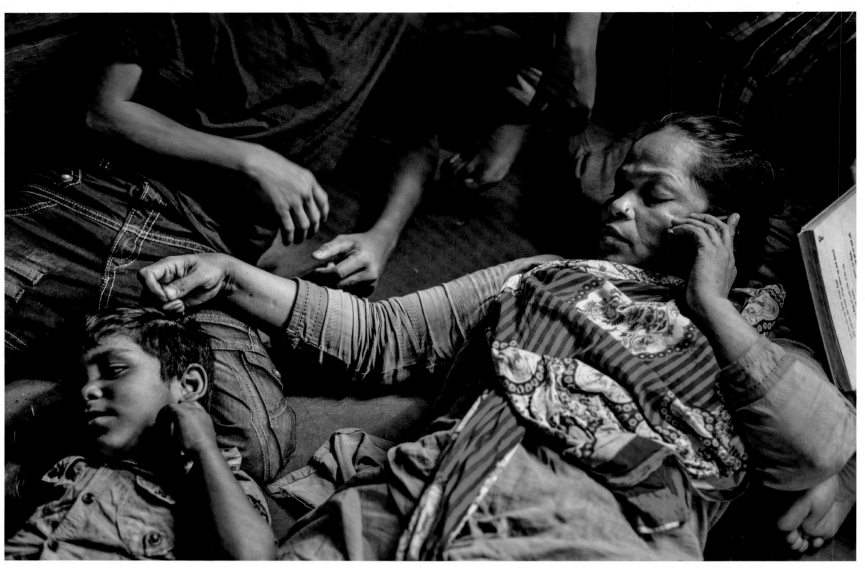
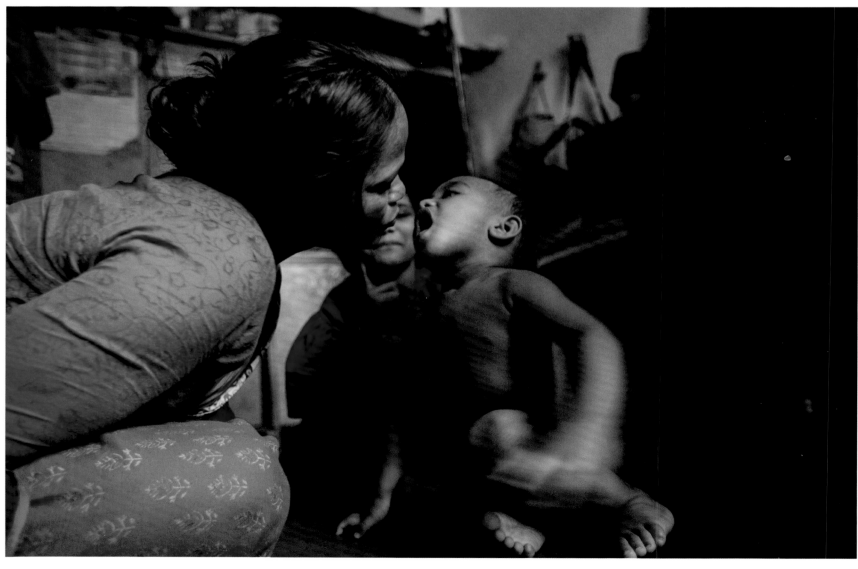

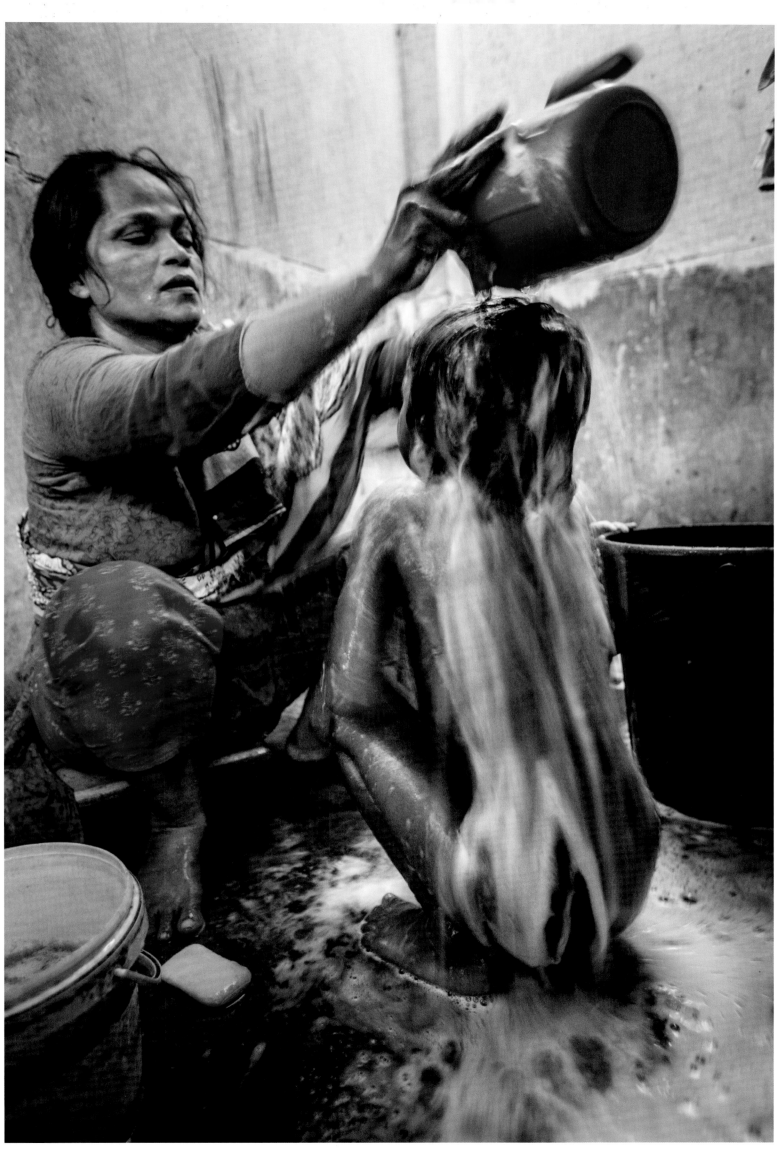

Shahidul Alam
And still she smiles ... former
prostitute Hajera runs an
orphanage for the abandoned
children of sex workers

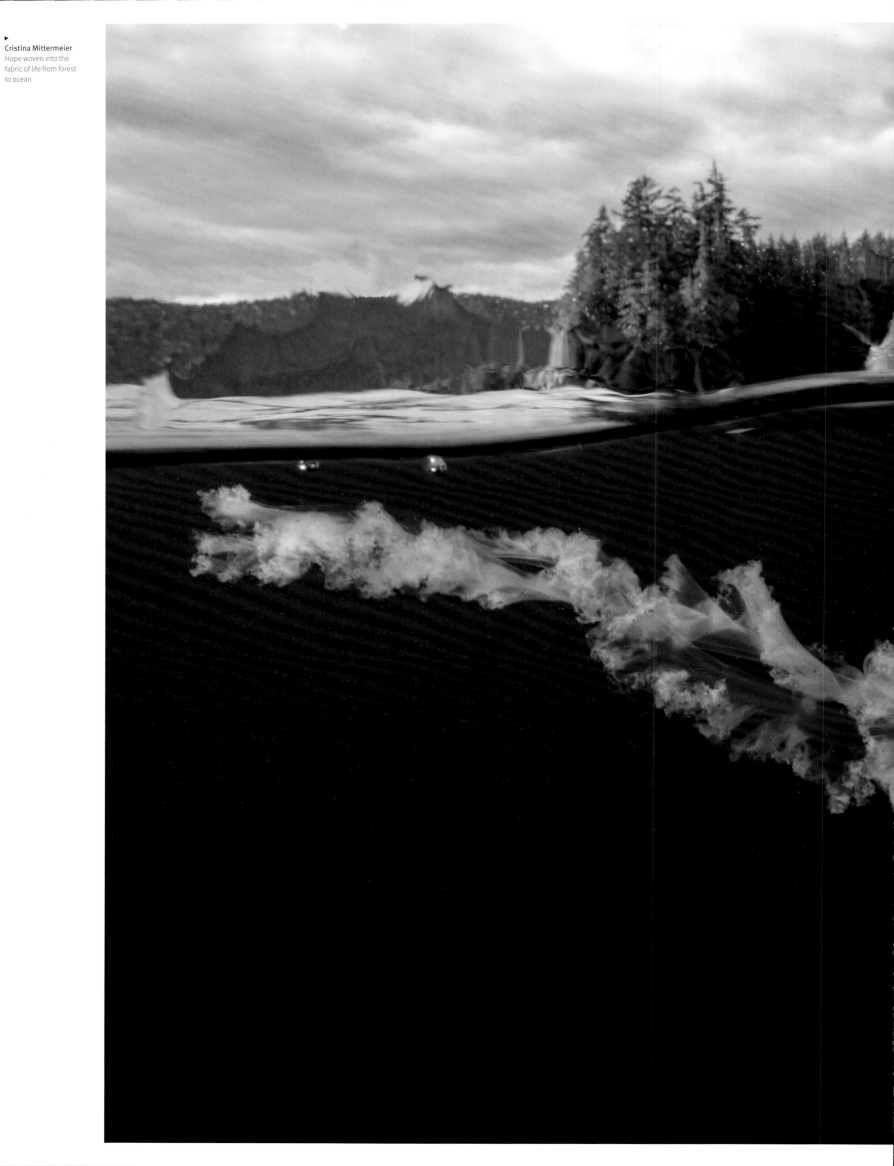

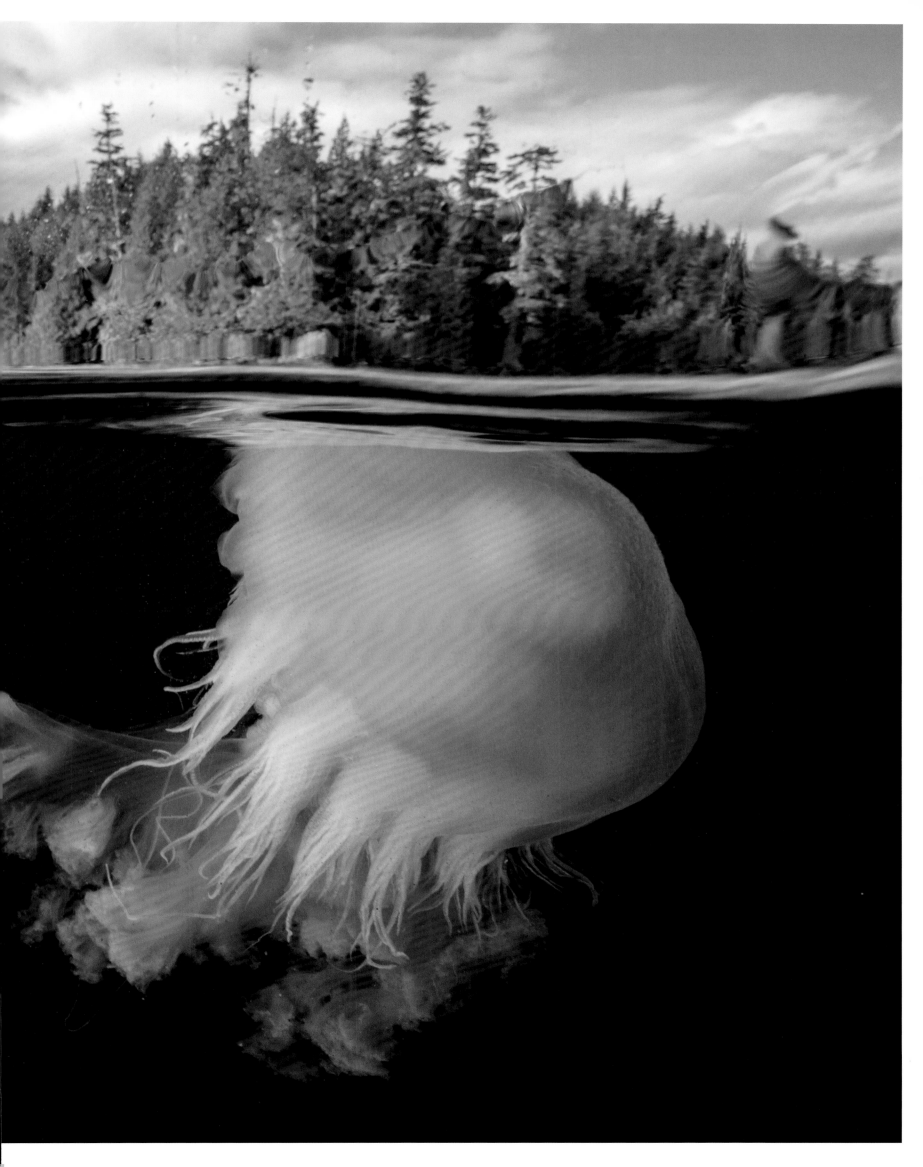

Gideon Mendel
The poetics of entropy – South Africa 1986:
a time of hope, activism and tragedy

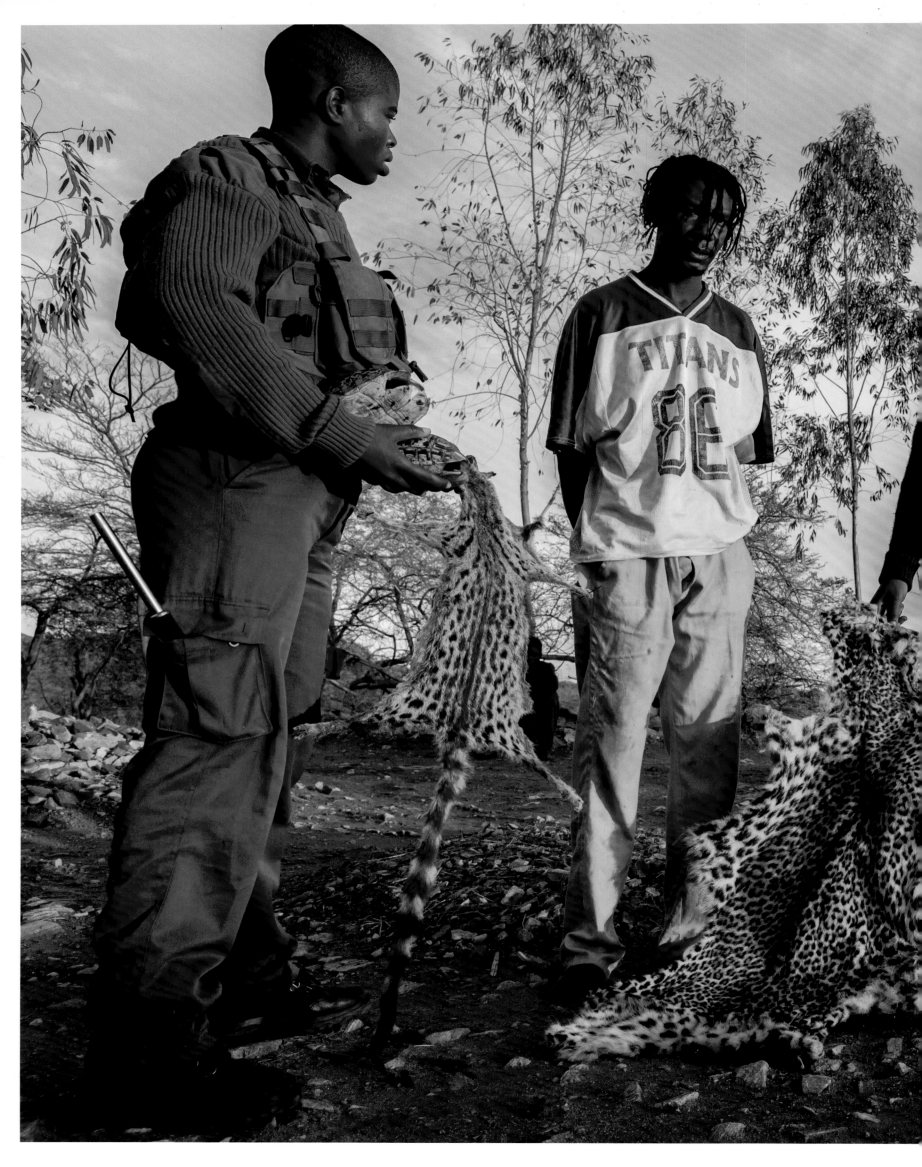

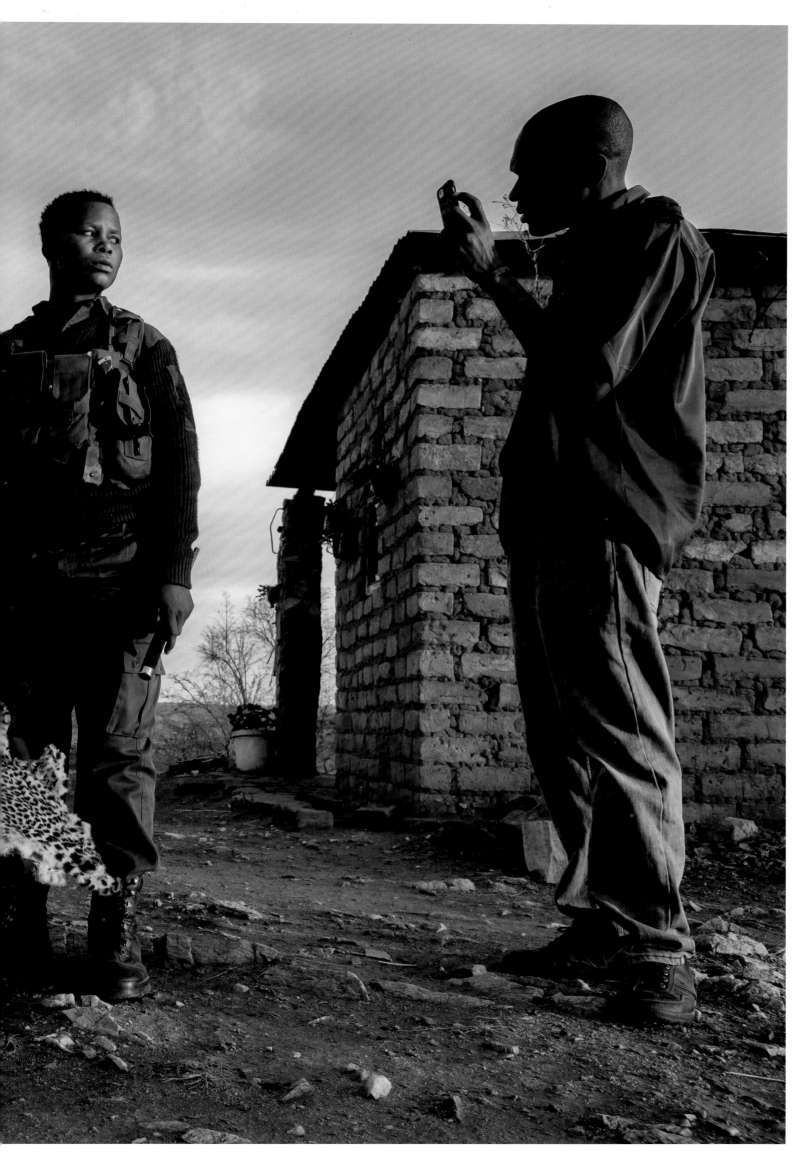

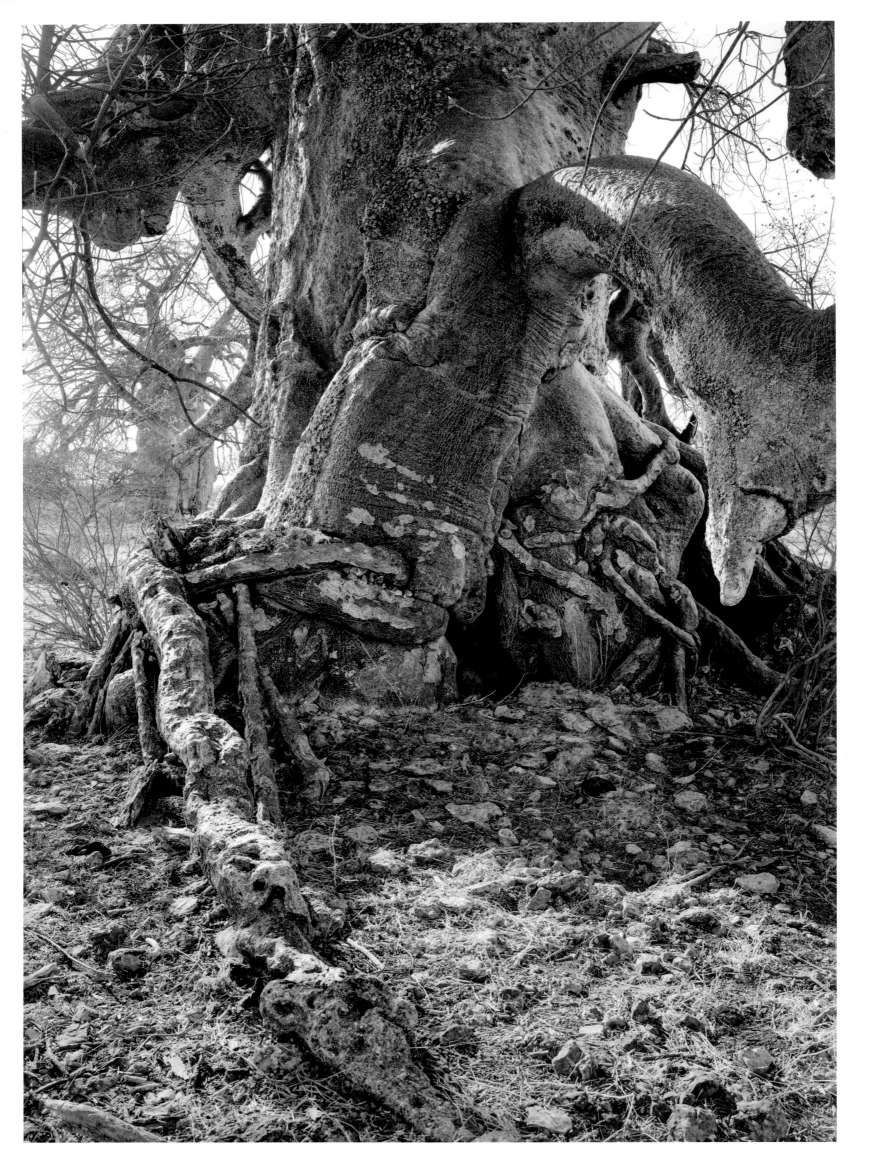

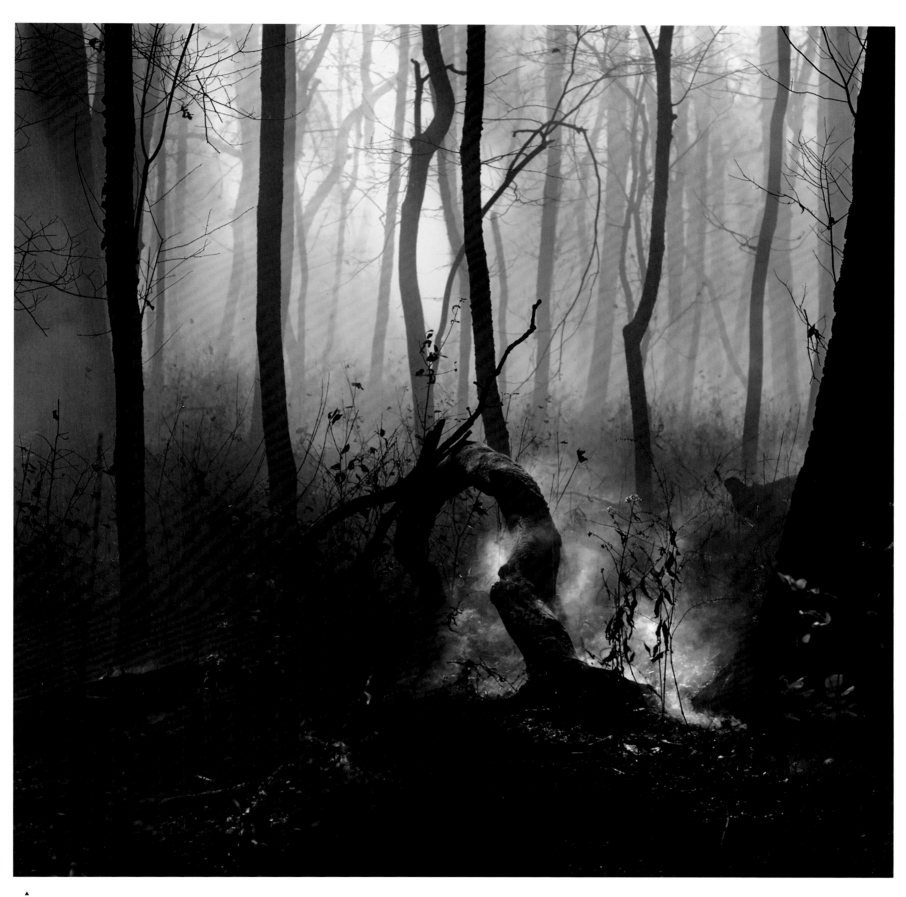

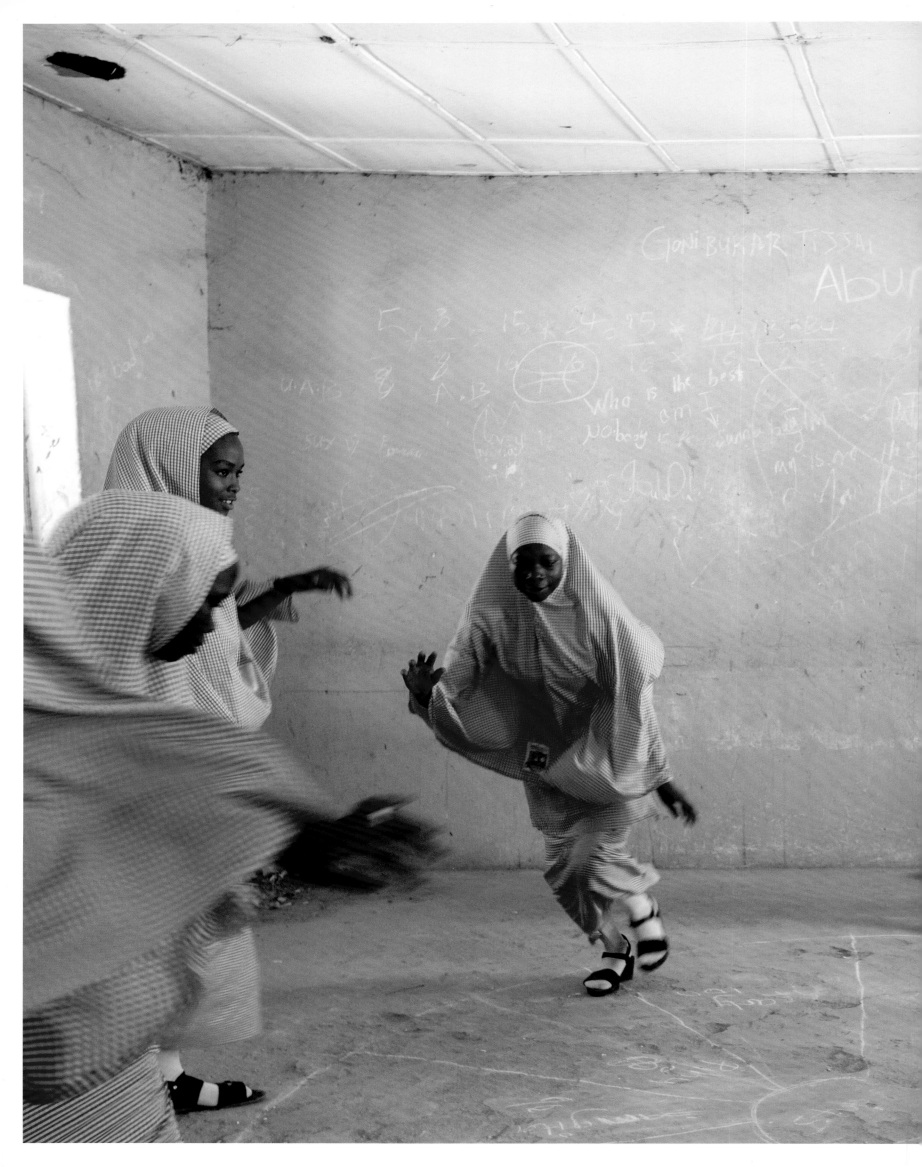

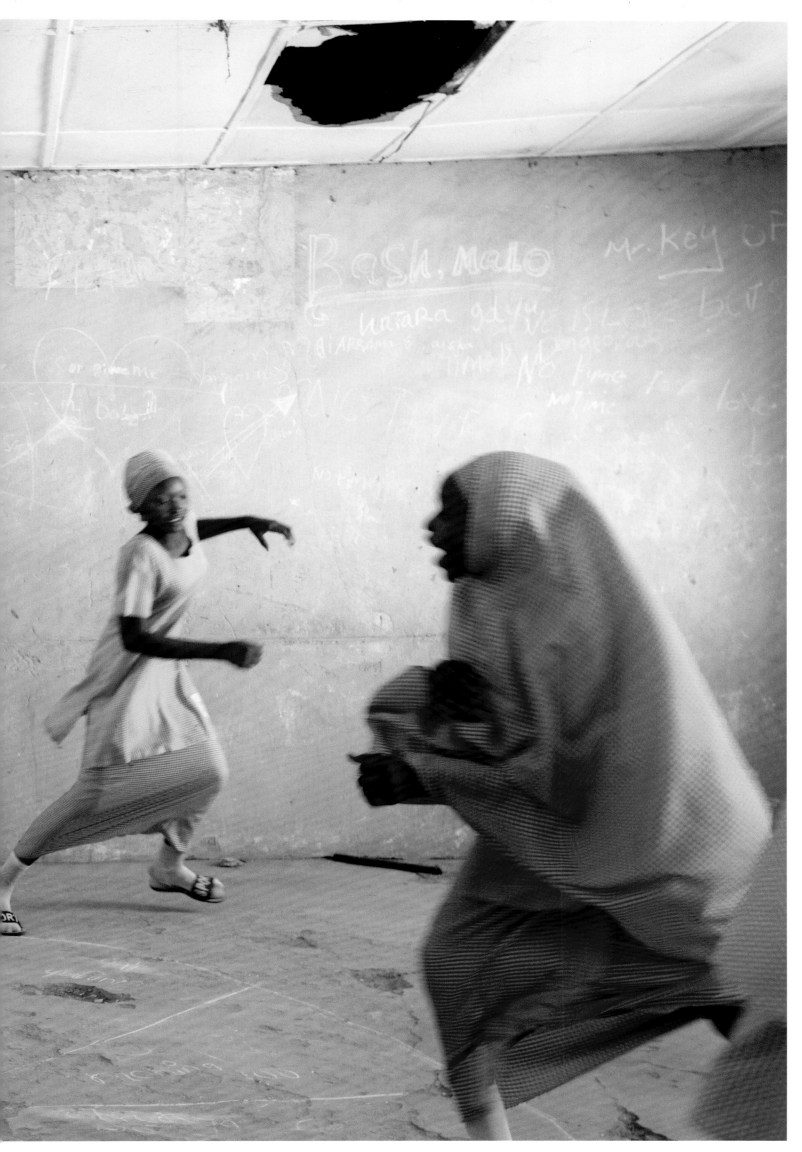

◄

Rahima Gambo
Playing out the dark
memories of the Boko
Haram abductions

Toby Binder
An Afghan boy arrives
in Dusseldorf for urgent
medical treatment – a vital
lifeline for the children of
the world's conflict zones

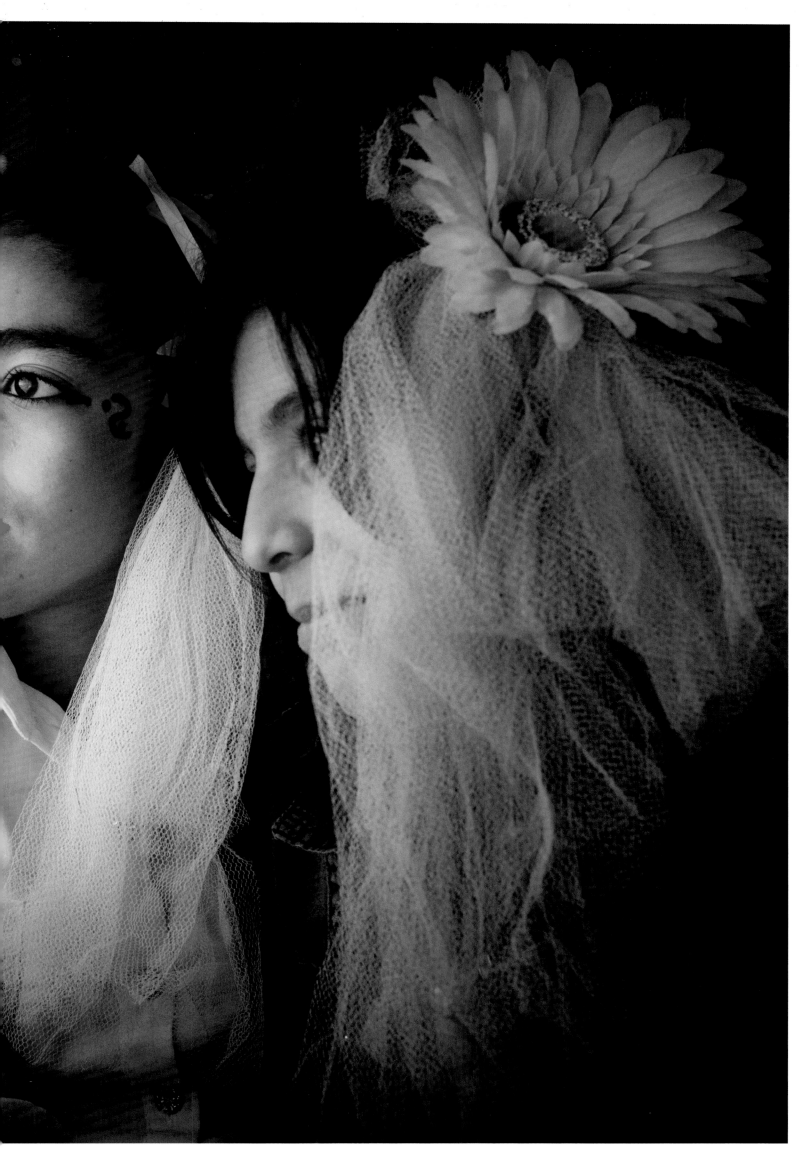

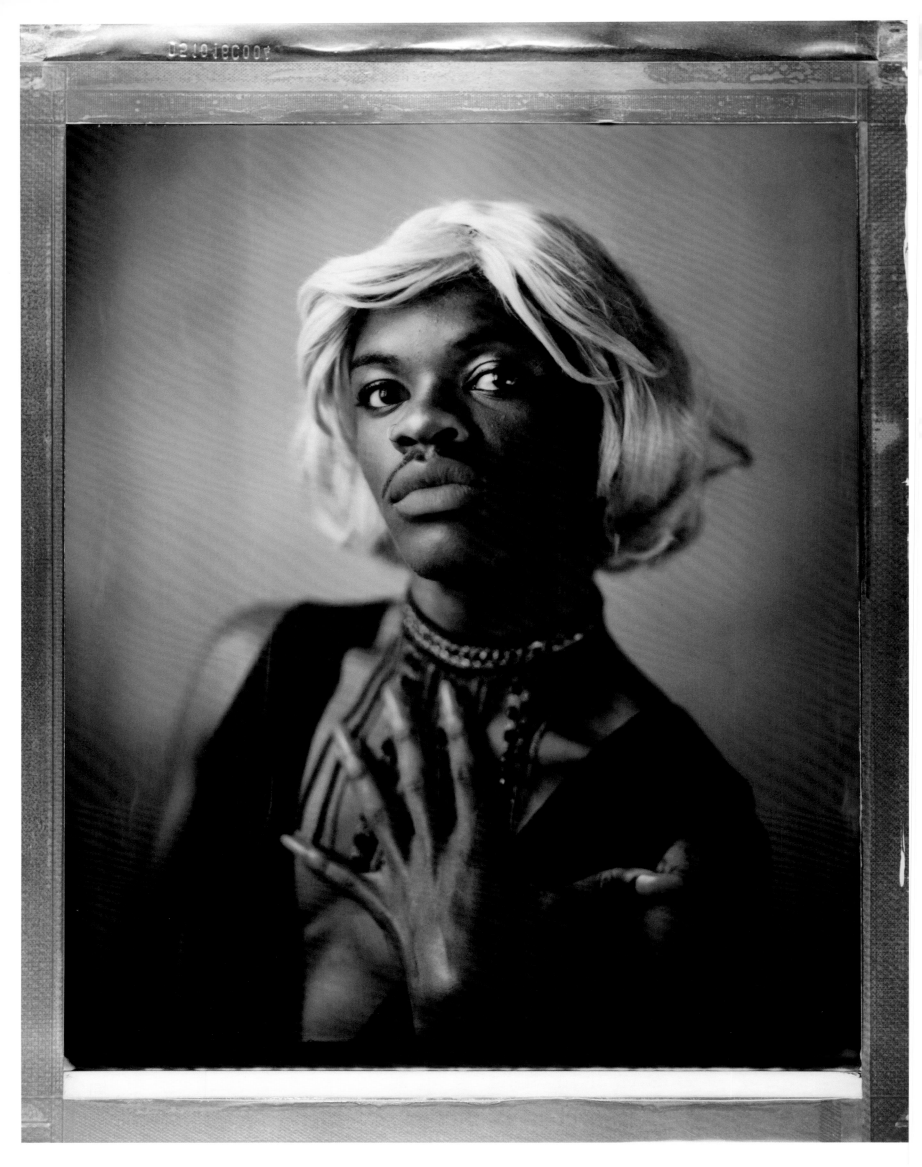

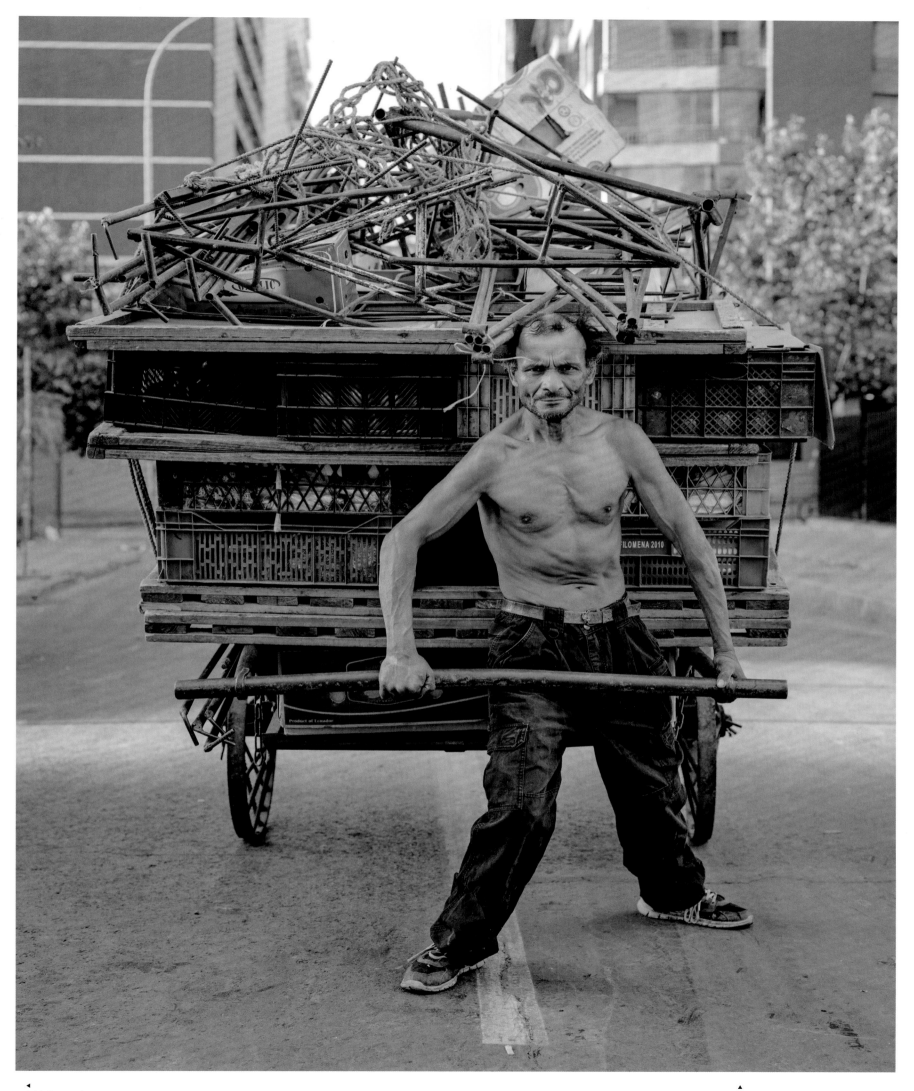

Robin Hammond
Where love is illegal –
hope persists even in hiding ...

Andres Figueroa
Tiradores – the wagon pullers of Santiago, Chile

49

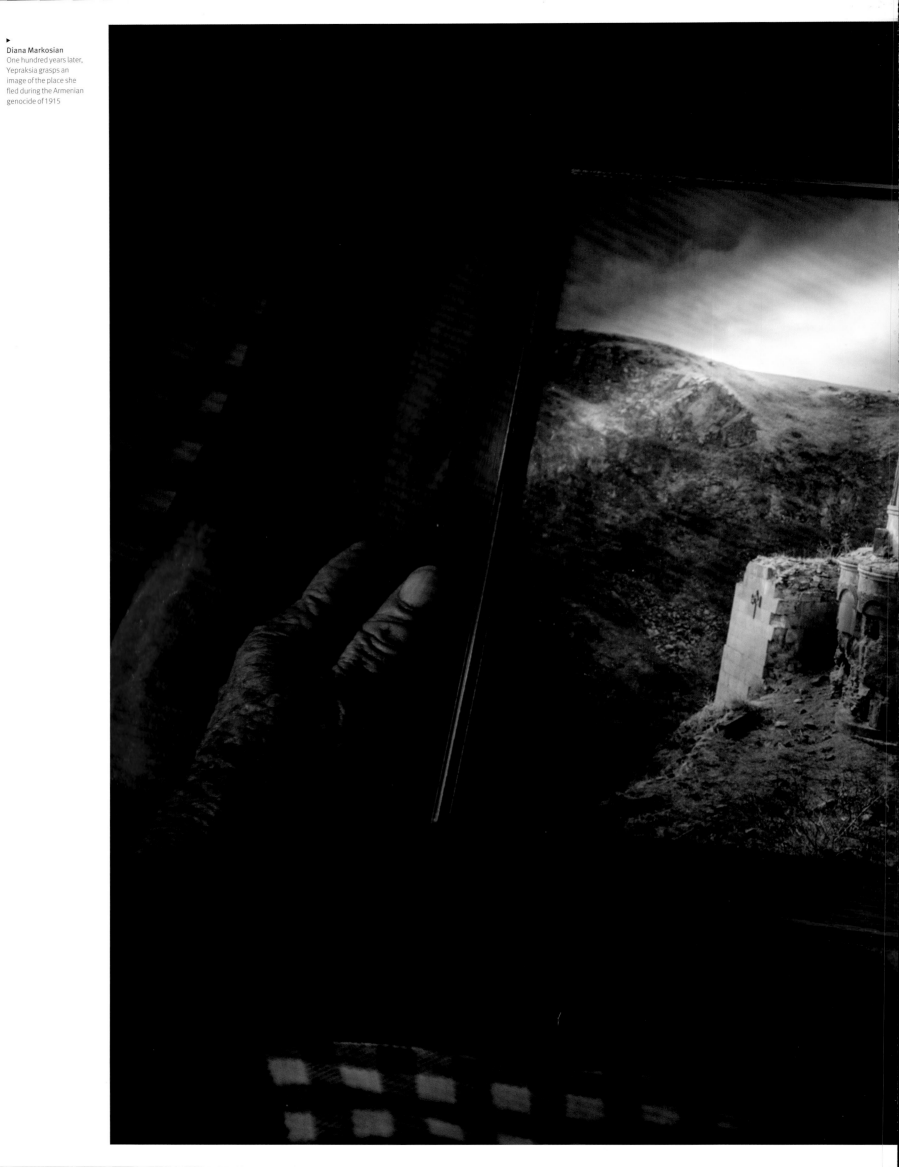

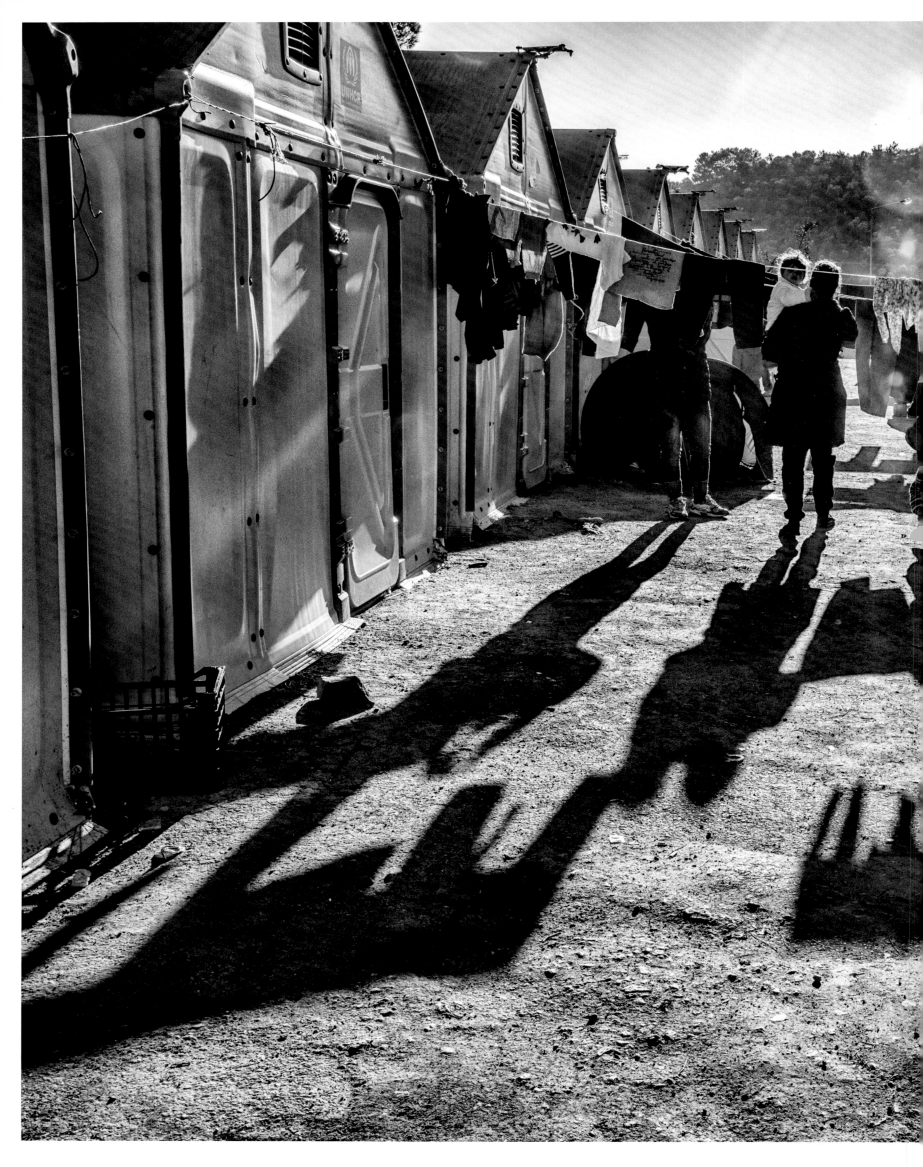

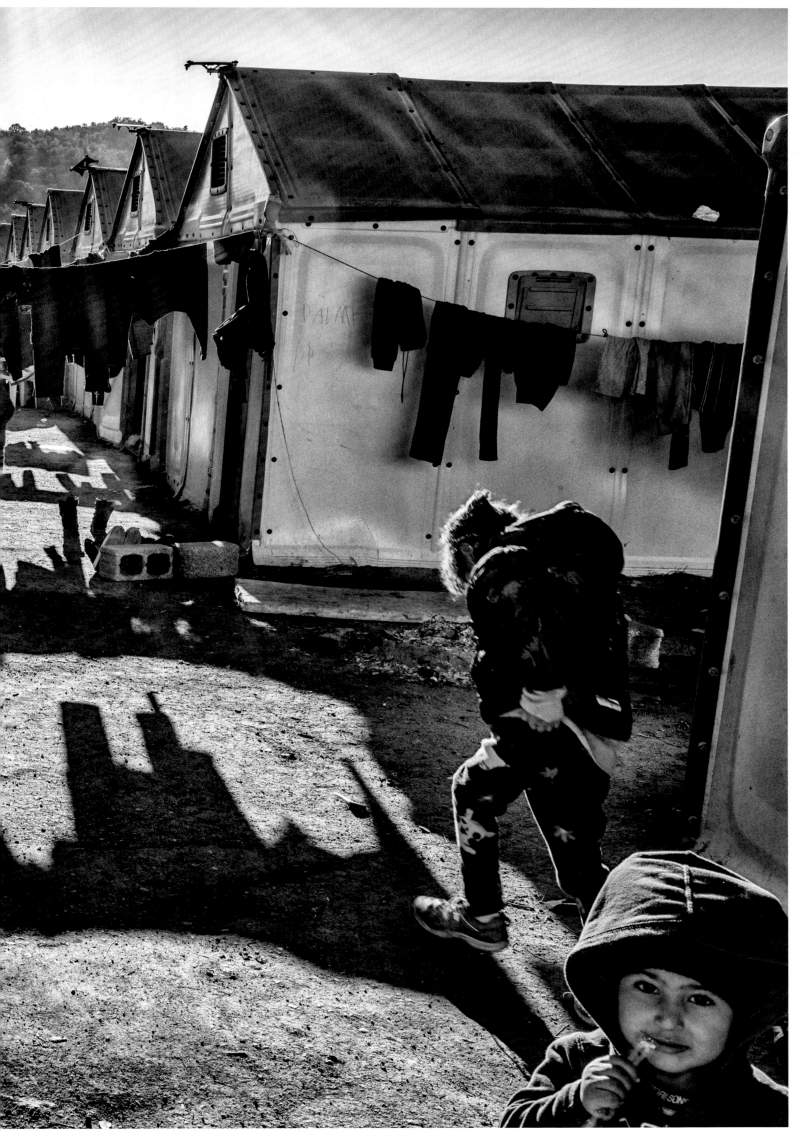

Margarita Mavromichalis
The flame of hope flickers
amidst the squalor of Lesvos

▶
Ross McDonnell
Prosthetic
expressions – limbs
adapted, constructed,
personalised.

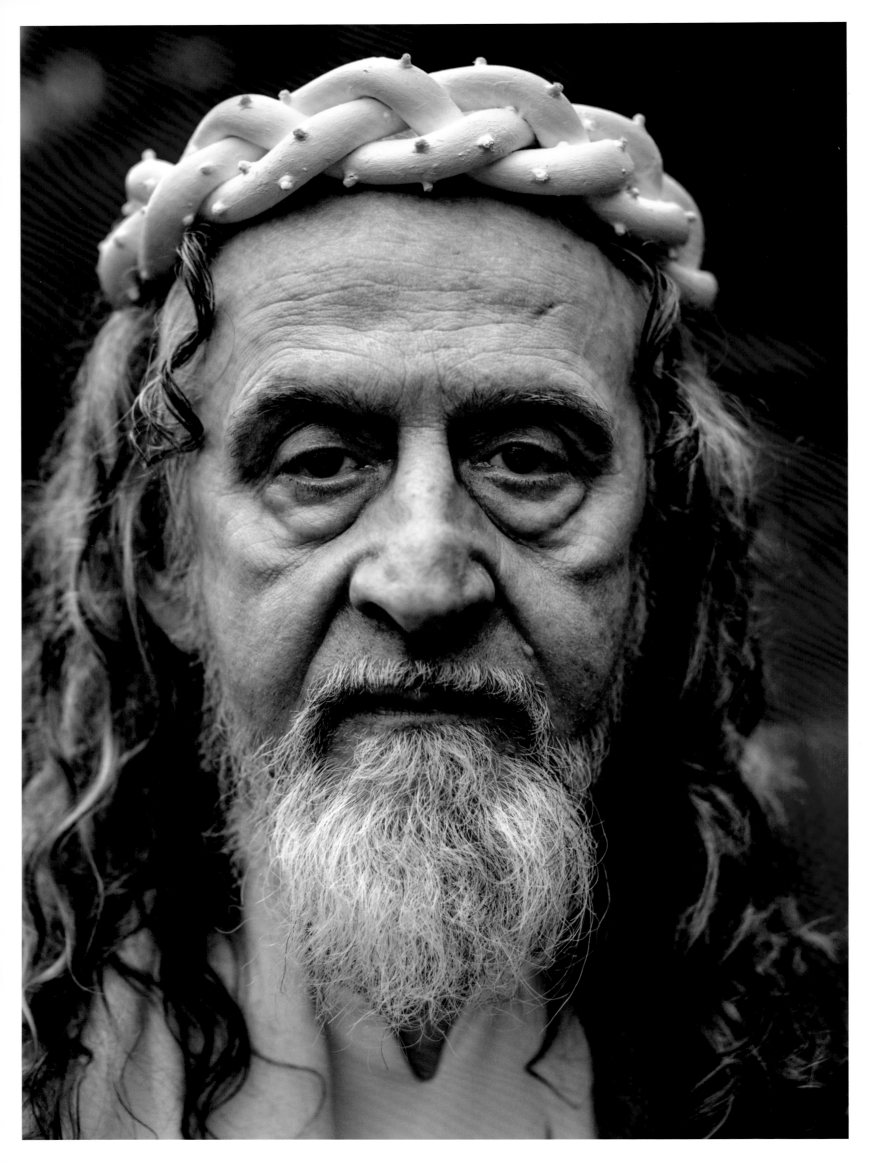

Jonas Bendiksen
"Verily I am coming soon': those who
think they are Jesus Christ reincarnated

Matthieu Gafsou
Colour-blind cyborg Neil Harbisson converts colour into sound
waves, which his brain perceives as colour

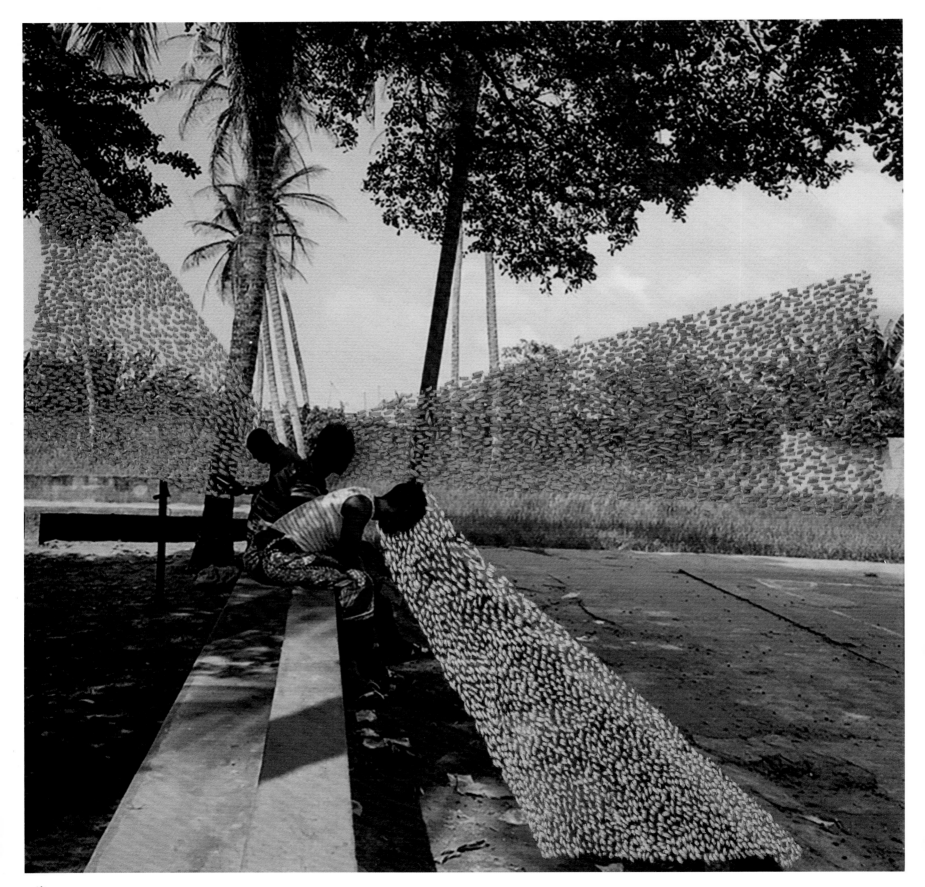

▲▶
Joana Choumali
Stitches of hope and resilience
in Cote d'Ivoire.

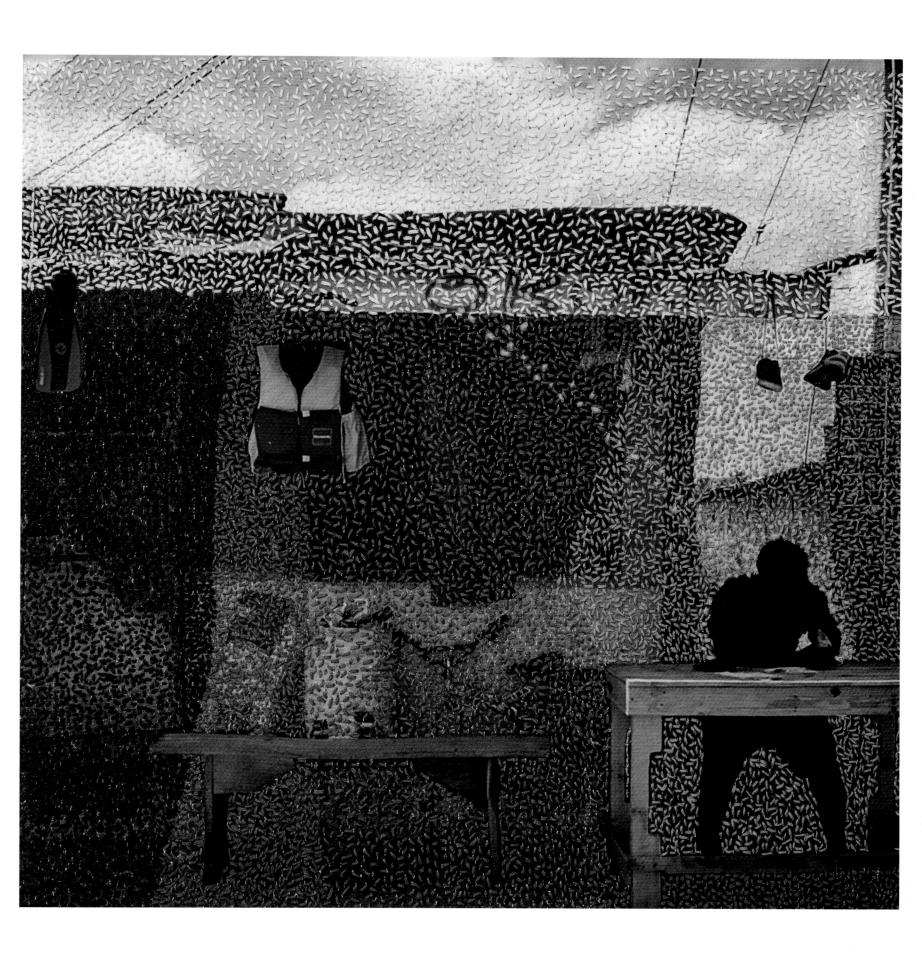

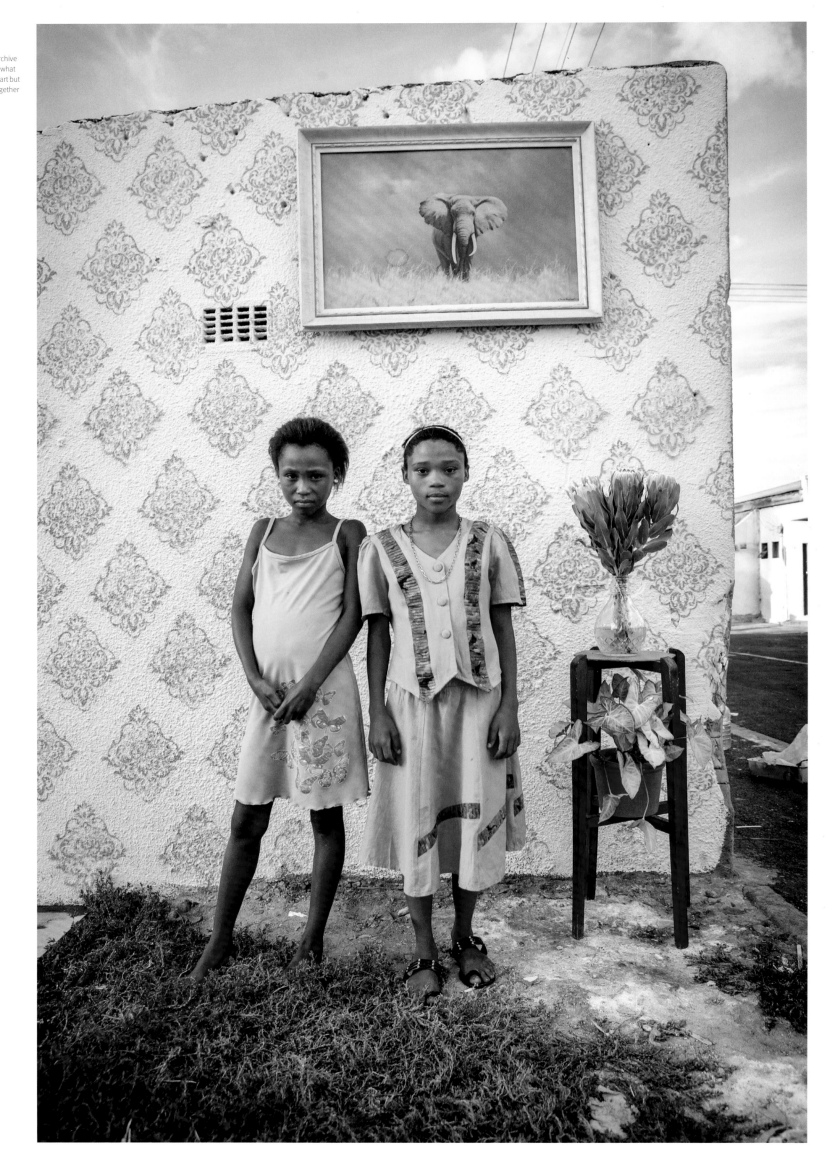

Alexia Webster
Street Studios: an archive
that documents not what
makes things fall apart but
what keeps them together

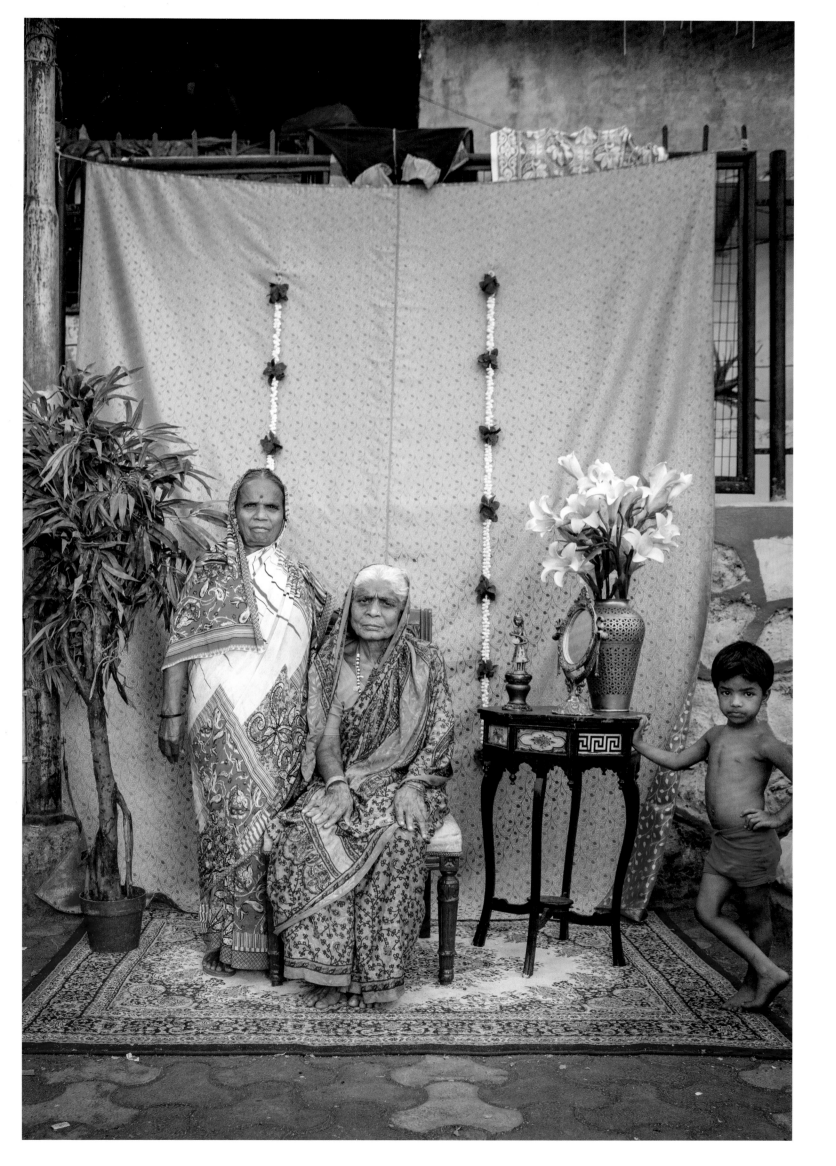

Erwin Olaf
Fear and suspicion stalk the
hallways of hope ...

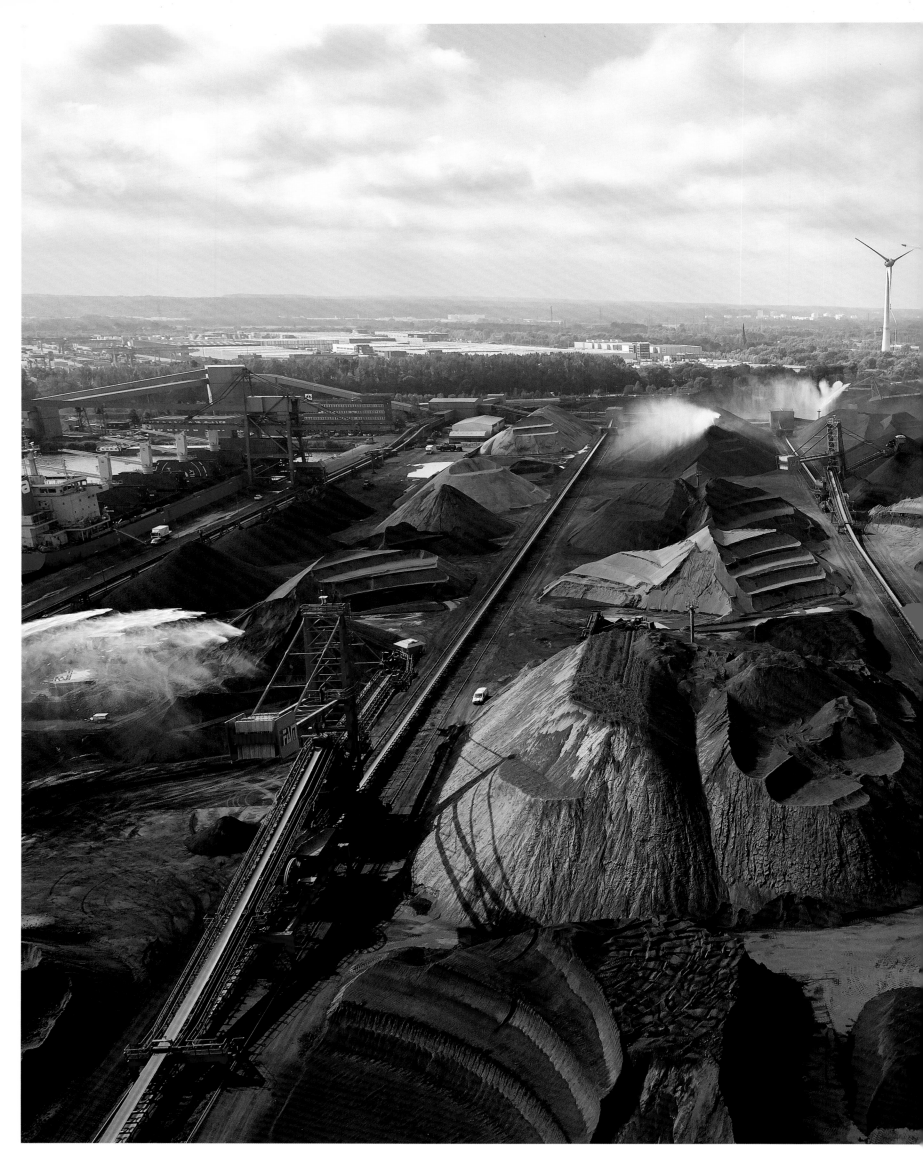

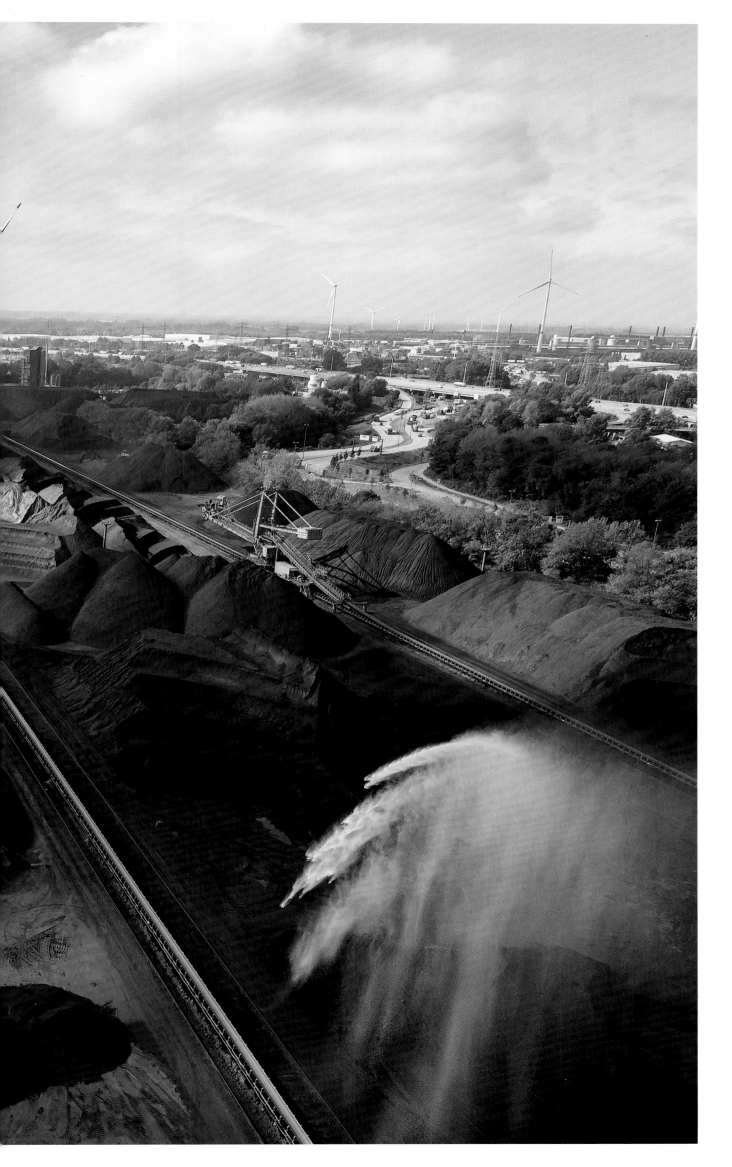

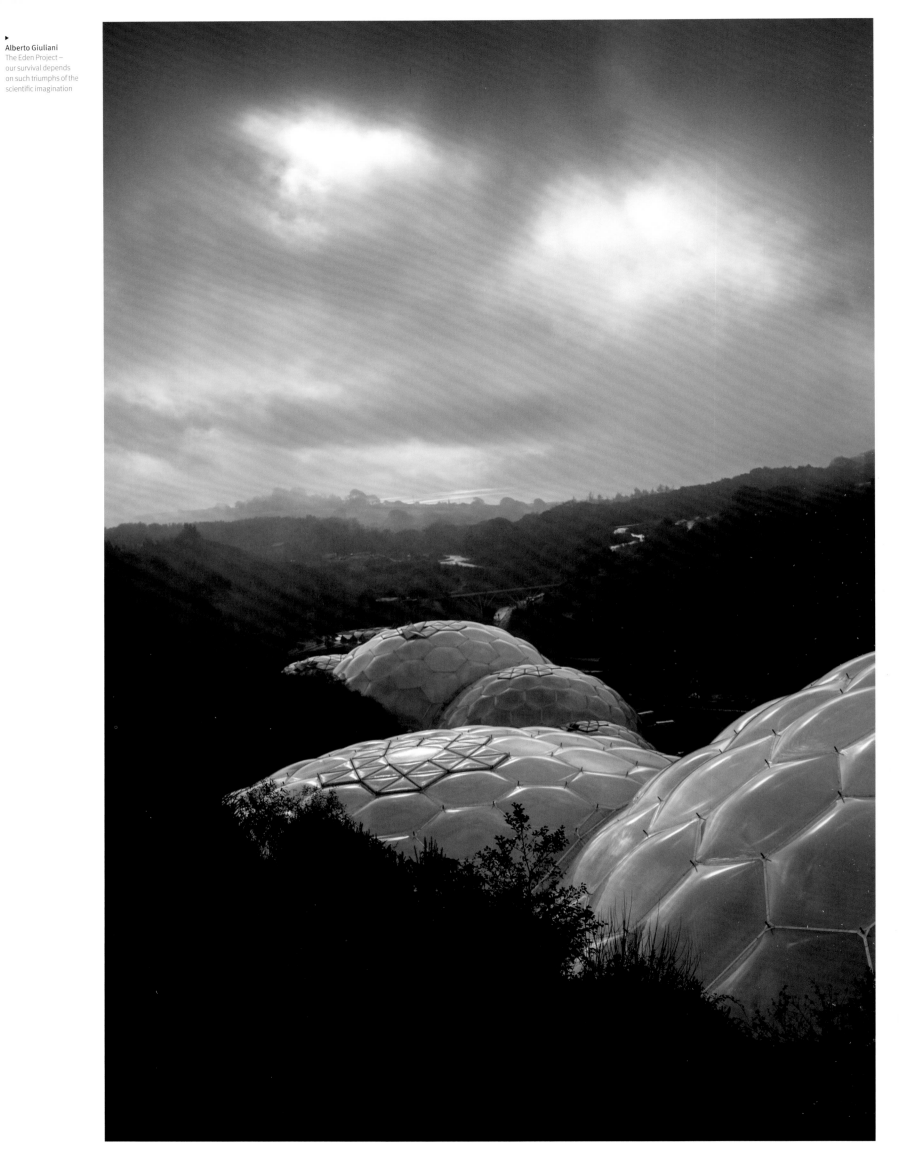

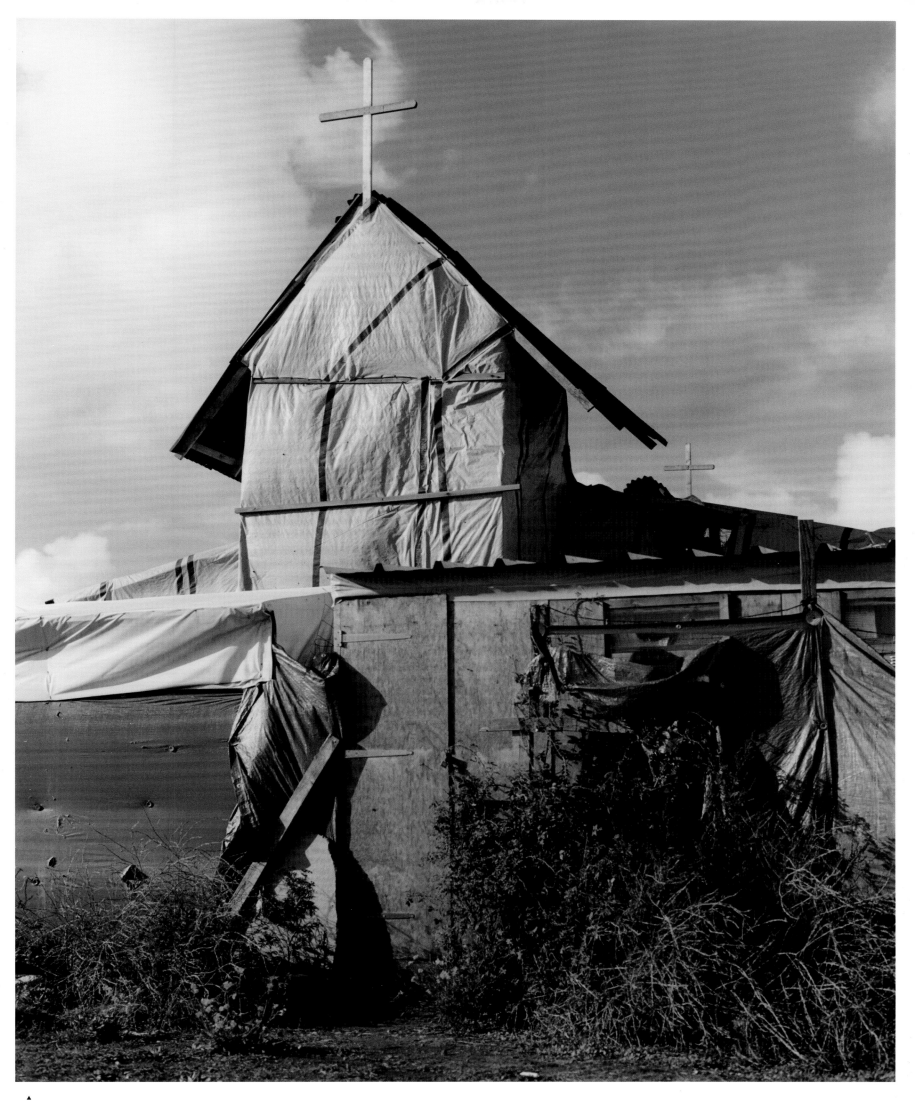

▲
Harley Weir
Homes – personal spaces of humanity
in the Jungle refugee camp

69

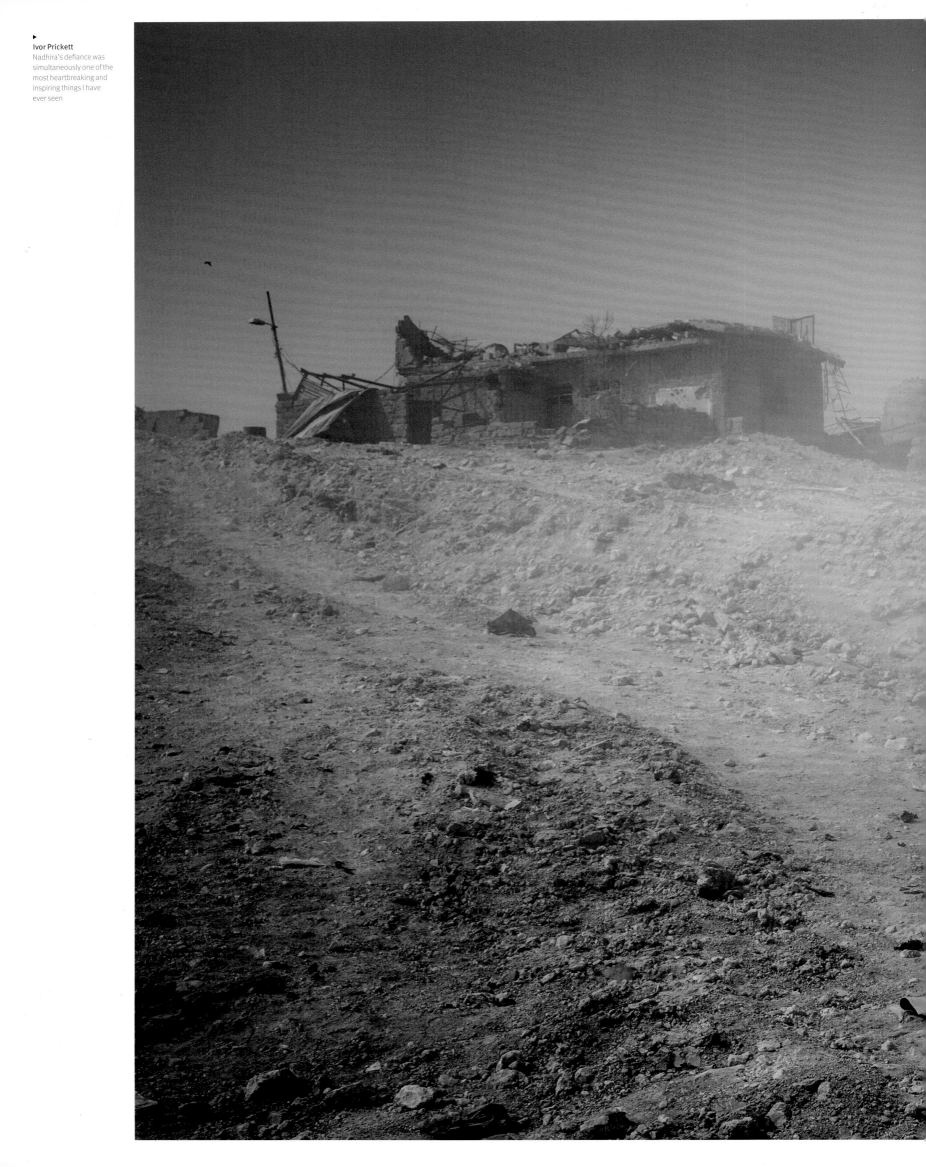

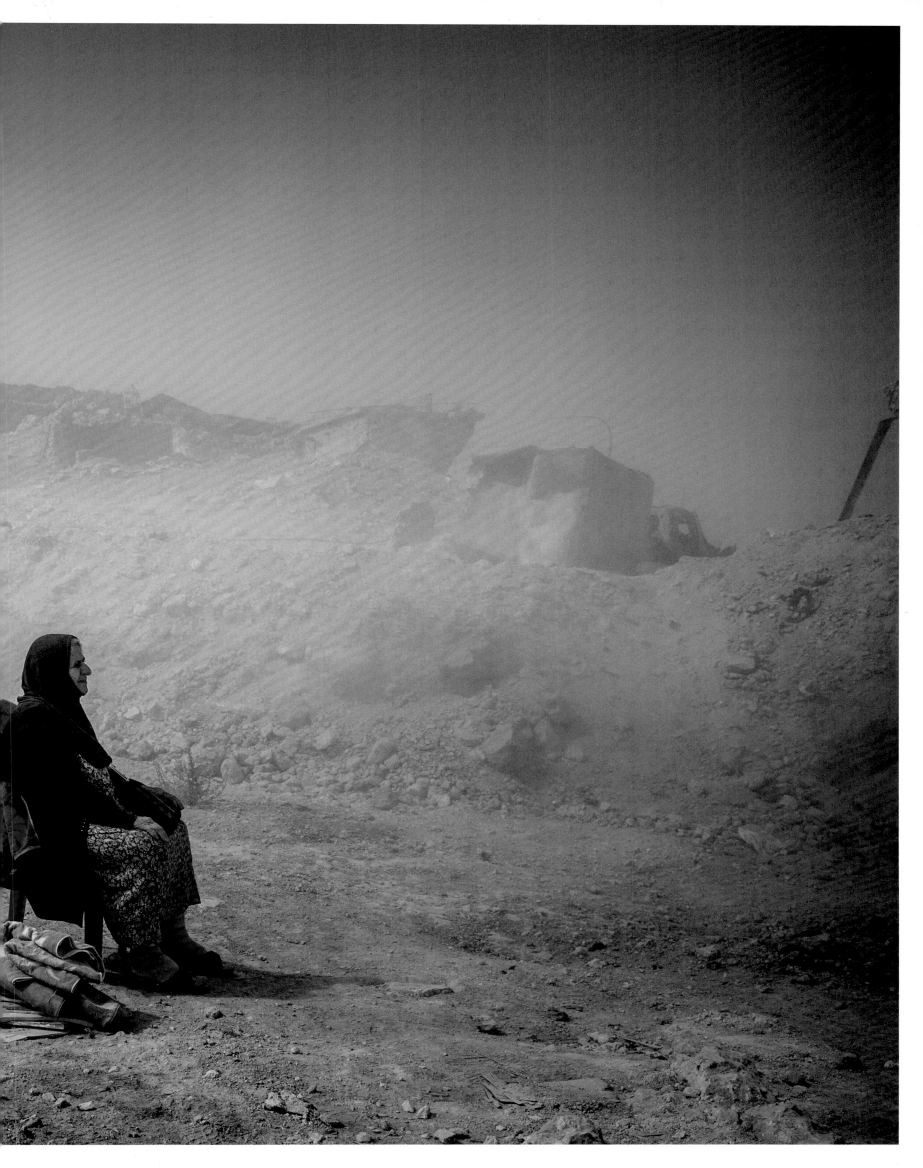

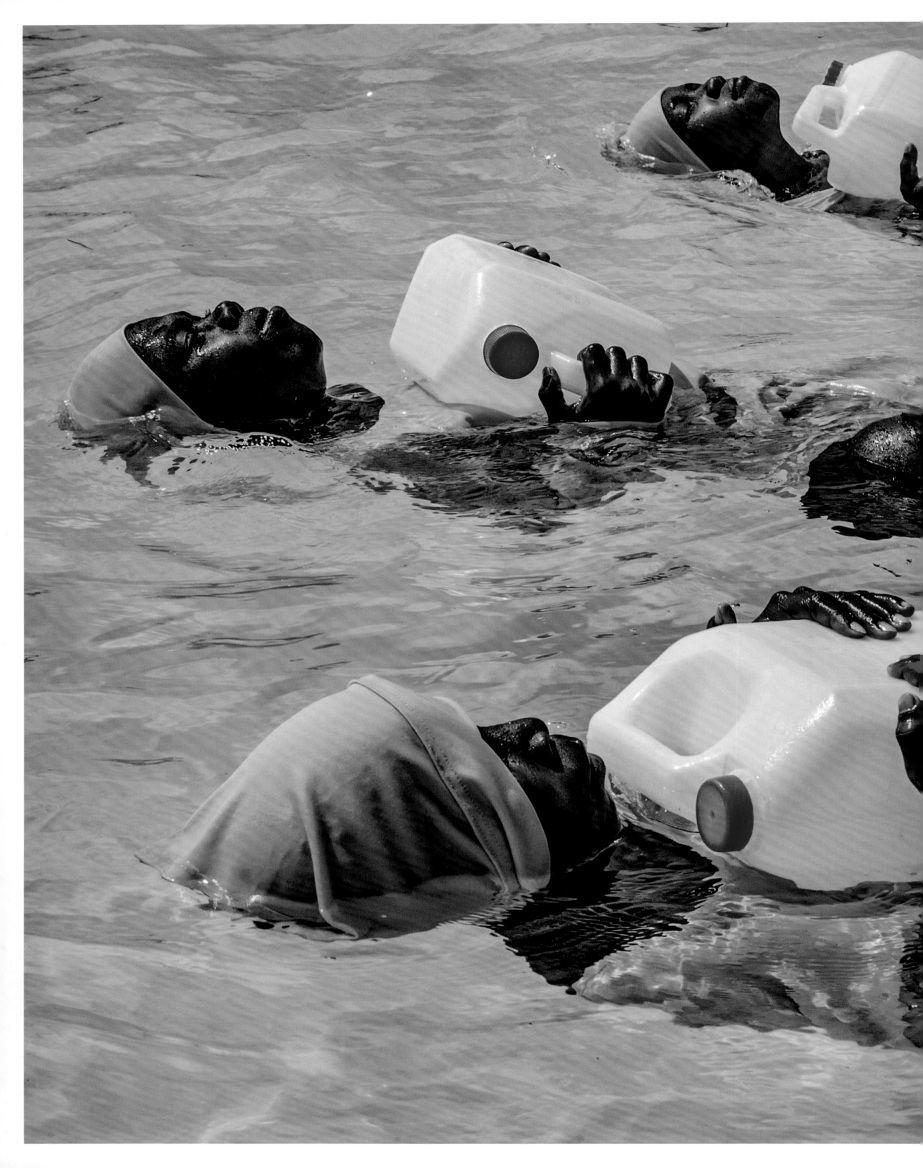

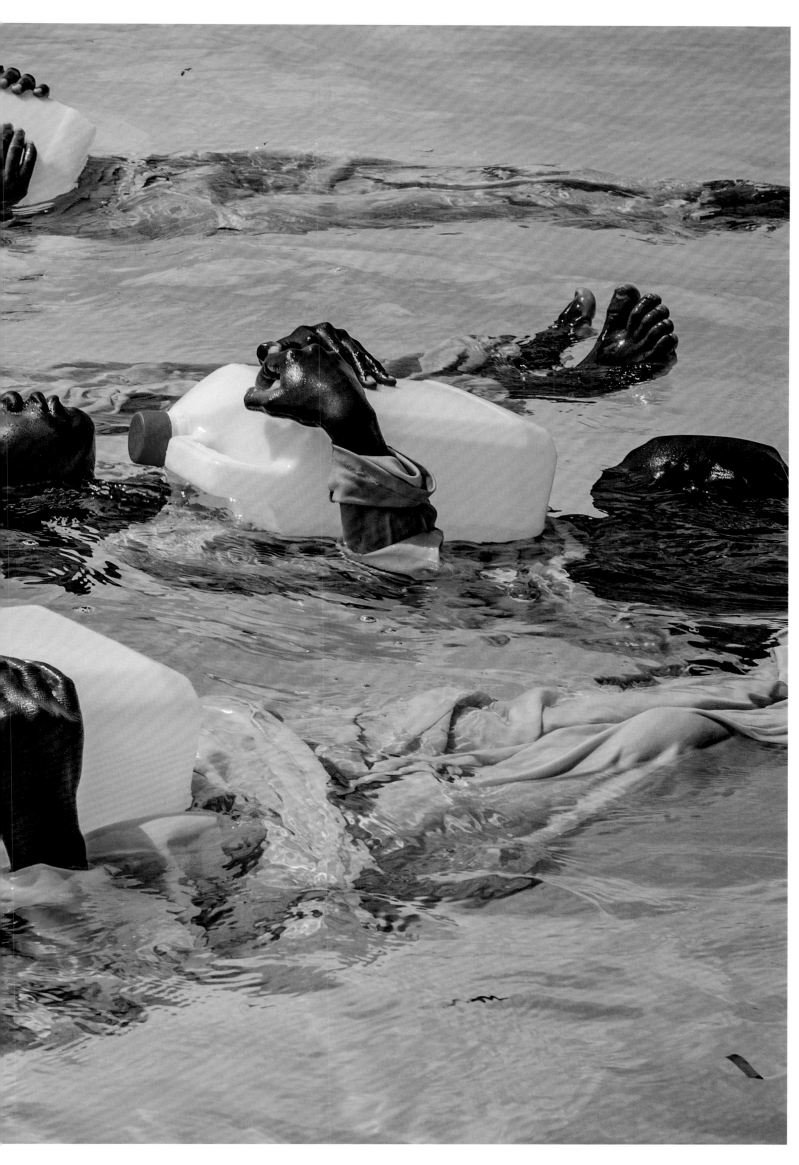

Anna Boyiazis
When you teach a woman
to swim she teaches her
whole community

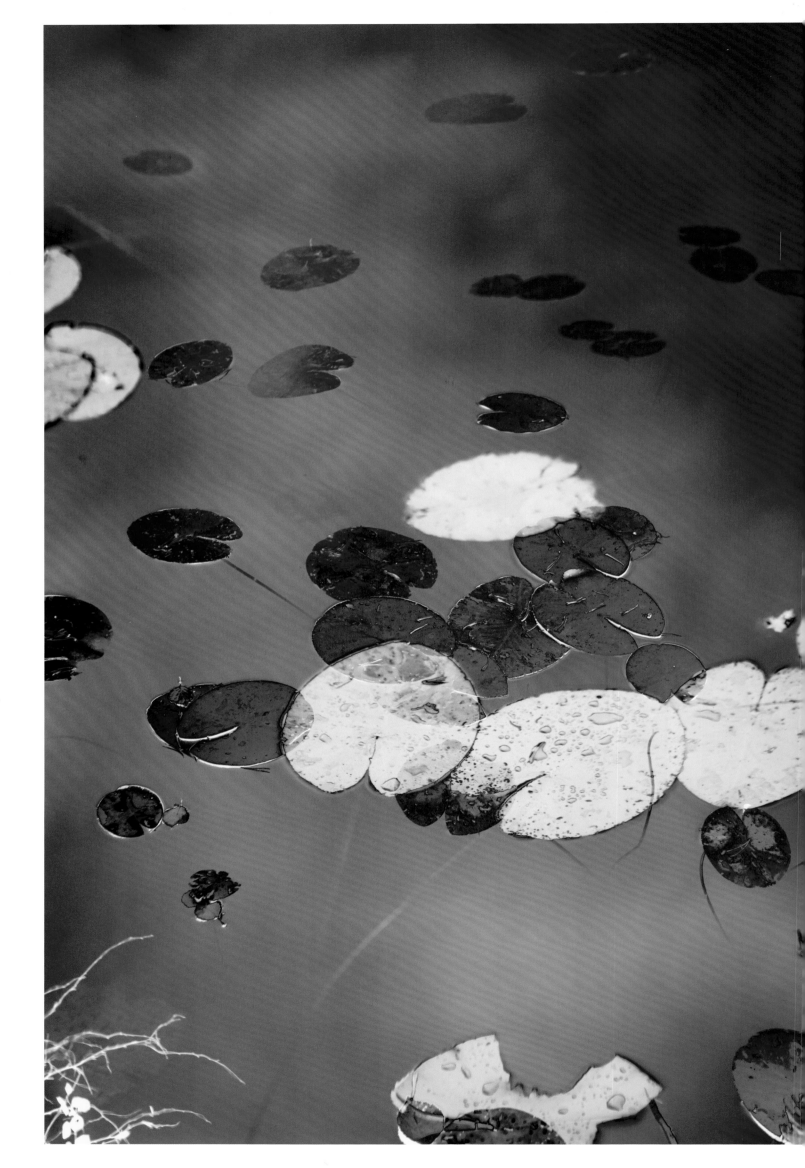

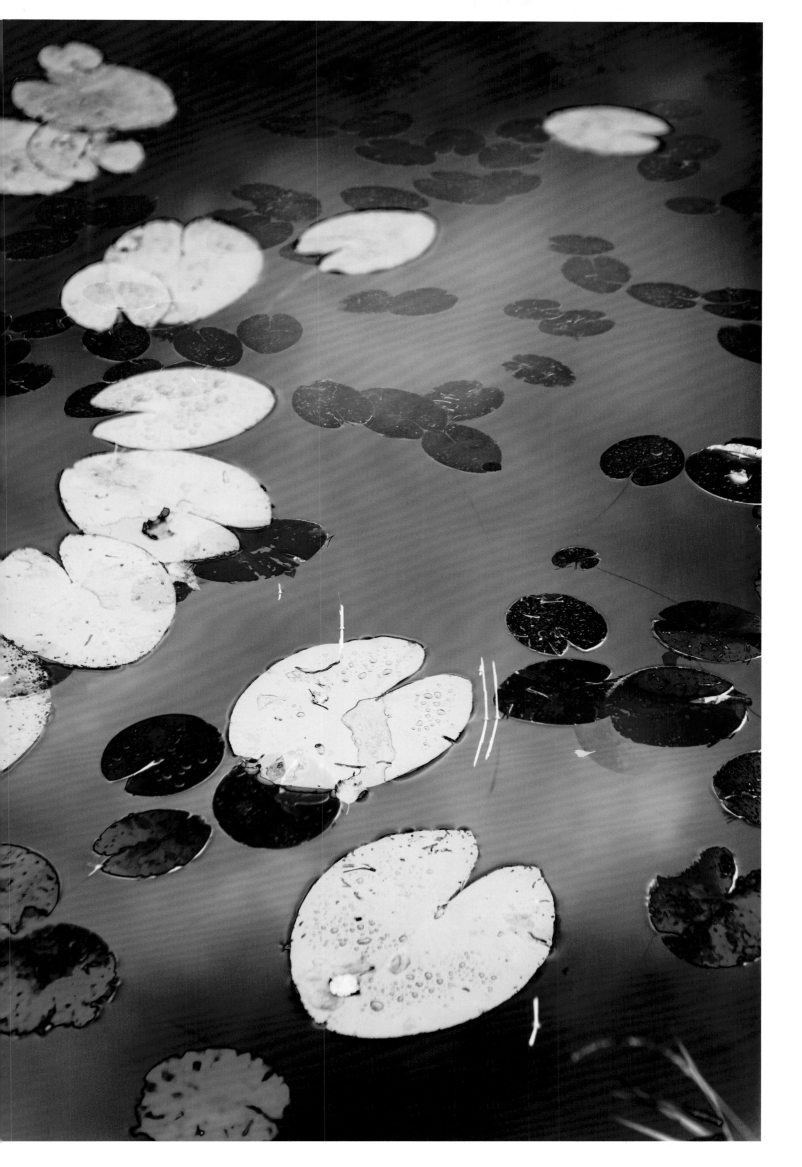

Santeri Tuori
Water lilies: fragile layers
of sustainability

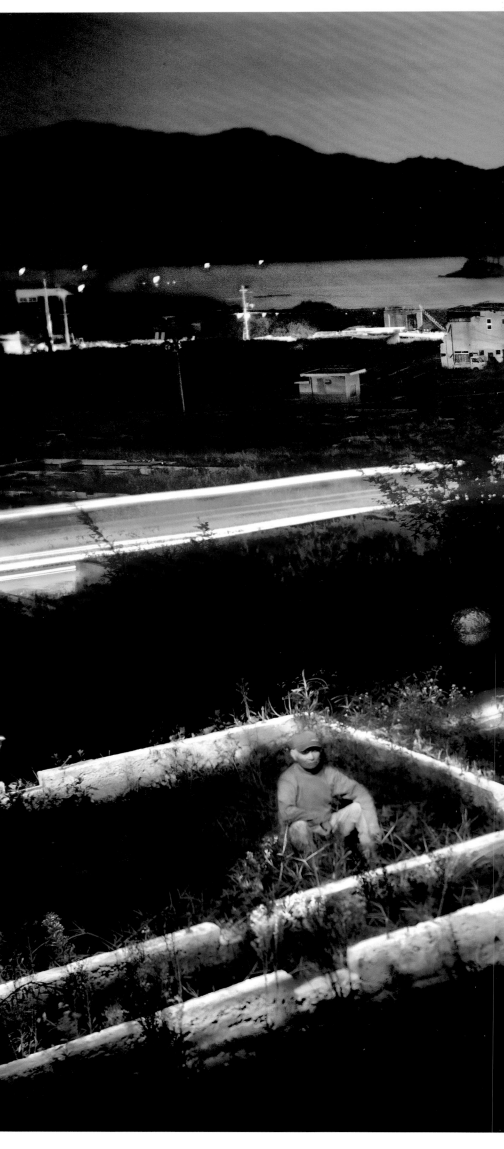

Alejandro Chaskielberg
After the tsunami – spaces haunted
by memories of identity and loss

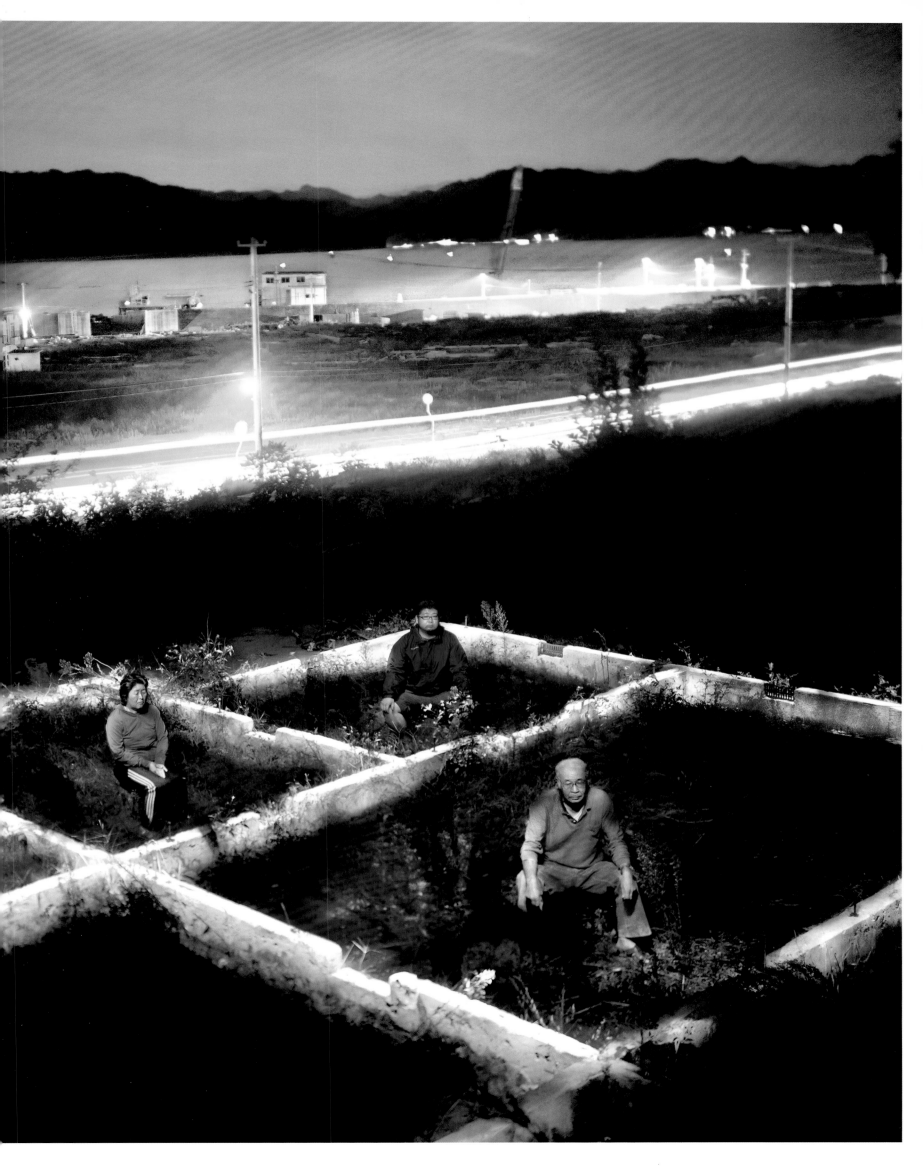

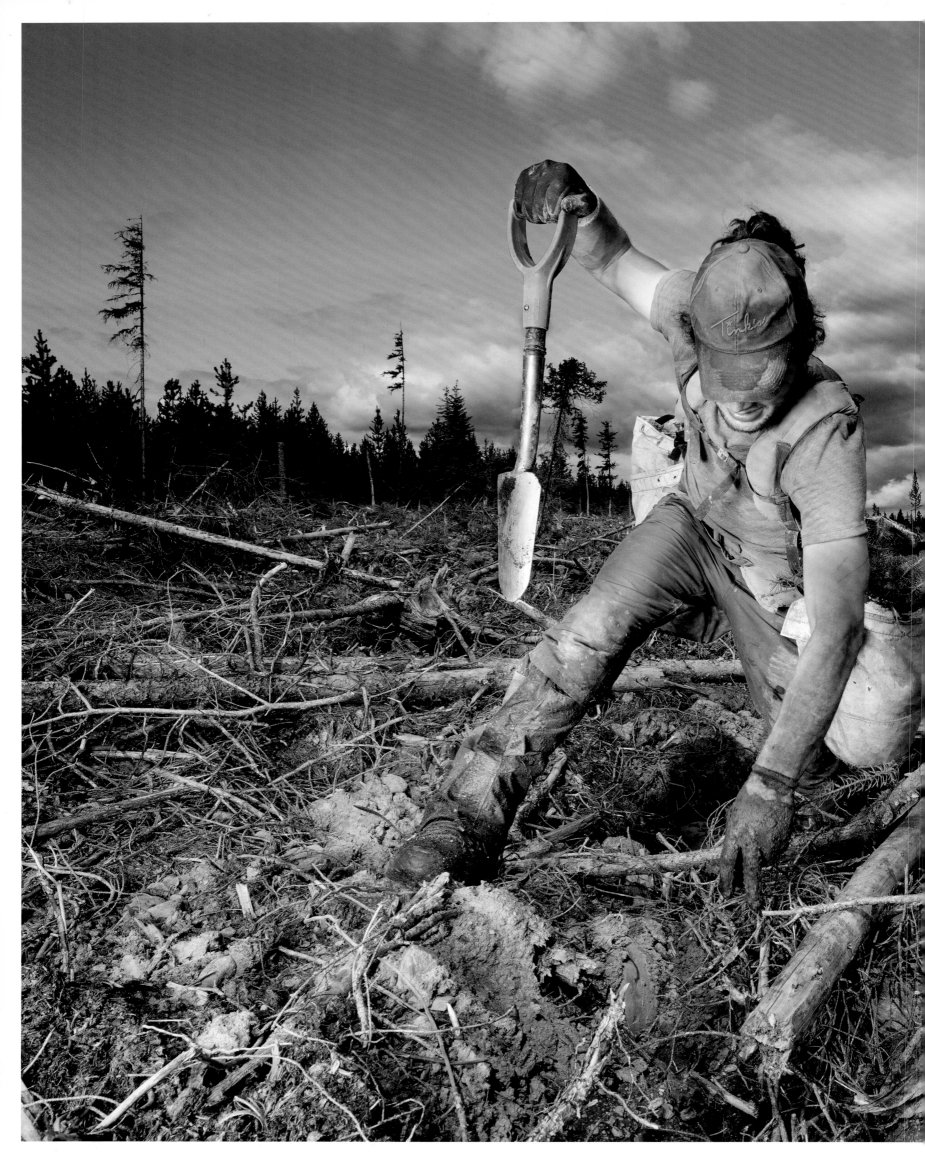

Rita Leistner
High-intensity tree planting
in Canada

▲
Simona Ghizzoni
In Somaliland and Somalia, the thorns of the
Qodax tree are employed for infibulation

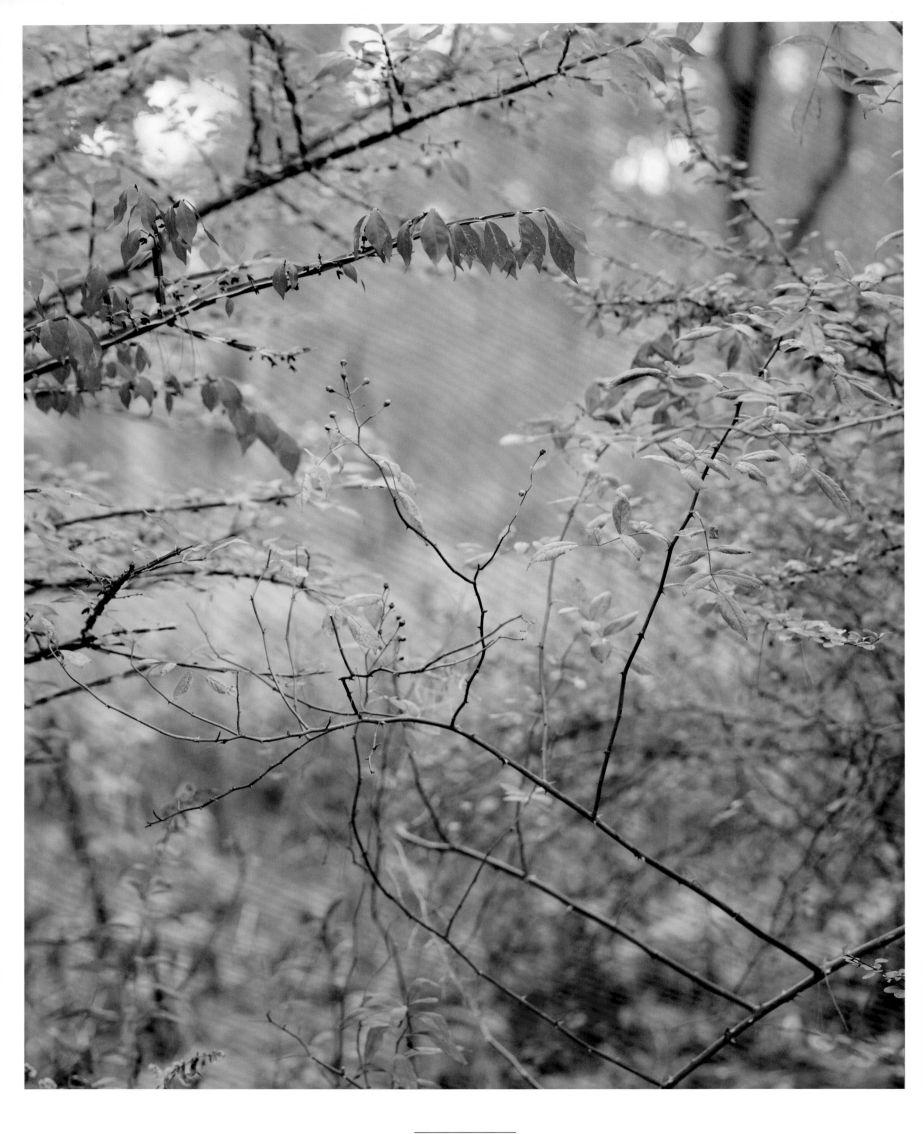

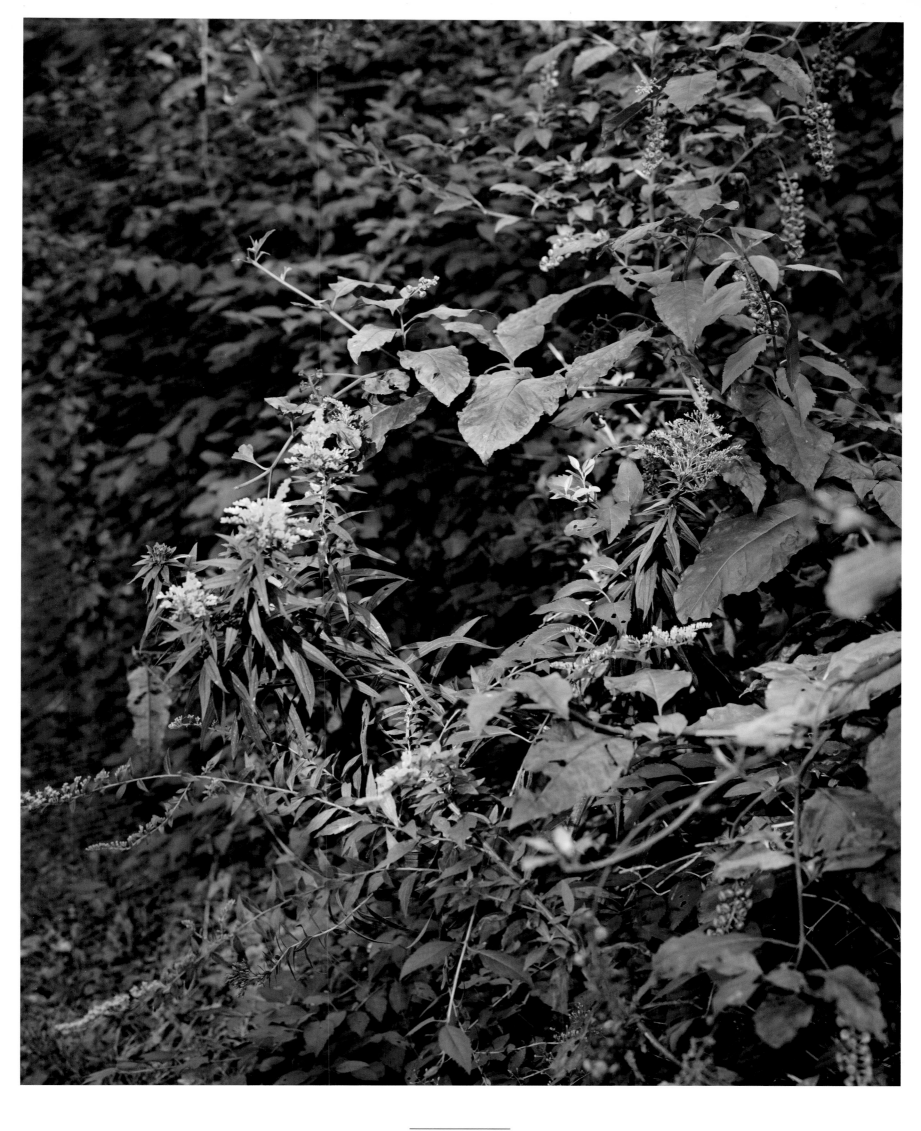

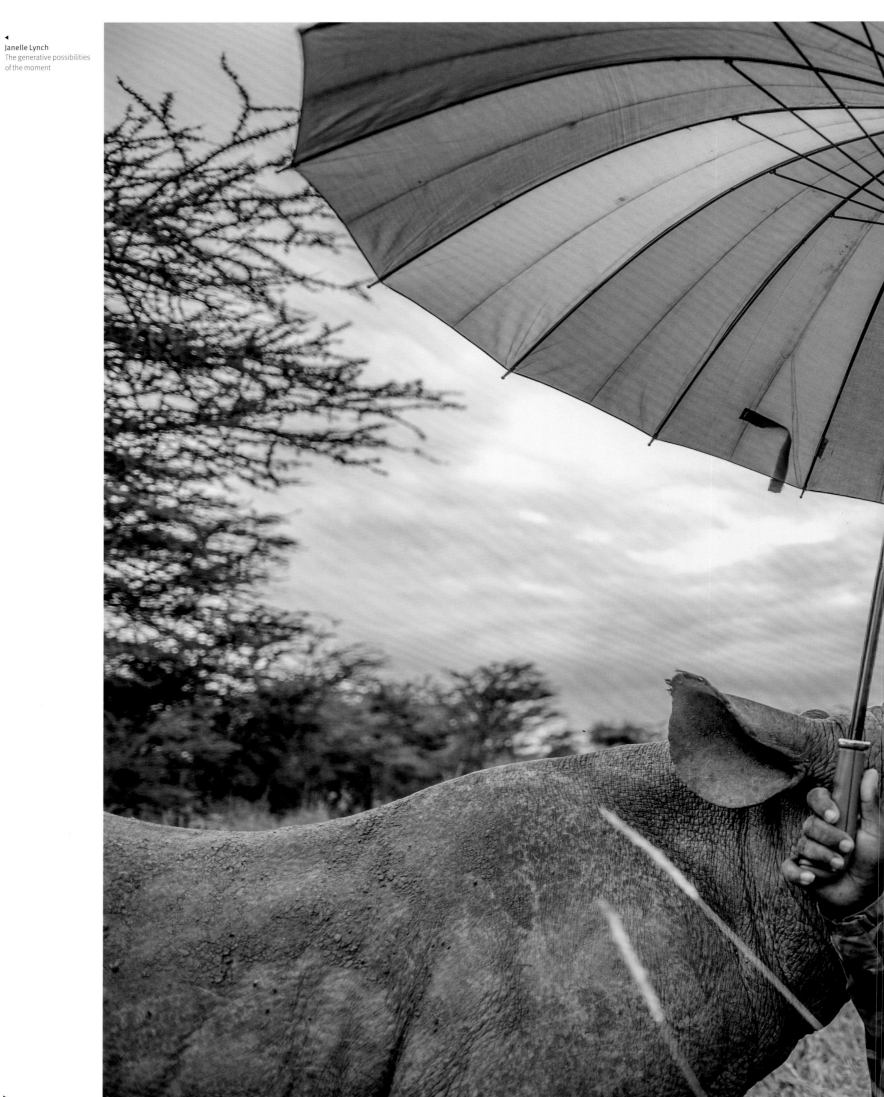

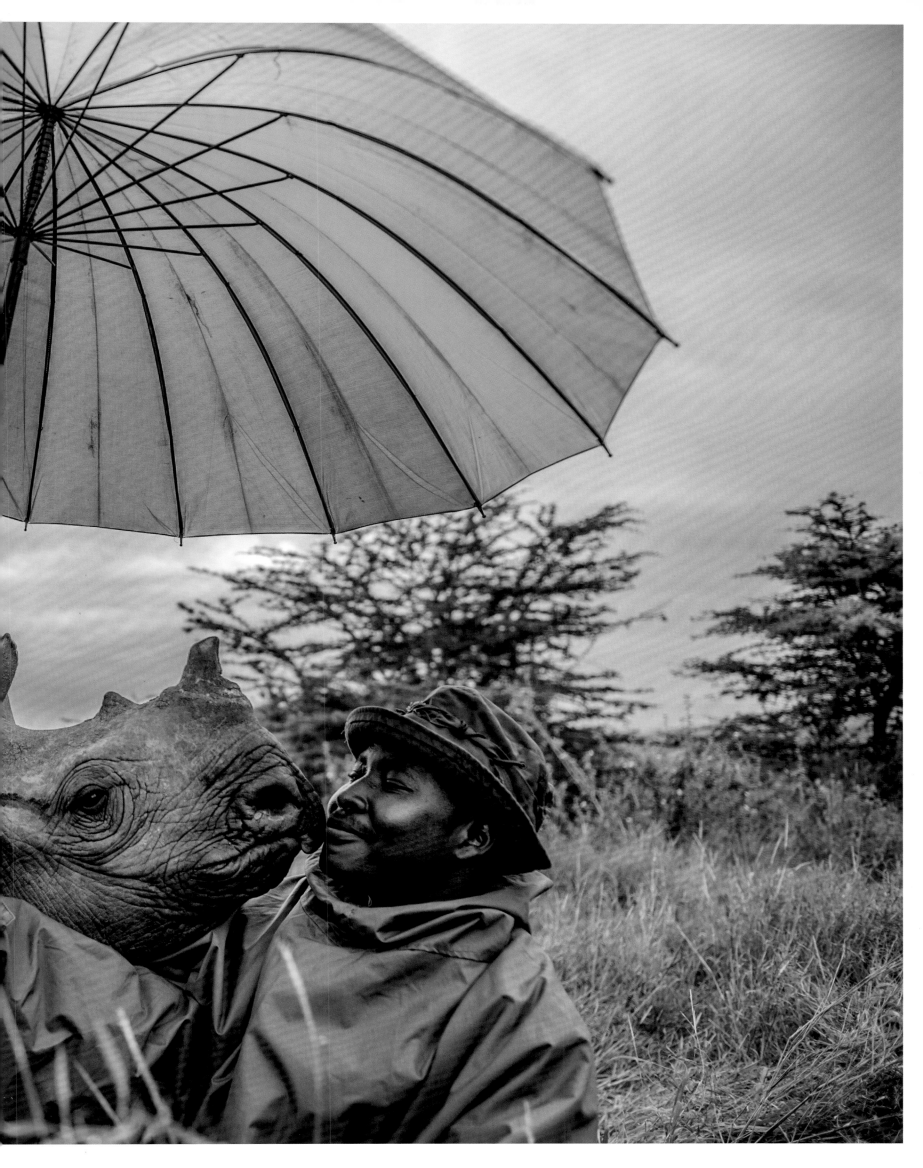

◄

Siân Davey
My daughter Alice has
Downs Syndrome, but she
is no different to any other
little girl ... she feels what
we all feel and needs what
you and I need. She teaches
us all that we can love what
is different

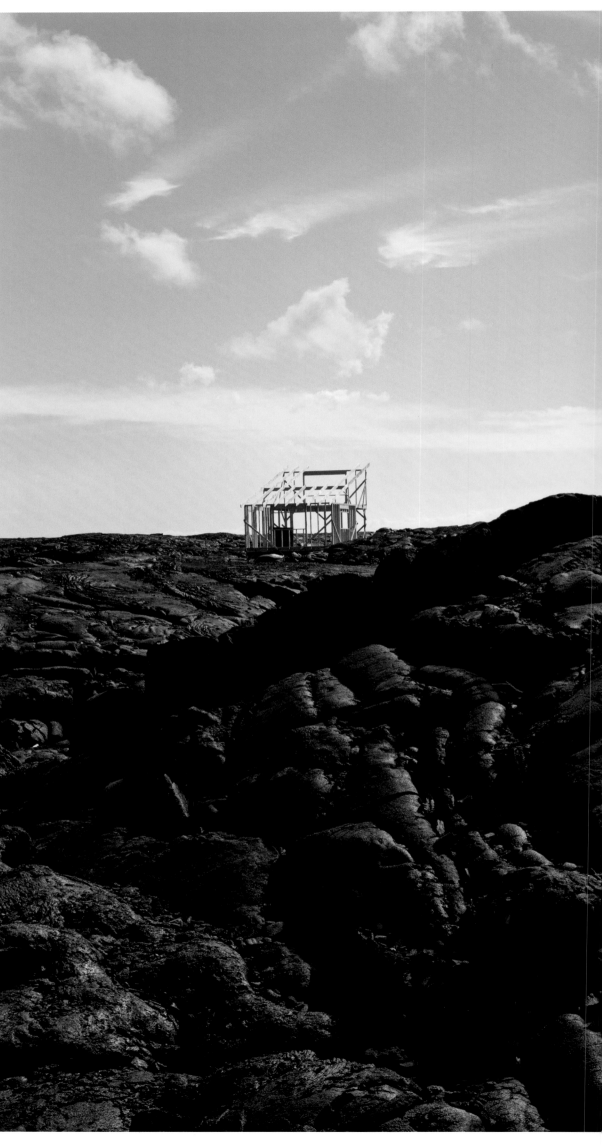

▶
Lucas Foglia
The new house on the
lava flow – in the same
place as the old house just
twenty feet higher ...

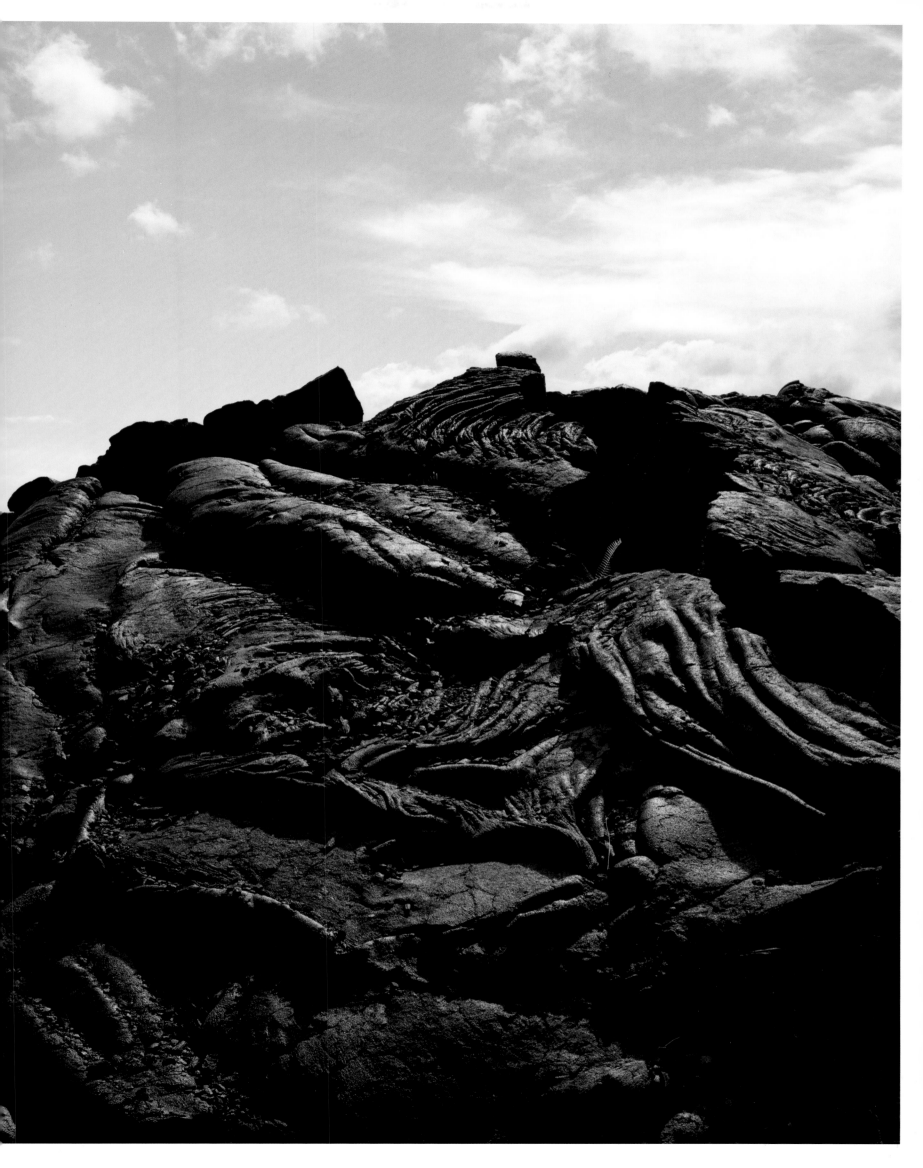

Josh Rossi
Superhero survivors: children with cancer
(now in remission) or severe disabilities

Joakim Eskildsen
Children lose their
connection to nature
as they grow up

Murray Ballard
Cryogenics – science fiction
or scientific innovation?

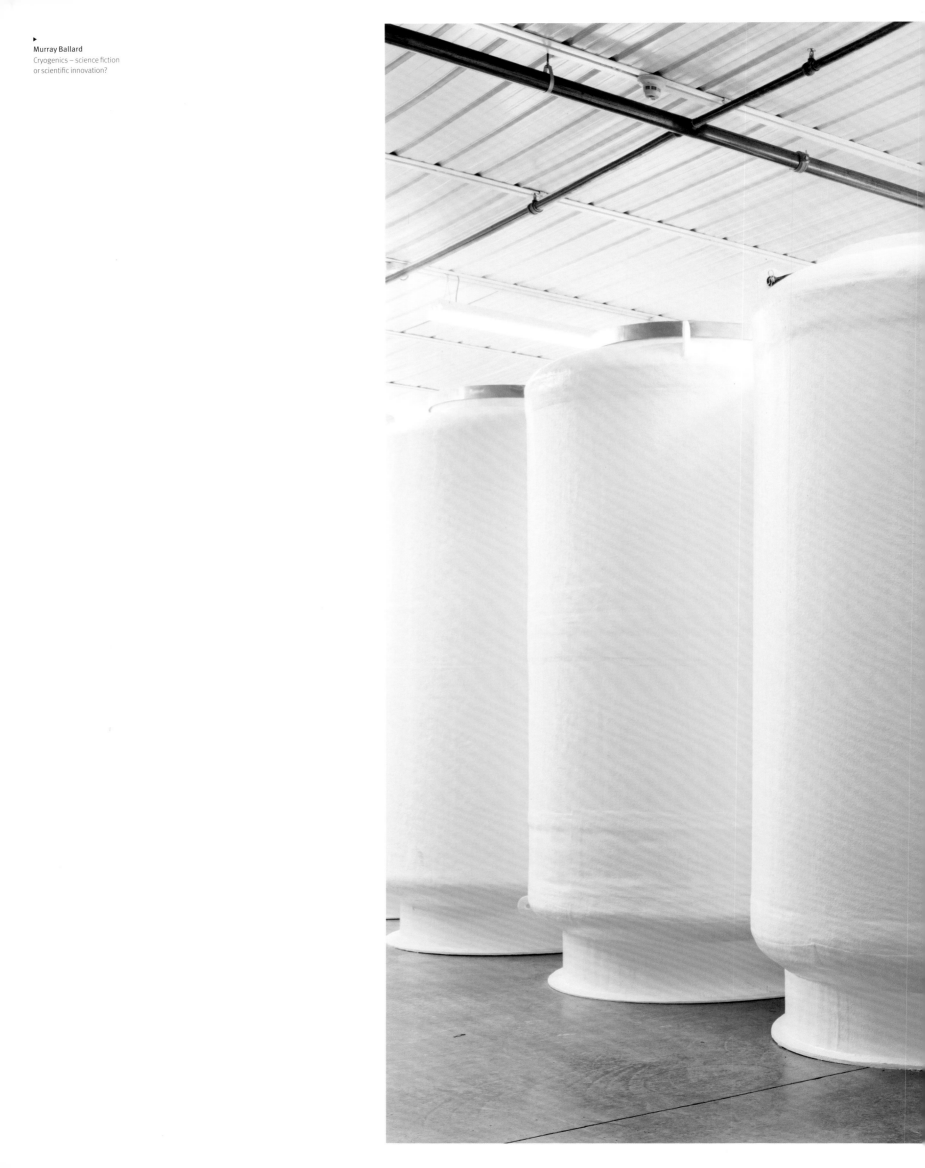

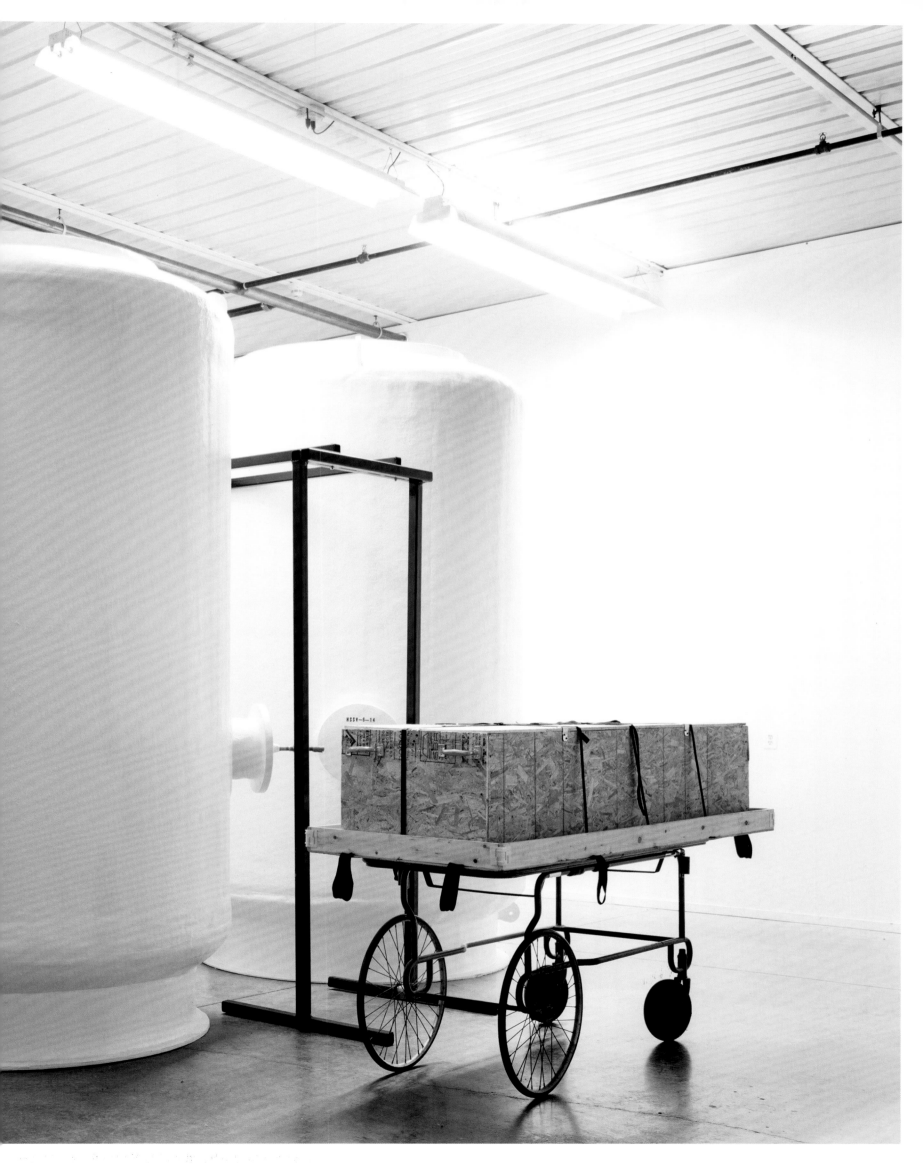

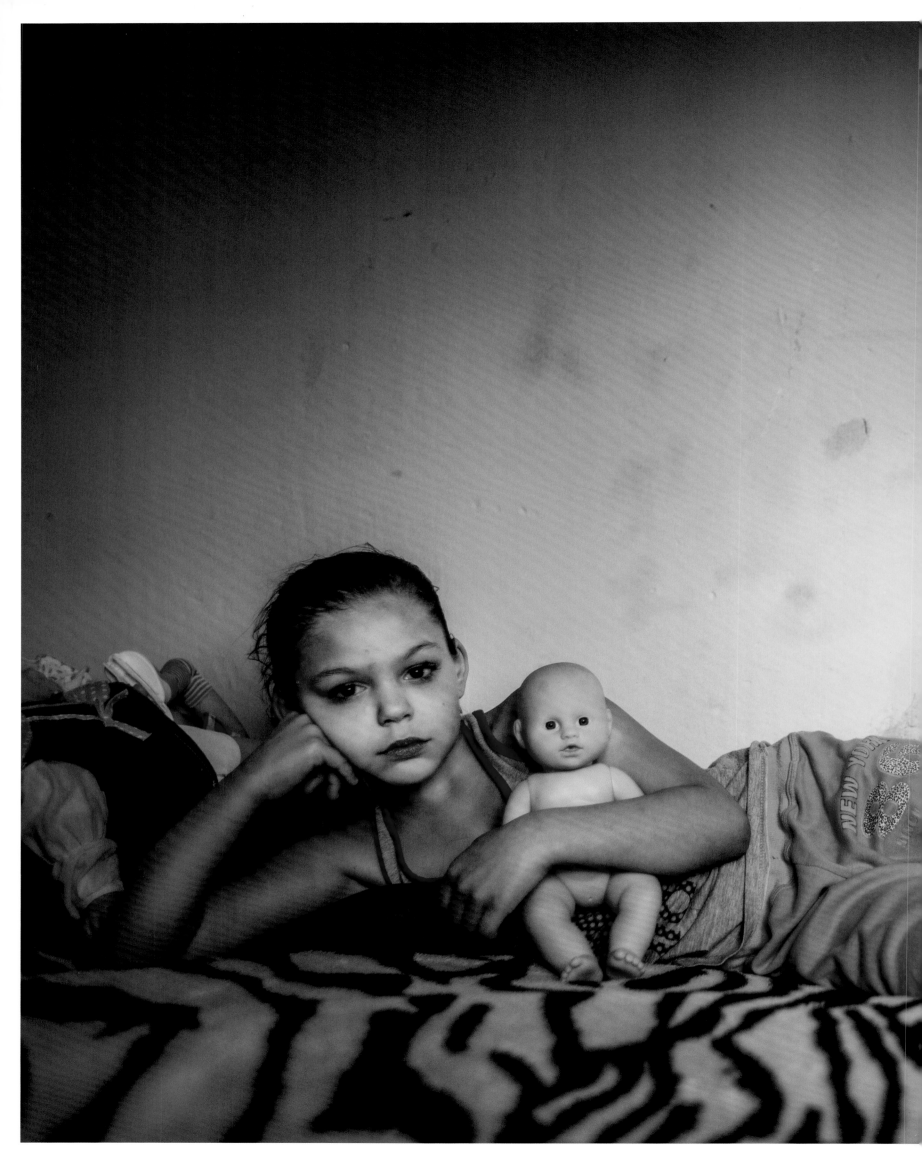

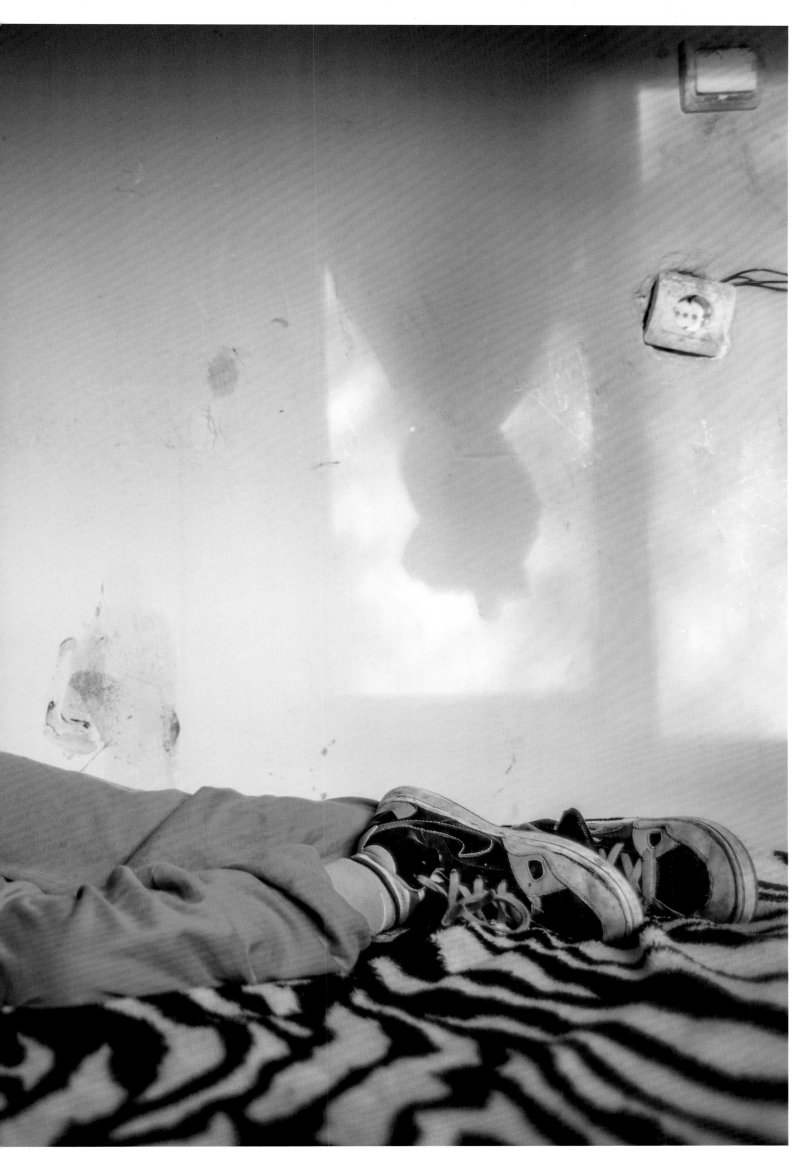

◄

Lena Mucha
The living spaces of
young Roma girls in Spain
are essays in hope for a
different future.

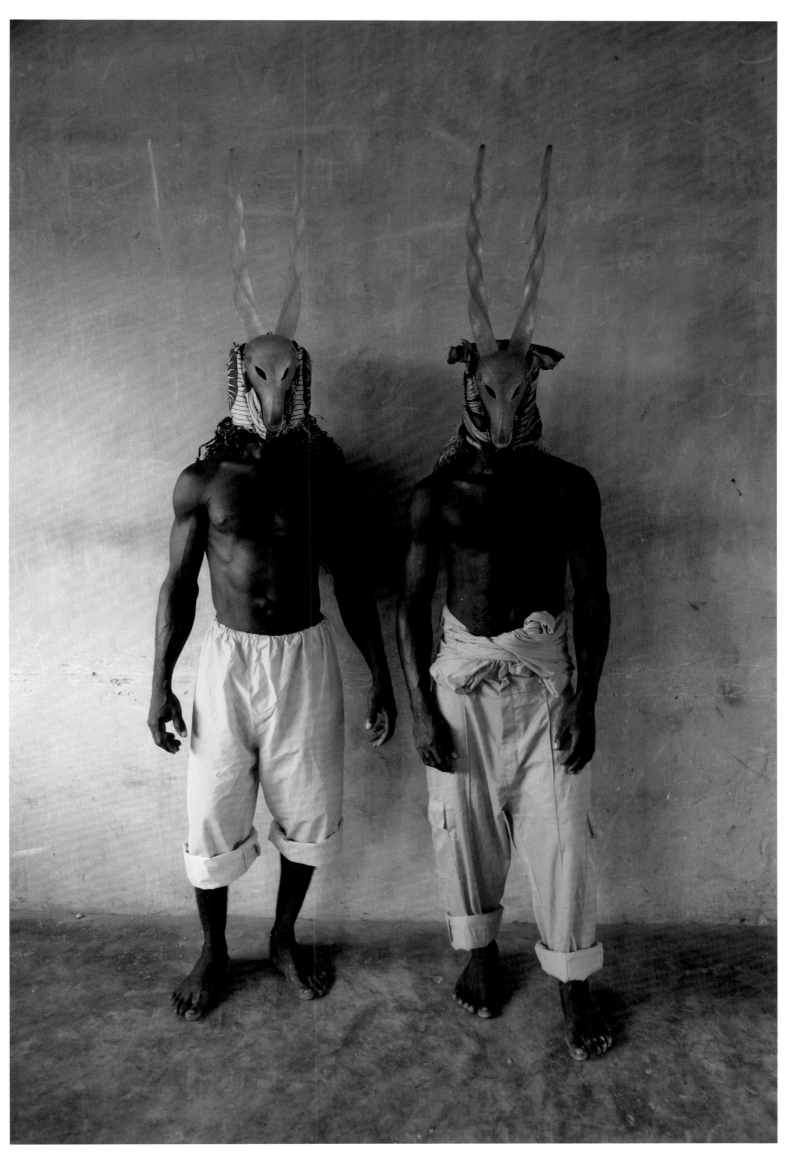

Zino Saro-Wiwa
Holy Star Boyz dance
an antelope-inspired
masquerade that is
unique to the Niger Delta

Susan Meiselas
The multiple possibilities
of an empty room

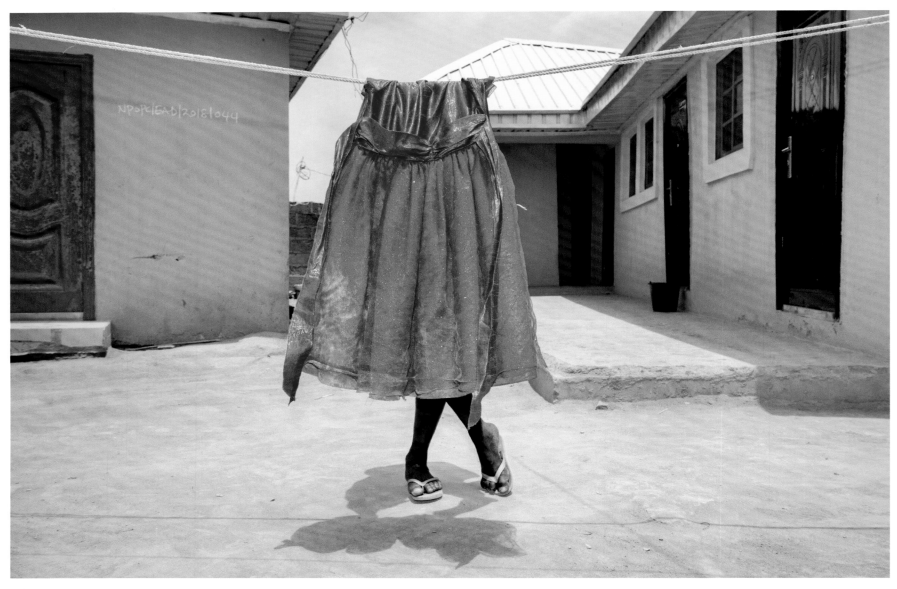

Sanne de Wilde
One to the power of two

Shortlist

Shahidul Alam

Biography

Born Bangladesh, 1955
Lives and works in Dhaka, Bangladesh

Photographer, writer, curator and human rights activist, Shahidul Alam obtained a PhD in Chemistry from London University before taking up photography. Returning to his hometown, Dhaka, in 1984, he documented the democratic struggle to remove General Ershad. President of the Bangladesh Photographic Society for three terms, Alam set up the Drik agency; Bangladesh Photographic Institute; Chobi Mela festival; Majority World agency and Pathshala South Asian Media Institute. A new media pioneer, Alam introduced email to Bangladesh in the early nineties.

His work has been shown at the Museum of Modern Art, New York; Centre Pompidou, Paris and Tate Modern, London. He has been a guest curator at the Whitechapel Gallery, London; Fotomuseum Wintherthur, Switzerland; National Art Gallery, Kuala Lumpur; Musée du quai Branly, Paris; Brussels Biennial and the Auckland Festival of Photography. His awards include the Shilpakala Padak, the highest cultural award given to Bangladeshi artists; a Lucie Award and the ICP Award. *Time* magazine named Alam as one of their "Persons of the Year" in 2018.

Alam has written and edited several publications including *My Journey as a Witness* in 2011. His exhibition *Kalpana's Warriors* was shown at the Commonwealth Heads of Government Meeting 2015 in Malta, and *Best Years of my Life* was shown at the Global Forum on Migration and Development in Berlin in 2017.

A speaker at Harvard, Stanford, UCLA, Oxford and Cambridge universities, Alam has been a jury member for the Prix Pictet and World Press Photo, which he chaired. Alam is a visiting professor of Sunderland University and an honorary fellow of the Royal Photographic Society.

Artist statement

Still She Smiles

And yet she smiles. Gang-raped numerous times as a child, forced into pickpocketing, caned until unconscious, sold to a Madam, Hajera Begum's life has little that would give cause to smile. Yet she smiles. She cries too. Not because of the rapes, or the beatings, or the years she lived on the streets as a rag picker, but when she remembers that a man who worked at an NGO refused to be part of her team because she was a sex worker.

Hajera decided she would change things for others like her. Previously, she had set up a support group for sex workers and eventually, with the backing of university students, friends and a generous journalist, she was able to set up an orphanage for abandoned children. Most are the children of sex workers, some of drug addicts and a few from parents who simply cannot afford to keep them. Hajera and 30 children now live in five small rooms near Adabor Market on the edge of Dhaka.

Remarkably, Hajera is not bitter. While she remembers every detail of her nightmarish life, she also remembers the friends who believed in her and helped her establish the orphanage. Instead of remembering that she is unable to bear children as a result of the brutal unwanted sex, she basks in the warmth of the 30 children who now call her mother.

When I first met Hajera, back in 1996, she was a sex worker in the grounds of the House of Parliament, Dhaka. As a friend, she would often visit my flat, an act deemed unacceptable by most. "You hugged me today when you saw me in the street, just like the old times. That's something men will never do. They will have sex with me, grope me in the dark, rape me if they get the chance, but they will never hug me, as a sister, as a friend. That is what I want for my children. That they will grow up with dignity, in a world where they will be loved."

As the children grow, there is increased need for money and schooling. Some students initiated a Facebook campaign to raise money for the orphanage, which has helped Farzana, aged 13, the daughter of Hasna who still works on the streets, to be admitted to a respectable boarding school. Hajera has high hopes for the other children too, although she worries about Shopon, who is deaf and mentally ill, but takes great pride in showing me the bunk beds she has had made, to ensure no one will have to sleep on the floor.

As I look back at Hajera peering through the little window, bidding me goodbye, I contemplate how lucky the children are to have her as their mother.

Portfolio

Hajera and her fellow sex workers share a joke at the House of Parliament grounds in Dhaka. They give out condoms to sex workers in an effort to prevent HIV/AIDS.
2014

Rented rooms form the orphanage where Hajera and her children live. Dhaka, Bangladesh.
2014

Hajera Begum
2014

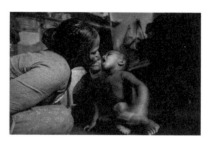

Hajera steals a sloppy kiss from Rahat, who was abandoned at three hours old. His nickname is Shongram, meaning 'struggle'.
2014

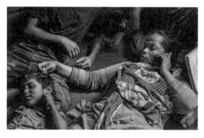

Hajera orders supplies for her orphanage while checking the hair of one of the children for lice.
2014

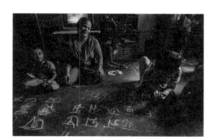

The floor of the orphanage is used as a giant slate for drawing.
2014

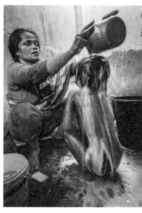

Hajera bathes the younger children.
2014

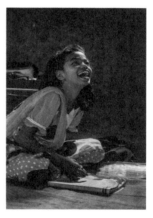

BRAC school. Hajera insists that all her children receive a good education and the older children get private tuition.
2014

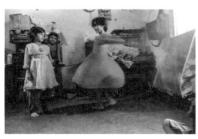

Fatema shows off her new dress with dreams of becoming a model.
2014

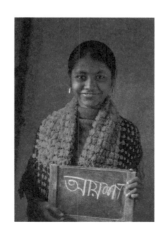

Ayesha at the orphanage.
Dhaka, Bangladesh.
2014

Joana Choumali
Page 58, 59

Biography

Born Côte d'Ivoire, 1974
Lives and works in Abidjan, Côte d'Ivoire

Joana Choumali studied graphic arts in Casablanca, Morocco, and worked as an art director in an advertising agency before embarking on her photography career.

Her work concentrates on conceptual portraits, mixed media and documentary photography, with a particular focus on Africa. In her latest work, Choumali embroiders directly onto her images, completing the act of creating the photograph image with a slow and meditative gesture.

Choumali has exhibited her work at the Museum of Civilisations, Abidjan; Vitra Design Museum, Basel; Museum of African Contemporary Art Al Maaden, Marrakech; Tropenmuseum, Amsterdam; Bamako Encounters Photography Biennial; Photoquai Biennial, Paris; Zeitz Museum of Contemporary Art Africa, Cape Town, among others.

In 2014, Choumali won the CAP Prize for Contemporary African Photography and the 2014 LensCulture Emerging Talents Award. In 2016, she received the Magnum Foundation Emergency Grant and the Fourthwall Books Photobook Award in South Africa. In 2017, she exhibited her series *Translation and Adorn* at the Pavilion of Côte d'Ivoire during the Venice Biennale.

Her work has been published in the international press including CNN; *The New York Times; Le Monde; The Guardian; The Huffington Post* and *La Stampa*, among others.

Her book *Hââbré* was published in Johannesburg in 2016.

Artist statement

Ça va aller

These pictures were taken three weeks after the terrorist attacks in Grand-Bassam on Sunday 13 March 2016.

Bassam is my refuge, the place I go to unwind and be by myself. A one-hour drive from Abidjan, Bassam is a place full of history, a quiet and peaceful little town where Ivorians take holidays at weekends. Bassam reminds me of insouciance, of the Sunday afternoons of my childhood I used to spend with my loved ones on the same beach where the attacks took place. To me, Bassam was a synonym of happiness, until that day.

Three weeks after the attacks, the atmosphere of this little town changed. A 'saudade', a kind of melancholy, invaded the town. I decided to wander the silent, empty streets and I chose to leave my reflex camera behind and shoot instead with my iPhone. I did not want to intrude on people's intimacy and disrupt their mourning. In that moment, I did not feel like a photographer, detached by the place; instead I felt part of the wounded inhabitants. Most of the pictures show empty places, people by themselves, walking the streets or just standing, sitting alone, lost in their thoughts.

In Côte d'Ivoire, people do not discuss their psychological issues or feelings. A post-traumatic state is often considered as weakness or a mental disease. People hardly talk about their feelings, and each conversation is quickly shortened by a resigned "ça va aller". "Ça va aller" is a typical Ivorian expression which means "it will be OK". It is used for everything – even for situations that are not going to be OK.

This series addresses the way Ivorian people deal with trauma and mental health. The attacks re-opened the mental wounds left by the post-electoral war of 2011. Back home I felt the need to process this pain and I discovered that I could do so through embroidery.

Each stitch was a way to recover, to lay down the emotions, the loneliness, and mixed feelings I felt. As an automatic scripture, the act of adding colourful stitches on the pictures has had a soothing effect on me, like a meditation. Adding embroidery on these street photographs was an act of channelling hope and resilience.

Portfolio

Untitled
2019

Untitled
2019

Untitled
2019

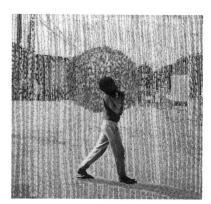

Untitled
2019

Untitled
2019

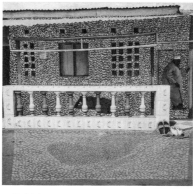

Untitled
2019

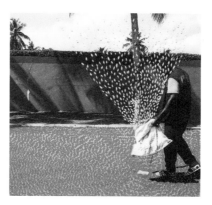

Untitled
2019

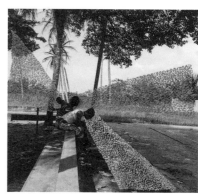

Untitled
2019

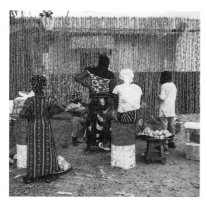

Untitled
2019

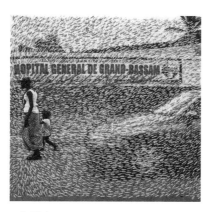

Untitled
2019

Margaret Courtney-Clarke

Biography

Born Namibia, 1949
Lives and works in Swakopmund, Namibia

Margaret Courtney-Clarke studied art and photography in South Africa and has spent the last four decades working as a photographer in Italy, the United States and across Africa.

Courtney-Clarke began her career working under Italian photographer and filmmaker Pasquale De Antonis before undertaking magazine assignments across Europe and Africa during the 1970s and 1980s. In 1979, she became a persona non grata under the apartheid laws and renounced her South African citizenship – she would later return to South West Africa under the protection of the United Nations and claim her Namibian citizenship. Throughout her career, Courtney-Clarke would pursue projects in Africa documenting feminine identity.

The body of work, *Cry Sadness into the Coming Rain* (2014–18), marks a new phase in Courtney-Clarke's photographic work, documenting the artist's return to Namibia and her engagement with its people and a landscape in crisis.

She has been recognised by the Deutscher Fotobuchpreis; the Kraszna-Krausz Book Award (longlisted); the 2018 PDN Photo Annual and the 2015 Fondation Henri Cartier-Bresson HCB Award (nominated). Over 200 exhibitions of Courtney-Clarke's photography have been held around the world.

Dedicated publications on Courtney-Clarke's work include, amongst others, *Cry Sadness into the Coming Rain* (2017); her trilogy on the art of African women, *Ndebele* (2002); *African Canvas* (1990) and *Imazighen* (1996) as well as several collaborations with Maya Angelou.

Artist statement

Cry Sadness into the Coming Rain

Namibia is steeped in histories dating from the earliest inhabitants – Khoi, Bushmen, Herero, Namaqua, Damara et al to German occupation, to the South Africans and apartheid, and now to 'liberation' and statehood – a nation of diverse peoples and cultures in a vast land of seeming nothingness and unparalleled light. I seek out the traces of their passing on the land.

Cry Sadness into the Coming Rain is a record of this social process, which has always hinged on the fragility of hope.

The existential world of the people I photograph is located in an unforgiving environment where life is precarious: little or no rain, scarce water and food, people abandoned by their government and forced to migrate to flee the emptiness ... Their only anchor is the expectation that life will persist against these odds.

I keep returning to the women and men I have met, photographing them anew as they share their unfolding stories.

Every form of human existence and of Nature, in its infinite variety, has wonder at its very core, and it is our 'openness' to the world that makes us both free to create in it and, at the same time, be responsible for our creations.

My art derives from this space, the point where freedom meets responsibility, rationality meets imagination and self meets other. This silent point is the source of all that is humanly significant.

My own motivation is to find a place here among my fellow people, building relationships over time that allow me to discover, against the seared backdrop, their hidden world of nurtured aspirations, the embodiment of hope.

Portfolio

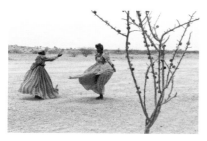

Life is Them
Emsi Tjambiru and Beverly Tjivinde dance on the road near their craft stall to flag down tourist buses.
2017

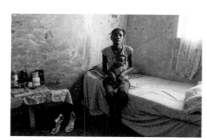

Always
Talita Witbooi, a shepherdess, with daughter Talisha, a year after losing her son to a snakebite.
2017

A Place Called Shelter
Sara Swartbooi carries a sheet of scrap metal to build a shelter near the gravel road from Henties Bay to Usakos. Here she will sell semi-precious stones to occasional passers-by.
2015

Melody under the Sun
Gottlieb ('God is love') ‡Khatanab ||Gaseb aka Die vioolman ('The Violinist') is a self-taught musician who lives in a remote outpost beneath the Dâures granite massif. He earns a living from playing the violin at community weddings and funerals.
2014

Frail and Flowering
The flowering wild tobacco *(Nicotiana glauca)* is used by local people for hunting rituals and medicinally as a poultice to treat wounds.
2014

Embodying Hope
A morning in the sand dunes.
2015

Waiting for Rain
Experimental plot to evaluate grass species and measure rainfall.
2015

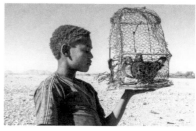

I'll get Rich
Francois !Uri-khob breeds pigeons to support his siblings after his family lost their goats and donkeys to drought and poaching.
2017

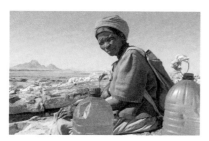

Mirror in the Landscape
Liskien Gawanas on her way from an aquifer, a daunting journey on foot over rock and a gruelling descent underground. This freshwater spring will have been used by southern Africa's earliest inhabitants, the Bushmen, who left their rock art throughout these parts.
2015

The Rain will Come
Susanna !Uri-Khos's iron bathtub, raised on a scaffold, serves as a rain-fed shower – a signal of optimism at odds with the brutal logic of this parched place. Though it has been dry for three years, the sky is now filled with hope.
2018

Rena Effendi

Biography

Born Azerbaijan, 1977
Lives and works in Istanbul, Turkey

Born in Baku, Azerbaijan and educated as a linguist, Rena Effendi's early work focused on the oil industry's effects on people's lives in her region. Over six years, she followed 1,700 km of oil pipeline through Georgia and Turkey, and in 2009, her first book, *Pipe Dreams: A Chronicle of Lives along the Pipeline*, was published. In 2012, Effendi published her second monograph, *Liquid Land*.

Effendi's work has been exhibited at institutions worldwide including the Saatchi Gallery, London; Istanbul Modern; the Venice Biennial and the Museum of Modern Art, New York. Her work is in the permanent collections of Istanbul Modern and the Prince Claus Fund for Culture and Development Amsterdam. She has received two World Press Photo awards; the Fifty Crows Documentary Photography Award; Sony World Photography Award; All Roads Photography Award from *National Geographic*; Magnum Foundation Emergency Grant; Getty Images Editorial Grant and the Alexia Foundation Grant among others. In 2011, Effendi became the laureate of the Prince Claus Fund Award, and in 2012 she was shortlisted for the Prix Pictet for her series *Chernobyl: Still Life in the Zone*.

Effendi has worked on editorial commissions for the *National Geographic Magazine*; *The New York Times Magazine*; *Vogue*; *The New Yorker*; *GEO*; *Time* magazine; *The Sunday Times* and many others.

Artist statement

Transylvania: Built on Grass

For centuries, the small villages in Transylvania have maintained hay meadows, raised cattle and operated self-sustainable farms. The agrarian fairy tale that is extinct in Western Europe still exists here, where young boys learn to cut and rake hay by hand, all village women learn to weave, and men can build a house from the materials they have to hand.

Having survived the collectivisation of Ceauşescu's communist regime, this fragile rural environment now faces the modern threat of industrialisation and globalisation – the result of Romania's 2007 entry into the European Union. Today, this world is on the brink of extinction, as local small-scale farmers cannot compete with European imports or industrialised farming methods and youths leave the countryside for work in the cities of Western Europe.

As horses are traded in for tractors and wooden houses and gates are disassembled and sold off for furniture parts, this pastoral dream is vanishing. However, when you see eighty-year-old men cut hay by hand you realise that these Transylvanian people will farm until they die. They are so deeply connected to the land and with them remains a hope that this traditional way of life will somehow persevere. A window into a world defined by traditional belief systems and respect for the environment, these proud, and mostly hidden faces deserve to be recognised before progress continues its march through the pristine meadows of Transylvania.

Portfolio

The Borca family build one of the 40 haystacks they make each summer. Maramureş, Romania.
2012

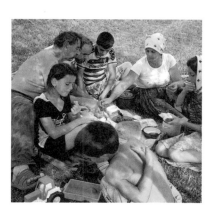

Members of the Borca family relax after a long day at work on the land. Maramureş, Romania.
2012

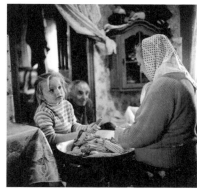

Ion Petric and his wife Maria Vraja teach their neighbour, seven-year-old Adriana Ţânţaş, to strip corn for cattle feed. Maramureş, Romania.
2012

Andrei Rus, aged 12, looks on as his father makes Pálinka, a traditional fruit brandy. Maramureş, Romania.
2012

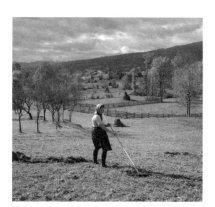

Ioana Oros rakes hay that she has cut in the field. Maramureş, Romania.
2012

A grandfather wears traditional Maramureş headwear while stirring a vat of boiling plum jam. Maramureş, Romania.
2012

Ileana Pop makes alterations to her daughter's skirt while her mother plays games with her grandson Ion. Maramureş, Romania.
2012

Vasile and Nastafa have been married for over 50 years. As is tradition, Vasile first declared his feelings for Nastafa to her parents. Pleased with her suitor, she waited eagerly on the front porch to meet him and begin their lives together. Maramureş, Romania.
2012

Cousins Anuţa and Magdalena wear traditional dress on their way to a wedding in Sat Şugatăg village, Maramureş, Romania.
2012

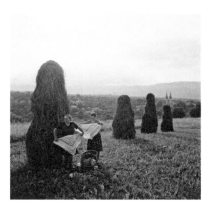

Alfalfa stacks stand on the hillside outside the village of Breb. Maramureş, Romania.
2012

Lucas Foglia

Pages 88, 89

Biography

Born United States, 1983
Lives and works in San Francisco, United States

Lucas Foglia grew up on a farm in New York and currently lives in San Francisco. His third book, *Human Nature*, was published in 2017 by Nazraeli Press.

Foglia's prints are held in major collections including Denver Art Museum; Foam, Amsterdam; the International Center of Photography, New York; The Museum of Fine Arts, Houston; Philadelphia Museum of Art; San Francisco Museum of Modern Art and the Victoria and Albert Museum, London.

Artist statement

Human Nature

Conservationists often disagree about how humankind should best move forward from the damage we have already done. Traditionalists argue that we should put a boundary around wild spaces to preserve them, but there is no way to contain the effects of people. More radical conservationists propose moving all people to green cities, supplied with renewable energy and sustainable agriculture, to allow the countryside to rewild itself.

Responding to this debate, I befriended and photographed people who are working towards a positive environmental future despite the enormity of the task. *Human Nature* is a series of interconnected stories about our reliance on the natural world and the science that fosters our relationship to it. Each story is set in a different ecosystem: city, forest, farm, desert, ice field, ocean and lava flow. From a newly built rainforest in urban Singapore to a Hawaiian research station measuring the cleanest air on Earth, the photographs examine our need for 'wild' places – even when those places are human constructions.

Hope fuels the work of the people I photographed and drives how I use their images. I exhibit prints of my photographs in galleries, festivals and museums. I publish photographs in books, in magazines and on social media. I also give my photographs to local and international organisations to use for advocacy. All are different methods of storytelling, and there is activism and optimism in each of them.

Portfolio

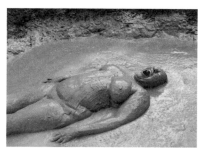

Rachel Mud Bathing, Virginia
Rachel immerses herself in the communal mud pit at the Twin Oaks Communities Conference in Louisa, Virginia. The conference attracts an international audience to discuss ways of living closer to nature.
2009

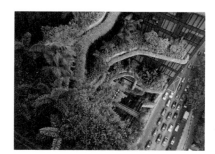

Esme Swimming, Parkroyal on Pickering, Singapore
The Parkroyal on Pickering contains over 15,000 square meters of greenery, amounting to twice its land area. As part of Singapore's Green Plan 'wild' nature is being reincorporated into the city.
2014

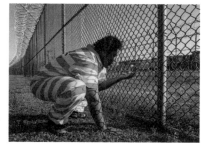

Troy Holding a Guinea Fowl Chick, Rikers Island Jail Complex, New York
Rikers Island, the largest penal colony in the world, incorporates five organic gardens run by the Horticultural Society of New York, where detainees and prisoners tend flowers, fruits and vegetables.
2014

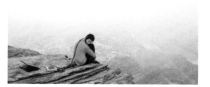

Kate in an EEG Study of Cognition in the Wild, Utah
Kate's EEG cap and facial electrodes record her brain's responses to the natural environment of rural Utah.
2015

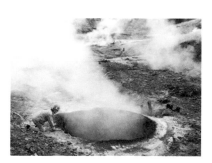

Chuck Taking Sample Readings at the Geysers, California
This is the world's largest geothermal field, containing a complex of 22 geothermal power plants that draw steam from more than 350 wells.
2015

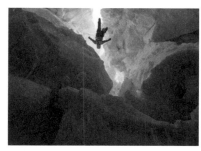

Kenzie in a Crevasse, Juneau Icefield Research Program, Alaska
Every summer since 1948, members of the program have traversed the Juneau Icefield, one of the largest ice fields in the world. This is the longest-running study of a glacier in the Western Hemisphere.
2016

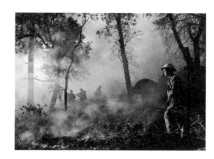

Jason Igniting a Controlled Burn, US Forest Service, California
In an attempt to arrest the rise in wildfires, which destroy almost 7 million acres of land each year, the US Forest Service performs controlled burns between the fire seasons.
2015

New Crop Varieties for Extreme Weather, Agricultural Experiment Station, New York
By crossbreeding domesticated crops with their wild ancestors, scientists are creating super-hardy climate-change-resilient strains that can withstand droughts, heat waves and freezes.
2013

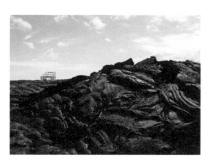

House Construction after a Lava Flow, Hawaii
The new house is at an elevation of approximately 20 feet higher than the last house, which was built in the same place, before the lava flow.
2016

Goda and Lev in the Cleanest Air on Earth, Hawaii
The air over Cape Kumukahi on the Big Island of Hawaii is arguably the cleanest air on Earth. This photograph was made on Goda and Lev's second date and was originally planned as a clothed portrait.
2016

Janelle Lynch
Pages 82, 83

Biography

Born United States, 1969
Lives and works in New York, United States

Janelle Lynch's work investigates themes of absence, presence, transcendence and the life cycle through the landscapes and waterways of the United States, Mexico and Spain. Her recent work explores nature as a metaphor to consider the personal, societal and environmental consequences of disconnection, and simultaneously, our inherent yearning for connection.

Lynch received an MFA in Photography from the School of Visual Arts, New York, where she studied with Joel Sternfeld and Stephen Shore. In 2003, she completed the Master Class in Photography, a one-on-one tutorial with Shore at Bard College. From 2015 to 2018, Lynch studied perceptual drawing and painting with Graham Nickson at the New York Studio School of Drawing, Painting & Sculpture.

Her photographs are in collections including The Metropolitan Museum of Art, New York; New York Public Library and Brooklyn Museum. She has had solo exhibitions at the Museo Archivo de la Fotografía, Mexico City; the Southeast Museum of Photography, Daytona Beach; the Burchfield Penney Art Center, Buffalo and the Hudson River Museum, Yonkers. Lynch has three monographs published by Radius Books: *Los Jardines de México* (2010); AIGA award-winning *Barcelona* (2013) and *Another Way of Looking at Love* (2018).

Lynch is a faculty member at the International Center of Photography, New York and frequent guest lecturer. She writes about photography for *Afterimage; photo-eye* and *The Photo Review*.

Lynch has received three 8x10 Film Grants from Kodak and several artist residencies. She was a finalist for the Cord Prize; Santa Fe Prize for Photography and Photo España Descubrimientos. This is her third Prix Pictet nomination.

Artist statement

Another Way of Looking at Love

Another Way of Looking at Love (2015–18) explores the interconnectedness of all life forms and supports a renewal of human relationships to each other, and to the natural and the spiritual worlds.

For some images, I create points of connection with elements from the same species – Japanese barberry or burdock, for example – while for others, I combine multiple species, such as goldenrod and pokeweed or burning bush and pine trees. Points of connection create spaces which represent areas where new realities can be envisioned. The depiction of unity, together with colour and light, show the beauty and magic of the natural world.

Another Way of Looking at Love follows the belief that in our organic and spiritual essence, we are inextricably linked to each other and to Mother Nature. We are hardwired for connection and our elemental sameness unites us and transcends our apparent differences. Our wellness and the well-being of the world depend on healthy connections to each other and to the earth.

The series was born of awe for the power of nature, and seeks to reimagine our connection to one another, to the planet and to the generative possibilities of the moment.

Portfolio

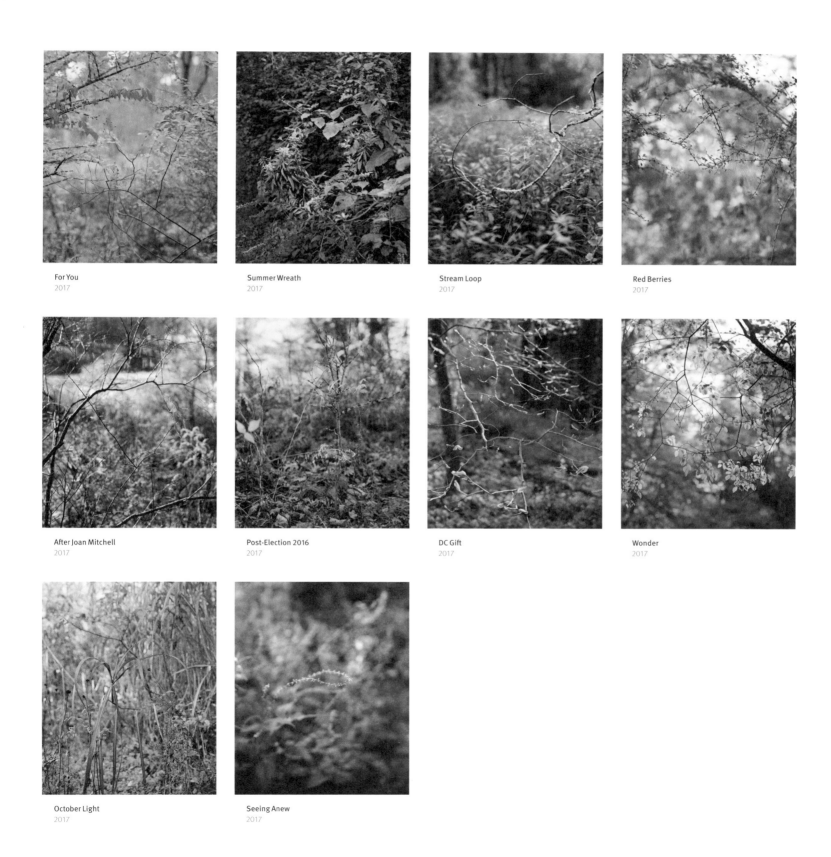

For You
2017

Summer Wreath
2017

Stream Loop
2017

Red Berries
2017

After Joan Mitchell
2017

Post-Election 2016
2017

DC Gift
2017

Wonder
2017

October Light
2017

Seeing Anew
2017

Ross McDonnell

Biography

Born Ireland, 1979
Lives and works in New York, United States

Ross McDonnell is a filmmaker and photographer from Dublin, Ireland. His work takes the form of long-term documentary projects focused on themes of sustainability, conflict, migration and ecology.

McDonnell's first film, *Colony,* was a multi-award-winning exploration into the plight of declining honeybee populations in the United States and its impact on agriculture. His following films focused on conflict in Mexico and Afghanistan as well as social housing in his native Dublin. His most recent film, *Elián,* produced for CNN Films, BBC and Amazon, was nominated for a News and Documentary Emmy Award in 2018.

Ross' photographic work has been exhibited and published around the world. He is a regular contributor to publications such as *Time* magazine, *The New York Times Magazine* and *The Sunday Times Magazine.*

Artist statement

Limbs

Limbs documents the prosthetic legs left behind by patients at the Orthopaedic Hospital in Jalalabad, Afghanistan following a fitting for modern, custom-made prosthetics organised by the International Committee of the Red Cross (ICRC). The hospital serves the semi-permanent battle space that has come to define Eastern Afghanistan throughout the country's 40 years of near continuous conflict. For McDonnell, *Limbs* served to anthropomorphise the particular resilience and optimism of the Afghan people he spent years documenting.

Stripped of their surrounding context, McDonnell seeks to break from depictions of civilian casualties and the visual tropes that have come to define the Afghan people. The viewer is presented with the image of a prosthetic limb and invited to imagine the individual who took the time to adapt, construct and personalise their own prostheses. The photographs humanise a subject that we, perhaps, automatically associate with suffering.

McDonnell presents these prosthetics as sculptural objects. The individuals who created these prosthetics rejected – both by necessity (due to an acute scarcity of materials) and through their own creative impulse – what the medical establishment sets as nominal criteria for a prosthetic leg. Seemingly unconcerned with function, cosmesis and comfort, these individuals favoured radical adaptation, combined with a personal sense of expression in the creation of their bodily extensions. The results are both idiosyncratic and poignant. A star-speckled night sky. A fashionable boot. Even the spent casing of a rocket-propelled grenade were viable materials for the Afghan amputee.

Experts state that the success of a prosthetic depends 10% on the object and 90% on the patient's attitude to it. These images are testament to that attitude.

Portfolio

Limbs No.1
2012

Limbs No.2
2012

Limbs No.3
2012

Limbs No.4
2012

Limbs No.5
2012

Limbs No.6
2012

Limbs No.7
2012

Limbs No.8
2012

Limbs No.9
2012

Limbs No.10
2012

Gideon Mendel

Biography

Born South Africa, 1959
Lives and works in London, United Kingdom

Born in Johannesburg, Gideon Mendel studied Psychology and African History at the University of Cape Town. He began photographing in the 1980s, during the final years of apartheid, and it was this period as a 'struggle photographer' that first brought attention to his work.

Moving to London in the early 1990s, Mendel continued to respond to global social issues with a focus on HIV/AIDS in Africa and further afield. He worked for several leading magazines, including *National Geographic* and *The Guardian Weekend Magazine,* and his first book, *A Broken Landscape: HIV & AIDS in Africa*, was published in 2001. More recently, Mendel has produced a number of photographic advocacy projects working with NGOs including The Global Fund; Médecins Sans Frontières; UNICEF; Christian Aid and Concern Worldwide.

Since 2007, Mendel has been working on *Drowning World*, his long-term project about flooding and climate change. A solo exhibition of this project has been shown at Les Rencontres d'Arles and several global institutions. Mendel's recent project, *Dzhangal*, an 'anti-photographic' response to the global refugee crisis, was shown at Autograph, London in 2017 with a book published by GOST.

Mendel has received the W. Eugene Smith Grant in Humanistic Photography; six World Press Photo Awards and the Amnesty International Media Award for photojournalism among others. He was shortlisted for the Prix Pictet *Disorder* in 2015, and the following year he received The Pollock-Krasner Foundation's Pollock Prize for Creativity and the Jury Prize for the Greenpeace Photo Award.

Artist statement

Damage: A Testament of Faded Memory

These images emerge from a time of hope, activism and tragedy. In the 1980s, I was part of a young generation of 'struggle photographers' in South Africa, documenting the fight against apartheid. In 1990, I left a box of my outtakes (negatives and transparencies) in storage in Johannesburg and subsequently forgot about them. A few years ago, they were returned to me and I discovered that at some point in their many years of neglect, the box had been rained on and the top layers had been affected by both moisture and mould.

I found that this process of decay revealed something potent and significant. Could the entropy of these negatives reflect ways in which communal memory of these pivotal events along with the idealism of that period is fading?

I was struck by the fact that the interventions that overlay my original photographs are happenstance, completely random impacts of time and water. The images still carry the power of those remarkable scenes I documented all those years ago, yet their corruption and damage seem to magnify that energy. My only action was in choosing to expand the frame into the negative rebate, reconsidering what might be included or left out of the final image.

At the start of my lifelong photographic journey, I experienced many intense and traumatic events, but chose not to take the time to 'process' them psychologically. Like these negatives, I left them packed away. So, this engagement with a distorted and clouded version of my memory reflects an intensely personal reconnection with my history. On a contemporary political and global level, it also serves as a reminder that in moments that may seem bleak and hopeless on all fronts, things can change in ways that surprise us.

Hope and tragedy seem so closely intertwined in my recollections of this period. It was a moment where the hegemony and power of the apartheid state seemed insurmountable in all its brutality, yet in response there was such heroic idealism within the township mobilisation that I witnessed.

I feel that the distortion of the negatives speaks to a deeper truth beyond their original documentary format. I am presenting them here as testaments to faded memories of hope and struggle, reconsidered and reframed in all their historical materiality.

Portfolio

Rally welcoming SWAPO leader Sam Nujoma on the day that he returned to Namibia after 30 years' exile. September 1989.
2012

Defiant activists during a mass political funeral for youths slain by the police in KwaThema township near Johannesburg. July 1985.
2012

Protestors outside Cosatu House, after a May Day Rally in which the Congress of South African Trade Unions (COSATU) called for a nationwide 'stayaway' and protest by workers. May 1986.
2012

Defiant activists during a mass political funeral for youths slain by the police in KwaThema township. July 1985.
2012

Protestors outside Cosatu House, after a May Day Rally in which the COSATU called for a nationwide 'stayaway' and protest by workers. May 1986.
2012

Pupils protest outside their school in Athlone during a week of protests and police violence. August 1985.
2012

A demonstration by students at Wits University shortly after the proclamation of a nationwide 'Emergency' which outlawed protest. August 1986.
2012

A demonstration by students at Wits University while the country was subjected to a nationwide 'Emergency' which outlawed protest. October 1986.
2012

Bishop Tutu addresses a crowd of mourners in Duduza Township during a political funeral of four young township activists killed in clashes with police. Shortly before this, Bishop Tutu intervened to save a young man the crowd accused of being an informer. July 1985.
2012

A young woman, asphyxiated by tear gas, is helped by other mourners after the political funeral of four young activists killed in clashes with the police in Duduza Township. July 1985.
2012

Ivor Prickett

Biography

Born Ireland, 1983
Lives and works in Europe and the Middle East

Working exclusively for *The New York Times*, Ivor Prickett's recent work has focused on the fight to defeat ISIS in Iraq and Syria. Based in the region since 2009, he has documented the 'Arab Spring' uprisings in Egypt and Libya, working simultaneously on editorial assignments and his own long-term projects. The complete body of work, entitled *End of the Caliphate*, was published by Steidl in 2019.

Between 2012 and 2015, Prickett documented the Syrian refugee crisis across the region and in Europe, working closely with the UN Refugee Agency to produce the body of work *Seeking Shelter*. With a particular interest in the aftermath of war and its humanitarian consequences, Prickett's earlier projects, *Dreams of a Homeland* and *Returning Home*, focused on the Kurdish people and displacement throughout the Balkans and Caucasus.

Prickett's work has been recognised through a number of prestigious awards including first prize in the General News Stories category of the 2018 World Press Photo awards; finalist of The Pulitzer Prizes; the Taylor Wessing Photographic Portrait Prize and The Ian Parry Scholarship, among others.

His work has been widely exhibited at institutions such as Foam, Amsterdam and National Portrait Gallery, London. He is represented by Verbatim Images in New York, and his archive is managed by Panos Pictures in London. He is a European Canon Ambassador and holds a degree in Documentary Photography from the University of Wales, Newport.

Artist statement

End of the Caliphate

This body of work is a reminder of the power of people to endure and survive.

Nadhira sat in a plastic chair 15 feet away from an excavator digging through the ruins of her home in Mosul's Old City. At times she was engulfed in dust, whipped up as the driver dumped mounds of stone and parts of her house beside her, but she refused to move. Slowly they found the remains of her sister and niece who had been killed when the house was flattened by an airstrike in the final weeks of a battle to defeat ISIS in Mosul in the summer of 2017.

The levels of violence and killing that I witnessed during this work were beyond comprehension. During the nearly two years that I documented the battle to defeat ISIS and its aftermath in Iraq and Syria, I struggled to see the high cost of the war as anything but disastrous. In Mosul alone, the death toll was estimated to be over 9,000 and vast tracts of the city were left in ruins.

However, I also saw glimmers of hope for humanity amid the rubble-strewn aftermath. Meeting Nadhira was one of those moments. Her defiance that day was simultaneously one of the most heartbreaking and inspiring things I have ever seen. Her stoicism in the face of absolute loss was a deeply symbolic moment for me. One which seemed to speak volumes about the futility of war and the failure of intervention in Iraq, but it was also a testament to the depth of strength people have in this fractured region.

Less than a year after the battle concluded, signs of life began returning to Mosul. I was drawn to photographing young couples laughing as they enjoyed themselves at a newly reopened theme park on the banks of the Tigris River. Through the shrieks of joy and booming Iraqi disco music, it was hard to imagine what had passed here not so long before.

One of the most moving scenes I witnessed was of students coming back in force to attend classes at the prestigious University of Mosul, which was heavily damaged during the fighting. Those young minds gave me hope for the future of this majestic city. A new generation was choosing to learn and equip themselves with knowledge as a weapon.

This selection of images is not an all-encompassing view of war, but rather a beacon of strength in the midst of terrible hardship. They can give us hope despite the challenges we face as a global community.

Portfolio

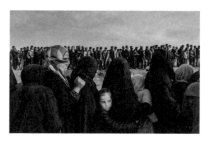

Civilians line up for an aid distribution in the Mamun neighbourhood, Iraq, having remained in west Mosul during the battle to retake the city.
2017

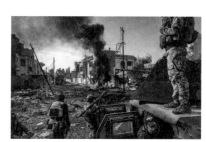

Iraqi special forces soldiers survey the aftermath of an ISIS suicide car bomb that managed to reach their lines in the Andalus neighbourhood of east Mosul.
2017

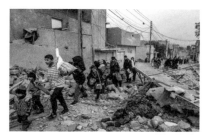

Early morning in the Jadidah neighbourhood of west Mosul, civilians flee heavy clashes between Iraqi special forces and ISIS militants.
2017

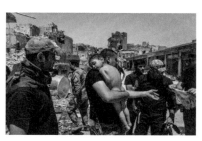

An unidentified young boy, who was carried out of the last ISIS-controlled area in the Old City of Mosul by a man suspected of being a militant, is cared for by Iraqi special forces soldiers.
2017

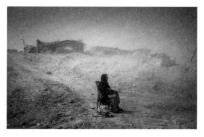

Nadhira Rasoul looks on as Iraqi Civil Defence workers dig to uncover the bodies of her sister and niece from her house in the Old City of Mosul where they were killed by an airstrike in June 2017.
2017

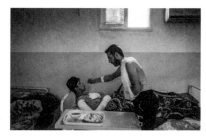

25-year-old Mohammed Sheko feeds his SDF comrade, 18-year-old Salah Al Raqawi, at a hospital for injured fighters in Kurdish-controlled Syria. The men were both injured in the previous week while fighting ISIS in Raqqa.
2017

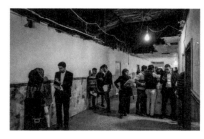

Students chat and walk through a partially repaired section of Mosul University during their lunch break. The prestigious university was badly damaged in the fight to retake the city from ISIS but students began to return as soon as the city was liberated.
2017

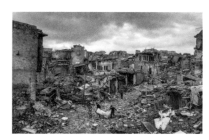

A group of volunteers work to collect unclaimed bodies, most of them suspected of being those of ISIS members, from the ruins of the Old City district, Mosul, where the militants made their last stand.
2017

Young couples enjoy a ride at a newly reopened theme park on the banks of the Tigris River in east Mosul. After ISIS, life is coming back to the city and people are starting to enjoy things that were banned under the militants' rule.
2017

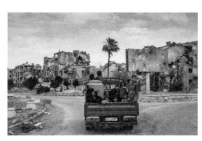

Eissa al-Ali and his family return home to their heavily destroyed neighbourhood in Raqqa, Syria, after years of displacement. The battle to liberate the city from ISIS destroyed 80% of buildings and probably killed thousands of civilians.
2017

Robin Rhode

Biography

Born South Africa, 1976
Lives and works in Berlin, Germany

Robin Rhode is a multidisciplinary artist who engages in photography, performance, drawing and sculpture to create narratives that are brought to life using quotidian materials such as soap, charcoal, chalk and paint. Born in Cape Town and coming of age in a newly post-apartheid South Africa, Rhode was exposed to new forms of creative expression motivated by the spirit of the individual rather than dictated by political or social agendas. The growing influence of urban music, film and sport on youth culture, along with storytelling in the form of colourful murals, encouraged the development of Rhode's hybrid street-based aesthetic.

His strategic interventions transform urban landscapes into imaginary worlds that compress space and time. Two-dimensional renderings become the subject of three-dimensional interactions by a sole protagonist, often played by the artist. Rhode's work plays with illusion, using historical and contemporary references to blend high and low art forms.

Rhode has had solo and group exhibitions at a number of museums around the world such as Haus Konstruktiv, Zurich; Haus der Kunst, Munich; Los Angeles County Museum of Art; Museum of Modern Art, New York; Centre Pompidou, Paris and Hayward Gallery, London. He has participated in the Venice Biennale; Biennale of Sydney and The New Orleans Biennial.

His work is in the public collections of Centre Pompidou, Paris; Fondation Louis Vuitton, Paris; National Gallery of Victoria, Melbourne; Solomon R. Guggenheim Museum, New York; Museum of Modern Art, New York and Walker Art Center, Minneapolis.

Artist statement

Principle of Hope

"A part of something is for the foreseeable future going to be better than all of it. Fragments over wholes. Restless nomadic activity over the settlements of held territory. Criticism over resignation ... limited independence over the status of clients. Attention, alertness, focus. To do as others do, but somehow to stand apart. To tell your story in pieces, *as it is*."

Edward W. Said, *After the Last Sky*, 1986

Using the street corner as my studio, *Principle of Hope* is photographed against a ruined wall in a township in Johannesburg. This wall is situated in a disadvantaged community that remains a footprint of the segregated apartheid era. Today, communities in this area are plagued by high levels of gangsterism, violence, poverty, drug abuse and unemployment, and occurrences of HIV/AIDS are increasing due to poor facilities and lack of education. Young people grapple with identity issues and self-esteem, even 20 years into newly-democratic post-apartheid South Africa. These geometric wall paintings and performances function as a form of photographic reportage, capturing creative gestures on a singular wall surface, but they also provide a form of rehabilitation that empowers these youths, my studio assistants and collaborators, reclaims urban space and embraces creativity as a productive outlet.

My photographic works evoke a sentiment that is perfectly articulated by Edward W. Said when he speaks of telling "a story in pieces, *as it is*" In my photography I attempt an even greater challenge – the mystic search for wholeness in the very midst of its impossibility. My photographic technique is similar to stop-frame animation. I attempt to capture each moment of the painting process, each choreographic action of the performers, frame by frame, a form of cinematic construct infused with political narrative.

In *Principle of Hope*, the glimmer of an answer lies in geometry – the illusion of perfectibility. Part of the wall is rendered grey to create the visual impression of stacked concrete bricks. This concrete spirals upwards towards a blue sky, a metaphor for an imaginary utopia. Moving between abstract speculation and visceral record, the artwork takes as a point of reference the philosopher Ernst Bloch's three-volume book *The Principle of Hope* (published in the 1950s), in which he explores utopian impulses in art, literature, religion and other forms of cultural expression, and envisages a future state of absolute perfection.

More a wager in the present tense than an edifying work of art, my photographic work is a vital challenge to our current disaffection. It is a testimony, perhaps, that art can save us.

Portfolio

Principle of Hope (still 1)
2017

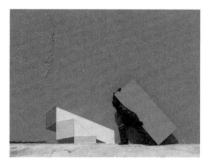

Principle of Hope (still 2)
2017

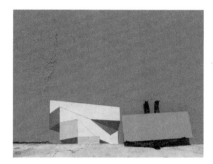

Principle of Hope (still 3)
2017

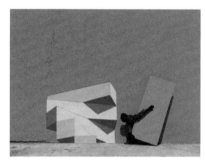

Principle of Hope (still 4)
2017

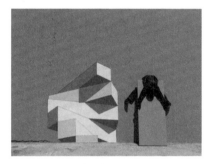

Principle of Hope (still 5)
2017

Principle of Hope (still 6)
2017

Principle of Hope (still 7)
2017

Principle of Hope (still 8)
2017

Principle of Hope (still 9)
2017

Principle of Hope (still 10)
2017

Awoiska van der Molen
Pages 34, 35

Biography

Born The Netherlands, 1972
Lives and works in Amsterdam, The Netherlands

Awoiska van der Molen is a Dutch artist working with the medium of photography. She studied architecture and design followed by photography at Minerva Art Academy, Groningen, The Netherlands. In 2003, she graduated with an MFA in Photography from the St Joost Academy of Fine Art and Design, Breda, The Netherlands.

In 2017, van der Molen was shortlisted for the Deutsche Börse Photography Foundation Prize for her exhibition *Blanco* and was also the recipient of the Larry Sultan Photography Award. She was awarded the Japanese Hariban Award in 2014 and was a finalist at the Hyères festival international de mode, de photographie et d'accessoires de mode in France in 2011. Her first monograph, *Sequester*, was nominated for The Paris Photo–Aperture Foundation PhotoBook Award in 2014 and received the Silver Medal for Best Book Design From All Over The World from the German Stiftung Buchkunst in 2015.

Solo exhibitions of her work have been held at Museum Kranenburgh, Bergen (2019); Foam, Amsterdam (2016) and Kousei-In, Kyoto (2015). She has participated in numerous group exhibitions including Les Rencontres d'Arles (2019); Pier 24 Photography, San Francisco (2017); Victoria and Albert Museum, London (2017); The Photographers' Gallery, London (2017); Stedelijk Museum, Amsterdam (2016) and Huis Marseille, Amsterdam (2013).

Her work is represented in museum collections worldwide including Pier 24 Photography, San Francisco; Victoria and Albert Museum, London; Stedelijk Museum, Amsterdam; Museum of Photography, Seoul; Fotomuseum The Hague and Foam, Amsterdam.

Artist statement

Am schwarzen Himmelsrund

When I came across the phrase 'Am schwarzen Himmelsrund' in Gustav Mahler's *Das Lied von der Erde*, it struck me as the perfect title for this selection of work. 'Himmelsrund', which translates as 'heavens' rim', was used in the Middle Ages to refer to the celestial firmament as a vaulted disc. This juxtaposition of the divine and the astronomic resonates with my process and quest as a photographer, where my solitary journeys in nature resemble those of the classic pilgrim or anchorite. We share the sense of hope present in alchemist, spiritual and even Christian beliefs that there must be a higher plane of existence to which humanity once had access, but with which it lost substantive contact.

Since I began my artistic practice 16 years ago (first photographing in urban settings, then increasingly drifting into natural wilderness), I have tried to get close to the true, unspoilt core of a place. By peeling back the layers of today's roaring world, I slowly eliminate all distractions in order to experience my surroundings with clean senses.

Due to cascading technological revolutions, our society has changed enormously over the last few centuries. Our bodies, however, have not evolved at the same pace, and we suffer when we are cut off from nature. Yet as this modern world engulfs us, I believe that the human body possesses a deep internal memory, an unconscious instinct, that recognises when we get closer to the place from which we stem: the uncorrupted territory of nature. This return is what I seek to visualise through my images.

My black-and-white photographs of mountains, forests or bodies of water become abstract representations of anonymised landscapes, the result of my urge to return to our origin. This process demands long periods of time spent in remote areas – in absolute solitude – to allow nature to imprint its specific emotional qualities on me. Few images travel back with me to be hand-printed in the dark room. Without titles or locations, the prints recreate my experience of these secluded natural worlds, erasing all boundaries of time and space.

The main constant of my photography, together with light, is an almost spiritual quality that transcends time. The obscurity of my images is crucial: I am drawn to the primordial space that can be found in the shadows of bright days. Like light, hope is subtle, intangible, elusive. It is something quiet and still. Yet at its core, hope also implies a sense of movement, a sense of direction.

Regardless of how personal my starting point may be, I hope my images touch the strings of a universal knowledge, something lodged in our bodies, our guts, an intuition that reminds us of our beginnings. A memory of our core existence, our bedrock, unyielding certainty in a very precarious world.

Portfolio

#364-18
2013

#206-8
2010

#311-16
2011

#511-7
2018

#542-16
2018

#491-16
2017

#448-18
2018

#545-16
2018

#417-05
2016

#435-3
2015

Alexia Webster

Page 60, 61

Biography

Born South Africa, 1979
Lives and works in New York, United States

Alexia Webster is a photographer and visual artist whose work explores intimacy, family and identity across the African continent and beyond. In 2013, she was awarded the Artraker Award for Conflict Art and the CAP Prize for Contemporary African Photography, and in 2007 she received the Frank Arisman Scholarship at the International Center of Photography, New York.

Her work has been widely exhibited across South Africa, Nigeria, the United States, Europe, Réunion Island and India and published in numerous international publications. Most recently, Webster travelled to Tijuana, Mexico, as part of an International Women's Media Foundation fellowship and grant.

Artist statement

Street Studios – An Archive of the Heart

Growing up, hanging in the hallway of my childhood home in South Africa was an old black-and-white photograph of my grandparents, great uncles and my mother as a toddler, posing in a photographer's studio. They were recent economic migrants to South Africa from a village on a small island in Greece. I would stare for hours at the photograph, my grandparents looking young and glamorous, dressed in their finest; at my three-year-old mother, sitting obediently with curls in her hair; at the painted studio backdrop, a misty romantic scene. Although they had left their whole world behind in search of a better life, to me they looked like elegant characters from a tale my grandmother would tell. This family photograph, of all the images I have, is my most-treasured.

Initiated in March 2011, the *Street Studios* project is a communal family photo album that began with the set-up of free outdoor photographic studios on more than 20 street corners and public spaces around the world. In each community we visited, we created public photo studio sets and invited any passing families and individuals to pose for a portrait. The photos were then printed on site and given to each participant to take away with them for their own family album. From street corners in informal settlements in Cape Town to refugee camps in South Sudan, neighbourhoods in Mumbai and parks and migrant shelters in Mexico, the studios are set up with the understanding that a family photograph can be a powerful and precious object. Both a participatory art performance as well as a communal gathering space, the studios are open and at the same time very intimate. By creating space for public displays of love and identity, they offer the community and individuals an affirmation of their heritage and belonging. With thousands of photographs taken over almost an eight-year period, *Street Studios* is an archive of family and love, an archive that documents not what makes things fall apart but what keeps them together.

Portfolio

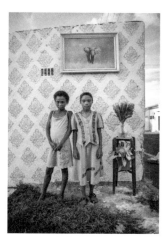

Two friends pose for their portrait on the corner of Cornwell and Hercules Street in Woodstock, Cape Town, South Africa.
2011

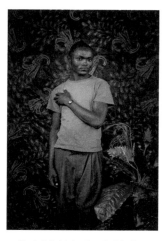

Charle Kahalalo has been in living for a year in Bulengo IDP Camp in Goma after escaping violent attacks on his village in Masisi, DR Congo.
2014

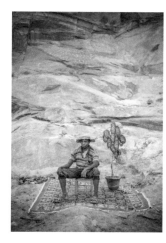

Jaspera Rahatavola, a rock breaker at the Ambohitrombihavana granite rock quarry outside Antananarivo, Madagascar, poses for his portrait in a temporary studio.
2014

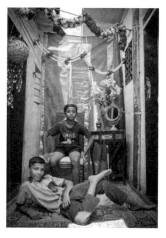

Two young friends pose for their portrait in a studio set up between houses in Dharavi, Mumbai.
2015

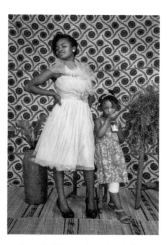

Mercy Mofokeng and her sister following a church service on Kaptein Street in Hillbrow, Johannesburg.
2013

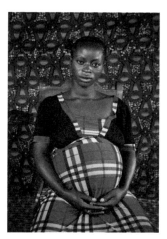

Neema Bonke, aged 35, pregnant with her third child, poses for a photo in Bulengo IDP Camp in Goma, DR Congo.
2014

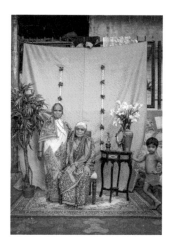

Two friends sit for a portrait in the communal courtyard of their neighbourhood in Dharavi, Mumbai.
2015

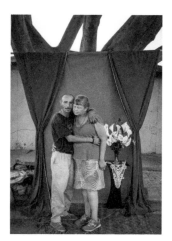

Jesus Gonzales Tejada, aged 40, a Mexican American who was deported from the United States, and Rhonda Moore, aged 54, an American nurse, pose for their portrait in the Mexican border town of Tijuana. Both are currently homeless.
2017

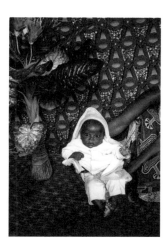

Akili, aged three months, is presented for a portrait by her mother Mapenzi Mwamini, aged 18. The family were farmers in Masisi, DR Congo, before they had to flee violence.
2014

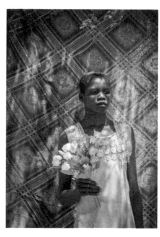

Nyaloki Mayor, aged 13, holds flowers in a United Nations IDP camp in Juba, South Sudan.
2016

Image Index

Prix Pictet

Prix Pictet *Hope*

Advisory Board

Lionel Barber
Editor, *Financial Times*

Sir Peter Bazalgette
Chair, ITV plc
Chair, Arts Council England 2013–17

Marcus Brauchli
Former Editor, *Washington Post, Wall Street Journal*

Christopher Brown
Director, Ashmolean Museum of Art &
Archaeology, Oxford 1998–2014

Melanie Clore
Founder, Clore Wyndham Fine Art
Former Sotheby's Chairman of Europe and
Former Co-Chairman of Impressionist and
Modern Art Worldwide

Régis Durand
Writer & Art Critic

Lady Foster
Founder and CEO, Ivorypress

Francis Hodgson
Professor in the Culture of Photography
University of Brighton

Maja Hoffmann
Founder, LUMA Foundation

Baroness Kennedy QC
Principal, Mansfield College
University of Oxford 2011–18

Dr Henry S. Kim
Director, Aga Khan Museum, Toronto

Fatima Maleki
Collector

Richard Misrach
Photographer

Lady Myners
Chair, Royal Academy Trust, London
Former Chair, Institute of Contemporary Arts
London

Sandy Nairne CBE
Director, National Portrait Gallery
London 2002–15

Fumio Nanjo
Director, Mori Art Museum, Tokyo

Michael Nyman CBE
Composer & Artist

Lord Palumbo
Art Collector & Trustee

Ivan Pictet
Chairman
Former Senior Managing Partner
Pictet Group

Nigel Pleming QC
Barrister

Thaddaeus Ropac
Owner, Galerie Thaddaeus Ropac
Paris & Salzburg

Ralph Rugoff
Director, Hayward Gallery, London

Sir Charles Saumarez Smith CBE
Senior Director, Blain|Southern
Former Secretary & Chief Executive
Royal Academy of Arts, London

Princess Marianne zu Sayn-Wittgenstein-Sayn
Photographer

Olga Sviblova
Director and Founder, Multimedia Art Museum
Moscow

Sir John Tusa
Trustee, Co-Chair, European Union Youth Orchestra
Former Chairman, University of the Arts, London

Roxane Zand
Senior Director, Deputy Chairman
Sotheby's Middle East and Gulf Region London

Slavoj Žižek
International Director, Birkbeck College
University of London

Jury

Sir David King
Chairman
Affiliate Partner, SystemIQ Limited
Senior Strategy Adviser to the President of Rwanda

Martin Barnes
Senior Curator of Photographs
Victoria and Albert Museum, London

Philippe Bertherat
Former Managing Partner, Pictet Group

Jan Dalley
Arts Editor, *Financial Times*

Herminia Ibarra
Charles Handy Professor of
Organisational Behaviour, London Business School

Richard Mosse
Photographer, Winner of Prix Pictet *Space*

Jeff Rosenheim
Curator in Charge, Photographs
The Metropolitan Museum of Art, New York

Kazuyo Sejima
Co-Founder, SANAA
Pritzker Prize-winning architects

Judging

In 2018, the worldwide network of Prix Pictet nominators made over 600 nominations for the award, with nominees submitting over 4,800 photographs to the secure competition section of the Prix Pictet website. These submissions were considered by the independent jury, led by Sir David King as Chairman, which met in April 2019 to decide on the eighth shortlist. The jury was charged with identifying photographic series of the highest artistic quality that presented a compelling narrative relating to the theme of *Hope*, and testified to the positive actions on sustainability that are beginning to emerge in the world around us. Reviewing the portfolios was immensely challenging because of the overwhelming diversity of the work submitted. After a rich debate the jury arrived at a final shortlist of 12 artists. The jury did not make any distinction between photographs of different genres. They looked for the series which they felt addressed the theme of *Hope* and highlighted efforts to confront the critical issue of global sustainability through photography of high artistic quality and compelling content. Following a scrunity of the shortlisted works exhibited at the Victoria and Albert Museum, London, the jury selected the overall winner in November 2019.

Space Tour 2017–19

Victoria and Albert Museum, London
4 May – 28 May 2017
Award and Finalists' Exhibition

LUMA Westbau, Zurich
22 September – 29 October 2017

Hillside Forum, Tokyo
23 November – 7 December 2017

Mouravieff-Apostol House & Museum, Moscow
19 January – 18 February 2018

Haus der Wirtschaft, Stuttgart
1 – 28 February 2018

Museum of Modern Art, Mexico City
2 March – 29 April 2018

CAMERA, Turin
23 May – 26 August 2018

Fondation CAB, Brussels
8 – 30 June 2018

EPFL – ArtLab, Lausanne
10 – 30 September 2018

Global Art Center, Istanbul
18 September – 17 October 2018

Flowers Gallery, New York
1 – 13 November 2018

Gallery of Photography, Dublin
16 November 2018 – 20 January 2019

Hope Tour 2019–21

The shortlist of the 12 artists selected for the eighth cycle was announced at the Les Rencontres d'Arles Festival in July 2019. The winner of Prix Pictet *Hope* was announced at the award ceremony at the Victoria and Albert Museum, London, in November 2019. The Prix Pictet *Hope* exhibition then embarks on a world tour with exhibitions in Tokyo, Zurich and Moscow among many others.

Further details of tour venues may be found on the Prix Pictet website www.prixpictet.com.

Prix Pictet *Hope*

Nominators

Africa
Roger Ballen | Rory Bester | Raphael Chikukwa |
Medina Dugger | Christine Eyene | John Fleetwood |
Joseph Gergel | Véronique Joo Aisenberg |
David Knaus | Stephan Köhler | Michket Krifa |
Nadira Laggoune | Jeanne Mercier | Azu Nwagbogu |
Ugochukwu-Smooth C. Nzewi | Oluremi Onabanjo |
Sean O'Toole | Katrin Peters-Klaphake |
Rachida Triki | Roelof van Wyk

Asia Pacific
Shahidul Alam | Rahaab Allana | Bérénice Angremy |
Françoise Callier | Christian Caujolle | Joselina Cruz |
Brian Curtin | Devika Daulet-Singh |
Nathaniel Gaskell | Shigeo Goto | Yumi Goto |
Salima Hashmi | Michiko Kasahara | Shiho Kito |
Bohnchang Koo | Eyal Landesman | Jiyoon Lee |
Kevin WY Lee | Szewan Leung | Ryan Libre |
Jean-Yves Navel | Elaine Ng | Harumi Niwa |
Lawrence Rinder | RongRong & Inri |
Bittu Sahgal | Farah Siddiqui | Sujong Song |
Shane Suvikapakornul | Mariko Takeuchi |
Eugene Tan | Rudy Tseng | Harsha Vadlamani |
Ivan Vartanian | Belinda Winterbourne |
Yuko Yamaji | Yan-Yan YIP | William Zhao |
Li Zhenhua

Europe
Alia Al-Senussi | Monica Allende |
Regina Maria Anzenberger | Karin Askham |
Gerry Badger | Quentin Bajac | Simon Baker |
Arnis Balčus | Sheyi Bankale | Christine Barthe |
Anne-Marie Beckmann | Ana Berruguete |
Tobia Bezzola | Daniel Blochwitz | Daria Bonera |
Enrico Bossan | Sophie Boursat |
Anne-Marie Bouttiaux | Emma Bowkett |
Krzysztof Candrowicz | Chiara Capodici |
Alejandro Castellote | Zelda Cheatle | Hans D. Christ |
Zoë Christensen | Dirk Claus | Charlotte Cotton |
Jess Crombie | Luc Debraine | Richard Duebel |
John Duncan | Maryam Eisler | Brandei Estes |
Chantal Fabres | Louise Fedotov-Clements | Eva Fisli |
Andrzej P. Florkowski | Valérie Fougeirol |
Benjamin Füglister | Tamar Garb | Adam Goff |
Anna Gripp | Francis Hodgson | Felix Hoffmann |
Genevieve Janvrin | Alain Jullien |
Mindaugas Kavaliauskas | Klaus Kehrer |
Hester Keijser | Tanya Kiang | Oliver Kielmayer |
Simone Klein | Fabian Knierim | Marloes Krijnen |
Evelien Kunst | Trish Lambe | Harriet Logan |
Vicky Long | Celina Lunsford | Francesca Malgara |
Rebecca McClelland | Manolis Moresopoulos |
Stavros Moresopoulos | Nat Muller |
Andreas Müller-Pohle | Philippa Neave |
Moritz Neumüller | Laura Noble | Alona Pardo |
Nina Pearlman | Timothy Persons | Benedict Philpott |
Fiorenza Pinna | Ulrich Pohlmann | Phillip Prodger |
Marc Prüst | Yasmina Reggad | Julian Rodriguez |
María Inés Rodríguez | Mario Rotllant | Ida Ruchina |
Beatrix Ruf | Torsten Scheid | Carrie Scott |
Thomas Seelig | Laura Serani | Fiona Shields |
Tamsin Silvey | Bernd Stiegler | Roger Szmulewicz |
Ingo Taubhorn | Anna Tellgren | Wim van Sinderen |
Enrica Viganò | Dragana Vujanovic |
Jean Wainwright | Artur Walther | Jeni Walwin

Latin America
Marcelo Araújo | Fernando Arias |
Gustavo Artigas | Daniel Brena | Eder Chiodetto |
Ramón Jiménez Cuen | Clara de Tezanos |
Elizabeth Ferrer | Elvis Fuentes | Tom Griggs |
Roberto Huarcaya | Jessica Hubbard Marr |
Nicola Maffei | Tobi Maier | Antigoni Memou |
Mayu Mohanna | John Mraz | Elena Navarro |
Thyago Nogueira | Gonzalo Olmos | Karla Osorio |
Nelson Ramirez de Arellano Conde |
Manuel Rivera-Ortiz | José Roca | Itala Schmelz |
Itzel Vargas Plata | Ricardo Viera | Luis Weinstein |
Trisha Ziff

Middle East
Basma Al Sulaiman | Peggy Sue Amison |
Sena Çakirkaya | Levent Çalıkoğlu |
Fariba Derakhshani | Elie Domit | Shadi Ghadirian |
Tami Gilat | Isabella Icoz | G. H. Rabbath |
Somayeh Rokhgireh and Ali Pooladi |
Khaled Samawi | Maria Sukkar | Sinem Yoruk

North America
Peter Barberie | Elisabeth Biondi | Phillip Block |
Joshua Chuang | Joerg Colberg | T.J. Demos |
Natasha Egan | Steven Evans | Merry Foresta |
David Griffin | Virginia Heckert | Darius Himes |
W. M. Hunt | Karen Irvine | Deborah Klochko |
Adriana Teresa Letorney | Lesley A. Martin |
Stephen Mayes | Michael Mehl |
Cristina Mittermeier | Kevin Moore |
Rebecca Morse | Alison Nordstrom |
November Paynter | Jaime Permuth |
Sandra S. Phillips | Jillian Schultz |
Paula Tognarelli | Sofia Vollmer de Maduro

Oceania
Paola Anselmi | Daniel Boetker-Smith |
Rebecca Chew | Maggie Finch | Helen Frajman |
Jennifer Higgie | Julie Millowick | Jeff Moorfoot |
Isobel Parker Philip | Anouska Phizacklea |
Elias Redstone | Heidi Romano | Moshe Rosenzveig |
Geoffrey Short | Juha Tolonen | Christine Tomas

Acknowledgements

Museums and Festivals (*Space*)

Galleries, Studios and Agencies (*Hope*)

Victoria and Albert Museum, London
Tristram Hunt, Director
Martin Barnes
Sarah Jameson
Sarah Scott

Les Rencontres d'Arles
Sam Stourdzé, Director
Lauriane Hervieux

Presentation and Music
Olivier Koechlin
Grégory Pignot

LUMA Westbau, Zurich
Anna von Brühl
Friedrich von Brühl

Hillside Forum, Tokyo
Miho Odaka, Adviser

Mouravieff-Apostol House & Museum, Moscow
Christopher Mouravieff- Apostol
Olga Sviblova

Haus der Wirtschaft, Stuttgart
Karin Grau

Museum of Modern Art, Mexico City
Sylvia Navarrete, Director
Diana Camargo Meade
Bernardo Sánchez

CAMERA, Turin
Walter Guadagnini, Director
Giulia Gaiato
Francesca Spiller

Fondation CAB, Brussels
Hubert Bonnet, Founder
Eléonore de Sadeleer, Director

EPFL – ArtLab, Lausanne
Sarah Kenderdine, Director
Giulia Bini

Global Art Center, Istanbul
Gökhan Özer
Gülten Cebeci

Flowers Gallery, New York
Matthew Flowers, Director
Brent Beamon
Hannah Hughes
Rebecca Reeve

Gallery of Photography, Dublin
Tanya Kiang, Co-Director
Trish Lambe, Co-Director

Shahidul Alam
Rezaur Rahman, Drik Gallery, Bangladesh
Majority World

Joana Choumali

Margaret Courtney Clarke
Jean Butler, Shona van der Merwe and
Lee Burgers, SMAC Gallery, Cape Town

Rena Effendi
Deanna Richardson, ILEX Gallery, Rome

Lucas Foglia
Erin Wallace, Michael Hoppen Gallery, London

Janelle Lynch

Ross McDonnell

Gideon Mendel

Ivor Prickett

Robin Rhode
Shona Alexander, Joost Bosland and
Cathy Duncan, Stevenson Gallery, Cape Town
Galleria Tucci Russo, Turin

Awoiska van der Molen
Eva Brussaard, Studio Awoiska, Amsterdam

Alexia Webster

Collectors/Lenders

Other

Scheryn Art Collection

Rick Brownsill | Dennis Chang | David Clayton |
Tim Delaney | Mark Foxwell | Pete Godsen-Phillips |
Fritz Gottschalk | Alwine Krebber |
Heidi Lightfoot | Catherine Philippot |
Jane Quinn | Isabella Salvadore | Harry Smith |
Rob Stone | Dave Ward | Diana Whittington |
Sian Williams

Prix Pictet Exhibitions

93 exhibitions in twelve years

London
Mall Galleries
Water 2009
Diemar/Noble Gallery
Earth 2010
Saatchi Gallery
Power 2012
Victoria and Albert Museum
Consumption 2014
Space 2017
Somerset House
Commissions 2013
Disorder 2016

Washington D.C.
Corcoran Gallery of Art
Growth 2011

Brussels
CAB Art Centre
Consumption 2015
Disorder 2016
Space 2018

Amsterdam
Huis Marseille
Power 2013

Luxembourg
Ratskeller
Consumption 2014

Dublin
Gallery of Photography
Earth 2010
Growth 2011/12
Power 2013
Consumption 2015
Disorder 2017/18
Space 2018/19

Paris
Palais de Tokyo
Water 2008
Passage de Retz
Earth 2009
Growth 2010
Galerie Les Filles du Calvaire
Growth 2010
Galerie Vanessa Quang
Power 2012
Musée d'Art moderne
Disorder 2015

Stuttgart
House of Economy
Space 2018

Rome
MAXXI Museum
Disorder 2016

Turin
Fondazione Sandretto
Re Rebaudengo
Consumption 2014
CAMERA
Space 2018

New York
Aperture Foundation
Power 2013/14
Flowers Gallery
Space 2018

San Diego
Museum of Photographic Arts
Laureates 2011/12
Power 2014
Disorder 2017

Mexico City
Museo Nacional de Arte
Consumption 2014/15
Museo de Arte Moderno
Space 2018

Arles
Les Rencontres d'Arles
Laureates 2014
Laureates 2018

Madrid
Delegación Principado
de Asturias
Earth 2010
Real Jardín Botánico
Growth 2011/12

Lucca
Photolux Festival
Space 2017

Geneva
Bâtiment des Forces Motrices
Water Commission 2009
The International Red Cross
and Red Crescent Museum
Disorder 2016

Milan
Fondazione FORMA
Earth 2010
Galleria Carla Sozzani
Growth 2011

Barcelona
Palau Robert
Consumption 2014
Disorder 2017

Hamburg
Kunstverein
Disorder 2016/17

Rossinière
Alt.+1000 Festival
Power Commission 2013

Eindhoven
University of Technology
Water 2009
Earth 2010
Growth 2012

Dresden
Kempinski Hotel
Water 2009
Residenzschloss
Water Commission 2009

Bonn
Sustainability Congress
Water Commission 2009
Earth 2010

Munich
Bernheimer Fine Art Photography
Power 2012
Consumption 2014

Dusseldorf
Arteversum
Growth 2011

Berlin
Caprice Horn Gallery
Earth 2010

Budapest
Hungarian House of Photography
Power 2013

Moscow
Moscow House of Photography
Earth 2010
Mouravieff-Apostol House & Museum
Laureates 2016
Space 2018

Zurich
Galerie Christophe Guye
Growth 2011
LUMA Westbau
Power 2013
Consumption 2014
Disorder 2016
Space 2017

Istanbul
Istanbul Modern
Power 2013
Global Art Centre
Space 2018

Lausanne
Musée de l'Elysée
Laureates 2010
EPFL ArtLab
Space 2018

Beirut
Ayyam Gallery
Growth 2012
Beirut Exhibition Centre
Power 2013
Consumption 2015

Tel Aviv
Artstation Gallery
Power 2013

Athens
The Municipal Gallery
of Athens
Disorder 2016

New Delhi
Religare Art
Gallery
Earth 2010

Hong Kong
The Rotunda
Water 2009
Hong Kong Convention
and Exhibition Centre
Growth 2012

Tokyo
Ba-Tsu Art Gallery
Consumption 2015
Bank Gallery
Disorder 2016
Hillside Forum
Space 2017
Prix Pictet Japan 2018

Dubai
Dubai International Financial Centre
Water 2008
Empty Quarter Gallery
Earth 2010
East Wing
Consumption 2015

Thessaloniki
Thessaloniki Museum of Photography
Water 2008/09
Earth 2009/10
Growth 2011
Power 2013
NOESIS Science Center & Technology Museum
Consumption 2014

water
Paris — Dubai — Thessaloniki — London —
Hong Kong — Eindhoven — Dresden

earth
Paris — Thessaloniki — Dubai — Eindhoven —
Dublin — London — Bonn — Moscow — Berlin —
Milan — Madrid — New Delhi

growth
Paris — Thessaloniki — Zurich — Milan —
Dusseldorf — Madrid — Washington D.C. —
Dublin — Beirut — Eindhoven — Hong Kong

power
London — Munich — Paris — Budapest — Istanbul —
Dublin — Amsterdam — Beirut — Thessaloniki —
Zurich — London — Tel Aviv — New York — San Diego

consumption
London — Barcelona — Thessaloniki — Turin —
Zurich — Luxembourg — Munich — Mexico City —
Dubai — Brussels — Dublin — Beirut — Tokyo

disorder
Paris — London — Rome — Brussels — Geneva —
Zurich — Athens — Tokyo — Dublin — Hamburg —
San Diego — Barcelona

space
London — Zurich — Lucca — Tokyo — Moscow —
Stuttgart — Mexico City — Turin — Brussels —
Lausanne — Istanbul — New York — Dublin

laureates
Lausanne — San Diego — Arles — Moscow — Arles

commissions
Dresden — Bonn — Geneva — Rossinière — London